The Scottish Colourists

Long and widely collected in Scotland, the four early twentieth-century painters known as the Scottish Colourists were largely forgotten in England or further afield – until the last few years. Their stock has now risen to such heights as to place them at the centre of attention: Peploe's *A Girl in White* was sold in 1988 for over £500,000, making it one of the most expensive twentieth-century British works of art. This is the first study to consider the work of all four painters and to do justice to their most characteristic quality by the standard of colour reproduction.

In the 1880s a group of young Scots painters, the 'Glasgow Boys', discovered the atelier system of training in Paris and the wealth of new work to be seen there. The Colourists were ardent admirers of the 'Boys' and also spent their formative years in Paris at the time of the great exhibitions devoted to Whistler, Cézanne, Van Gogh, Gauguin and Toulouse-Lautrec. Encountering at first hand the latest Fauve and Cubist works by Matisse and Picasso, they brought back to Scotland the first truly modern painting to be seen in Britain this century.

Strong, emotive colour, fluent brushwork and a keen sense of pattern marked their painting as different from and more advanced than anything else to be seen in Britain before the appearance of the Vorticists in 1914. Throughout the 1920s they exhibited regularly in Scotland, London, Paris and New York. Following his pioneering study of *The Glasgow Boys* (1985) Roger Billcliffe's book confirms the Colourists' reputation and re-assesses the importance of their work in the context of twentieth-century British painting.

Roger Billcliffe has lived in Glasgow since 1969 when he became a Lecturer in Fine Art at Glasgow University and Assistant Keeper of the Art Collections there. In 1977 he became keeper of Fine Art at Glasgow Art Gallery before moving to The Fine Art Society as Director in charge of the company's Scottish galleries in Edinburgh and Glasgow. In 1992 he established the Roger Billcliffe Gallery in Glasgow, specialising in 20th century and contemporary Scottish art. His previous books include *Mackintosh Watercolours* (1978); *Charles Rennie Mackintosh: The Complete Furniture*, etc. (1979 and 1986); *Mackintosh Textiles* (1982 and 1993) and *The Glasgow Boys* (1985).

Roger Billcliffe

The Scottish Colourists

Cadell, Fergusson, Hunter, Peploe

John Murray
Albemarle Street, London

First published in 1989

First published in paperback in 1996
by John Murray (Publishers) Ltd.,
50 Albemarle Street, London W1X 4BD

Reprinted 1998, 2000

The moral right of the author has been asserted

A catalogue record for this book is available from the British Library

ISBN 0-7195-5437 3

Typeset in Joanna

Printed in Great Britain by
St Edmundsbury Press Ltd, Bury St Edmunds, Suffolk (Text)
and Caledonian International, Glasgow (Colour Plates)
Bound in Great Britain by
Hunter & Foulis, Edinburgh

Contents

Author's Note

Ten years after I wrote the preface to the first edition of this book I find the wheel has come full circle. In 1987 an exhibition of British painting in the 20th century in the Royal Academy contained no works by the four artists celebrated in this volume; in 2000, in the same galleries, they are the subject of an exhibition devoted solely to their work. It would be invidious and unfair of me to claim sole credit for this turn of events. Indeed, my original book was itself inspired by a growing interest in Scotland and England in the work of the Scottish Colourists that was evident throughout the 1980s. This made their exclusion from the 1987 exhibition all the more curious. In the 1990s their star has risen and fallen with the vagaries of the market but their artistic reputations are now truly established in international terms.

The revival of interest in Scottish painting in general could be said to have been driven by the attention that the Colourists have received in the last decade. Each of them has been the subject of individual exhibitions and the establishment in Perth of a whole museum devoted to his work has further honoured Fergusson. Their influence in Scotland extended to three or more generations of Scottish painters not just in pictorial terms but also through their open acceptance of French painting and the delights they discovered in the French landscape. Their international success has been emulated by many post-war Scottish artists who have no doubt found the hard road to foreign fame paved by the efforts of Cadell, Fergusson, Hunter and Peploe, just as they themselves were able to walk in the footsteps of the Glasgow Boys.

Roger Billcliffe
Glasgow
January 2000

Preface

In 1987 the Royal Academy in London staged an exhibition entitled *British Art in the 20th Century*. There was not a single work on show painted by a Scottish artist before 1950, save Duncan Grant who, although born in Scotland, spent all his working life in England and was a member of that thoroughly English movement, the Bloomsbury Group. The Welsh were similarly under-represented. The casual observer might be forgiven for believing that the Scots had contributed nothing to the development of avant-garde painting in Britain in this century. Since 1910, when Roger Fry organised the first in the series of exhibitions devoted to the latest happenings in painting in France and England – under the catch-call title of 'Post-Impressionism' – Scottish artists have been all but ignored in England. Why?

The four painters who are the subject of this book chose to paint in a manner which is particularly un-English. They chose to follow the gestural, highly coloured manner of Matisse and the Fauves, a movement which did not meet with universal approval within English artistic circles; even English painters who fell under the same spell, such as Matthew Smith, found recognition difficult to come by. It was not purely chauvinism which caused the English to ignore what was happening in Scotland; they were not attuned to the kind of painting which Scottish artists are particularly good at, where colour and a painterly manner go hand-in-hand to produce an emotive and highly charged image.

The work of these four painters, now popularly known as the Scottish Colourists, showed, in my opinion, a greater understanding and far more advanced knowledge of the latest movements in painting and sculpture in the years before the outbreak of war in 1914 than its counterpart in England. Almost all of these advances stemmed from Paris and, while the Camden Town Group were still absorbing the work of the Divisionists and Bonnard and Vuillard, Fergusson and Peploe were in close touch with Matisse, Derain and Vlaminck; their work almost immediately reflected the discoveries of these French painters. The artistic politics which had riven the London art world divided painters into those for and against Roger Fry and his particular view of the state of modern painting. The Scots were outside his field of vision, and as his star rose their fell.

In Scotland they were nurtured, after a fashion. A younger generation looked to them as a direct link with Paris, still the centre of the art world until the 1930s. Collectors bought their paintings because they admired them for their aesthetic and intellectual qualities, or because they envied their use of bold colour and the expression of emotions which were too often suppressed in polite Scottish society. Others, no doubt, bought them because they were Scottish and it is this very devotion to these painters as Scots that contributed to

the rarity of their appearances in London galleries. Collectors in Scotland were able to absorb almost all of the works which came on to the market, thus removing any incentive on the part of London dealers to look for new markets.

In recent years this has changed. A number of young scholars who have begun to investigate the effect of the Modern Movement on British painting have come to realise that it had its greatest impact on this group of young Scots, and others, who welcomed the new developments with an open mind. The few dealers in London who had made any attempt to further the cause of Scottish painting found that, about ten years ago, the Colourists were suddenly in wider demand and competition for them much increased. All this was a belated recognition of the Colourists' intrinsic qualities, further reinforced by the inclusion of some of Fergusson's best paintings in the exhibition *Post-Impressionism* at the Royal Academy in 1979. It was also the realisation that by the standards of French painting of the first half of this century, and even some English painting, they were surprisingly underpriced. The Scots, thanks to that particular aspect of their character that causes them to denigrate those who praise Scottish achievements (only fellow Scots can do that with any hope of impunity), have often ridiculed the recent prices paid for Colourist pictures after half a century of neglect. 'I ken't his faither' (meaning he can't be any good) was a maxim applied to Mackintosh and the Glasgow Boys with disastrous results for Scotland.

The Scottish Colourists are at last now receiving the international recognition that only just eluded them fifty years ago. I hope this volume will go some way to help establish their true place in the history of painting in the twentieth century.

I have many people to thank for the help and advice they have given me over the years that I have been looking at Colourist paintings. The late Professor Alec Macfie first introduced me to them and spent many hours, in his analytical manner, describing the differences he saw in their work. His brother, Jock, was just as committed, but made much more intuitive judgements both about the painters and their paintings, delivered in the manner that only a Major-General in the RAMC could ever aspire to. Since those days, now twenty years ago, I have been fortunate enough to see all of the best collections of Colourist paintings still in private hands. To Lord Macfarlane, Ross Harper, and all of those collectors who are cloaked in the anonymity of 'Private Collection' elsewhere in this book, I offer my warmest thanks.

Many Colourist paintings have entered museum collections over the years, both by gift and purchase. To the curatorial staff of these institutions, and to their photographers, I am most grateful. At Robert Fleming's, London, where one of the best collections of Scottish painting to be found outside Scotland is hung for the daily pleasure of its employees, I am grateful for the help and keen interest of Bill Smith, its devoted custodian.

Andrew McIntosh Patrick, at The Fine Art Society, has shared his knowledge of paintings sold long ago both in and out of Scotland. Richard Green and Tom Hewlett have similarly helped locate paintings which I might otherwise have missed. Marilyn Muirhead took many of the transparencies used in the making of the plates and I shall be forever astonished at the results she produced in the most uncomfortable and unpredictable of working conditions. Other transparencies came from the archives of The Fine Art Society, Robert Fleming's, Richard Green, J D Fergusson Art Foundation, and the museum collections cited in each caption.

Lord Macfarlane has been a constant source of encouragement in the development of this book, providing a financial subsidy which has ensured that the Colourists are represented here in colour and not in less-expensive black and white. Duncan McAra and, at John Murray, Roger Hudson have applied gentlemanly pressure to ensure that my deadlines were not totally disregarded and have honed my text with their own editorial skills.

My family, as always, offered continuing encouragement and support, and without their help and forbearance this book would never have been completed.

Roger Billcliffe
Glasgow
February 1989/1996

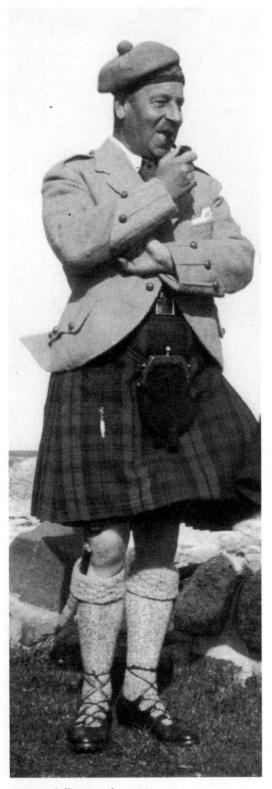

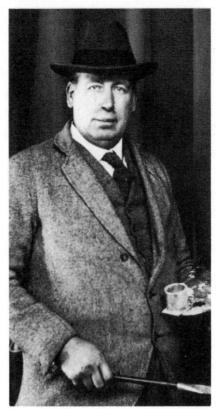

G Leslie Hunter

S J Peploe

F C B Cadell in October 1932

J D Fergusson

The Scottish Colourists

At the beginning of 1939 London was in the middle of one of those periodic assaults that Scottish artists have made upon the city over the last two centuries. The previous year a great survey of Scottish painting had been shown at the Empire Exhibition in Glasgow and its success led to an invitation to bring a similar exhibition to the Royal Academy. Other galleries took up the theme and Scottish art, ranging from Sir David Wilkie to the latest avant-garde work, could be found in Bond Street and St James's. At Reid & Lefèvre, a gallery established through the merger of Alex Reid's Glasgow gallery – La Société des Beaux Arts – and the Lefèvre Gallery, and managed by Scots, 1939 opened with a show of the work of three recently deceased artists, billed as 'Three Scottish Painters: S J Peploe, Leslie Hunter, F C B Cadell'. The following month a fourth Scot, J D Fergusson, was given a one-man show in the gallery.

Herbert Furst, the editor of *Apollo*, reviewed both Reid & Lefèvre exhibitions and cast a sidelong glance at the Royal Academy's offering. He found himself puzzled with the catalogue introduction to the exhibition of the three painters which was written by Douglas Percy Bliss, a fellow artist and later Director of the Glasgow School of Art. Bliss wrote that these three artists had 'carried on and brought up to date the tradition of the Glasgow School', a statement which confused Furst who could see no tradition at all in Scottish art. Furst went on:

the likeness between our triplets or quadruplets [the Lefèvre painters] and the Glasgow School is about as striking as the likeness between ... Princes Street, Edinburgh, and Sauchiehall Street, Glasgow, on an autumn day – sparkle and colour in one, gloom and greyness in the other.

The evidence for this statement – and probably the sum total of the writer's knowledge of either Scottish painting or the streets of Scotland's two great cities – came from his visits to the exhibition of Scottish art at the Royal Academy. He continued:

To step from Sir James Guthrie's room at Burlington House into Peploe's room there illustrates what I mean. It has the effect of stepping from fog and murk into sunshine and air. And as fog and murk more or less characterise almost all the other rooms in the Academy at present ... the Peploe-Hunter-Cadell-Fergusson School seem to represent a break with tradition, rather than a continuance.

What the reviewer failed to recognise was that in the best of Scottish painting there is a feeling for the liquidity of paint – an obvious pleasure in the way it can be manipulated by the brush. Scottish artists have always seemed peculiarly aware of the effects of light, whether it be as a result of the lack of it (which the reviewer presumptuously associated

with Scotland) or the extreme effects of its super-abundance; through its particular clarity on the east coast; or the scintillation of fleeting cloud on sparkling waters around the western coast and the isles. Above all, the Scots have always been conscious of the power of colour which is perhaps the most identifiable factor which links Scottish art from the eighteenth century to the present day. The intense blue of eastern skies and the vivid greens of the coastal fields are countered on the west by the brilliant sunsets and the sharp contrast between the blue-green seas around the isles and their own pale sands. The colours of moors and hills are more subtle and tempered by the more frequent greyness of light that is many people's perception of Scotland. Even in the Highlands, in what was once the everyday dress of its people, the colour of Scotland is clearly woven in the tweeds and tartans that have become the traditional symbols of the country.

What the reviewer also failed to see was that the Glasgow School was not all about James Guthrie's low-keyed portraits. In fact, by the time that Guthrie was producing these in any number the Glasgow School had all but burnt itself out as a force of any artistic integrity. When Bliss made the claim that Peploe, Cadell and Hunter were working in the footsteps of the Glasgow School, he certainly did not have in mind the academic portraits that were so much in evidence at Burlington House that year. It was the more irreverent work of the Glasgow Boys (as the artists of the Glasgow School called themselves and have come to be known) that had so appealed to these younger men and any reviewer worth the name should have been able to grasp the difference between Guthrie's *Midsummer* or *Schoolmates* and the 'fog and murk' that he found in Guthrie's room at the Academy.

If this reviewer's perception of Scottish painting was shared by many of the visitors who walked through Burlington House that year then the organisers had failed miserably in their brief to represent the best of Scottish painting. It could well have been, of course, that their brief was only to represent the best of Scottish *academic* painting and in that, in the opinion of J D Fergusson at least, they were clearly successful. Certainly, the selection was less catholic than the exhibition seen in Glasgow in 1938. There were no young avant-garde artists included in the show and the one great masterpiece of the Glasgow School – George Henry's *A Galloway Landscape* of 1889 – was excluded. Fergusson, more than any of the three other artists mentioned in the review, maintained a distrust and dislike of academies and institutes throughout his life. They were, he felt, the downfall of the Glasgow Boys whose ambitions and aspirations for success caused them to turn away from their early essays in naturalist painting towards the academic formulas which appealed to a wider but less discerning public. At the same time it satisfied those artists who controlled the Academies in London and Edinburgh for whom originality was usually anathema. The Academies realised that by inviting them to join their ranks they both weakened the claims of the new men and improved their own image by appearing to be open and genuine in their acceptance of the new art.

The Glasgow Boys had originally despised the Academy because of its blinkered and

dogmatic attitude towards any art which did not conform to its own narrow concepts. Their early pictures, however, (those produced before 1895) had a considerable effect on other painters who were swithering between adopting the Academy line and breaking out on their own. Those Glasgow paintings which were shown on the walls of the Academy had, therefore an effect disproportionate to their numbers, and one of the Boys' greatest achievements was in forcing the Royal Scottish Academy to relax its attitude towards painting which did not meet its own criteria. The Boys may have 'sold out' in Fergusson's eyes by joining the Establishment but they did ensure that in future there could be a place for more imaginative, experimental and individual paintings on the walls of the annual summer exhibition in Princes Street.

It was these pictures, which began to appear in Edinburgh during the late 1880s and 1890s, that were to spur on the young Peploe and Fergusson towards a career as artists and to mould their life-long attitudes to their profession. Cadell was somewhat younger and his introduction to the Glasgow Boys came at first hand through family friendships with one of the most influential figures among the Boys, Arthur Melville. Leslie Hunter, who spent the 1890s in the United States, can have known of their work only from books and magazine articles (of which their were many) or possibly from their exhibitions on the east coast of America from about 1896 which he could have visited. This more recent phase of the Boys' work, which was well exhibited in Edinburgh, had a particular concentration on colour. The artistic centre of the group had by this time moved away from Guthrie and Lavery towards George Henry and E A Hornel. Henry had never entirely adopted the relatively low-keyed palette called for in the naturalist paintings of the early and mid-1880s which slowly gave way to a greater interest in the value and symbolism of colour. He and Hornel found their inspiration in the emotive and brilliant colour of the watercolours of Arthur Melville. In his earlier paintings Melville had captured the intense light of Africa and the Middle East. Now, having settled in London from the early 1890s, Melville concentrated more on the landscape of his homeland and western Europe but his eye was to isolate the same intensity of hue in more familiar surroundings.

Hornel and Henry combined clarity of colour with a more vigorous brushwork and use of impasto. Adolphe Monticelli (1824-86), a French painter whose work is typified by a heavy impasto, became an important influence alongside Whistler and the art of Japan. (Monticelli was one of the few artists whose work Leslie Hunter was to buy in later years). Hornel and Henry's paintings, produced between 1888 and their return in 1896 from a visit to Japan, display another major link with European painting – the symbolism of Gauguin and the Pont Aven School. Nowhere is this better seen than in *A Galloway Landscape*. Whether it was produced as a direct result of contact with French Post-Impressionism is not known but it came to represent all that was vigorous, imaginative, bold and accomplished in the work of the Glasgow Boys. While its impact was negligible

on the younger generation of artists in London who were to follow, broadly, the way of Post-Impressionism, it became an icon for the four young painters who came to be known as the Scottish Colourists.

The group of artists whom we now call the Scottish Colourists comprised only four men. They were all a generation or so younger than their early idols, the Glasgow Boys, and all grew up in relatively comfortable middle-class backgrounds. Samuel John Peploe (1871-1935) and John Duncan Fergusson (1874-1961) were the first to come to public attention in Edinburgh in the late 1890s. George Leslie Hunter (1877-1931) was born in Rothesay, Isle of Bute, but emigrated to California with his family at the age of thirteen and did not return to Scotland until 1906. Edinburgh-born, like Peploe, but twelve years younger, Francis Campbell Boileau Cadell (1883-1937) began to exhibit there in 1902.

Like the Glasgow Boys, who were never a coherent single group, these four rarely, if ever, all worked together. A series of friendships between Peploe, Cadell and Fergusson was at different times to produce the critical spur to their development – Peploe and Fergusson from 1900 to 1914 and Cadell and Peploe from 1918 to 1930. Hunter kept in touch with the group through his patrons and various dealers in Edinburgh, Glasgow and London, but he was a much more solitary character and was never close to any of the others. He was in touch with Fergusson when the latter had settled in France after 1925 but his residence in Glasgow and his periods of isolation in Fife and France kept him away from regular meetings with Peploe and Cadell. In many ways this paralleled the Glasgow Boys, who can be divided into three quite distinct groups and who were all working individually towards the same goals, coming together in any sort of unison only in 1885, soon after which they began to go their separate ways. The Colourists never quite achieved, nor wanted that degree of unanimity, but at the outbreak of war in 1914 they were as close to each other in painterly manner and outlook as they would ever be.

S J Peploe (by some quirk of politesse, three of these painters are regularly referred to by their initials and not their first names) was the first of the four to embark on a career in painting. He did it much against the wishes of his family who were firmly entrenched in the narrow band of professions that Edinburgh seems to recognise for young men of the Peploes' station in life. His father had been Secretary of the Commercial Bank of Scotland but had died in 1884, leaving the young Samuel an orphan, cared for by trustees and his half-brother, James. After the latter had tried in vain to persuade Peploe to follow him into the army it was decided that a career in the law was the only option. Peploe was not happy in the offices of Scott & Glover, Writers to the Signet, and for a while considered emigrating to become an indigo planter. It is an early sign of Peploe's persistence and integrity that he persevered with his own plans to study to become an artist. Eventually, in 1893, his trustees were persuaded to allow him to enrol in the Edinburgh School of Art, a

poorly organised collection of classes under the general supervision of the Royal Scottish Academy. I am sure that they felt this was a temporary aberration on the young man's part that would soon pass if properly humoured. He was sent on his way with this warning from the senior partner: 'Are you sure you have the divine afflatus? You know it is often confused with wind in the stomach.' It must have been at this time that Peploe became aware of the works of the Glasgow Boys, either at the Academy itself, where they were just becoming regular exhibitors, or at the Royal Glasgow Institute of the Fine Arts. By this time, Melville, Henry and Hornel were the only members of the group who were contributing the exciting works for which the Boys had become famous, notorious even, although Peploe would have seen Guthrie's *Midsummer* when it was shown at the RSA in 1893.

It was well known that several of the Boys had trained in France and Peploe escaped from Edinburgh to Paris, where he attended the classes at the Académie Julien and the Académie Colarossi in 1894. He won a silver medal at the latter but the true advantages must have come from his immersion in Parisian artistic society rather than from anything he might have learned from Bouguereau, who was professor at Julien's ('Damned old fool' was Peploe's later judgement on him). It was on this first visit to Paris that Peploe would have encountered the work of Manet in any quantity. It was to have an immediate effect. He had been prepared for it through his knowledge of the Barbizon School and recent French painting, acquired in Scotland at the Edinburgh and Glasgow exhibitions. The Glasgow dealers, in particular, had been very active in bringing the work of Millet, Diaz, Rousseau, Breton and Corot to Scotland as well as the paintings of their Hague School contemporaries. Millet was an immediate attraction for Peploe in Paris but his early fascination for the possibilities of still-life painting took him beyond the Barbizon painters to Manet and his circle. Peploe recognised in Manet's manipulation of tonal values that he was continuing a tradition in still-life painting that had begun with Chardin. Everywhere he went he searched out the best examples of still-life work, discovering in Amsterdam the masterly series of compositions by Frans Hals.

On his return to Scotland, Peploe translated his new-found enthusiasms into a series of still-life paintings, studio interiors and small landscape panels. For the rest of his life Peploe was to be fascinated by the endless permutations of arranging fruit, bottles, knives, silver jugs and ceramic vases against a carefully chosen background. In the mid-1890s, when he returned to Edinburgh to a studio in the Albert Buildings at 24 Shandwick Place, Peploe arranged all these individual elements against a dark background. He even preferred to work in a studio that was predominantly brown or grey in colour, which allowed the highlights on a silver coffee pot, or the flash of light on the skin of an apple to shine out against the gloom of the background. Peploe's continuation of the Glasgow Boys' search for tonal values was carried to its ultimate in these tightly controlled works of the period 1896-1906. He never lost his awareness of the physical qualities of the paint,

however, and his pleasure in its creamy texture is obvious in all these works (see Pl 3, 11, 12, 15–17, 19–20). This painterly handling at an early stage in their careers is a characteristic of all four of the Scottish Colourists, brought about mainly by their shared enthusiasms for a specific group of artists but also a tangible reminder of their Scottish ancestry.

About this time Peploe was very close to another young Scots artist, Robert Brough, an Aberdonian who had plans to become a portrait painter. Brough's heroes were no doubt shared with Peploe but he brought one or two crucial influences into their shared studio in Edinburgh. The first was Velàzquez, whose grasp of spatial relations and ability to maximise the impact of patterns within a composition was not something Peploe would ever have learned from Bouguereau. The second, and one which had in its time made a great impact on the Glasgow Boys, was James McNeill Whistler. Whistler's gospel of 'art for art's sake', his belief in the freedom of the artist to choose his own subjects and please himself before his public, was a crucial factor in his adoption by the Glasgow Boys and then by the Scottish Colourists. His own immersion in tonal painting and his obvious pleasure in the medium of oil paint – although he used it quite differently from most Scottish artists – further endeared him to Peploe, Fergusson and Cadell.

J D Fergusson had had less of a struggle with his family in his determination to become a painter. He had been born on 9 March at 7 Crown Street in the port of Leith, on the north side of Edinburgh. His parents had originally come from Perthshire, which he was always to consider his spiritual home. He had a happy and comfortable childhood and to please his parents agreed to enrol at medical school, where he wanted to qualify as a doctor before joining the navy – boats and the sea being a lifelong passion. There is no evidence that Fergusson was ever matriculated at any of the medical schools in Edinburgh but by his own account he left after two years to train as an artist. His father had worried that he would not make a secure living from art but eventually relented insisting, however, that Fergusson should have a proper training at the School of Art. Ready to humour his father, Fergusson prepared his portfolio which gained him a place in the school. On his arrival and after discovering the curriculum, however, Fergusson decided that two years' drawing from the antique before he was allowed to join the life class was not the training that he had in mind. He set himself the task of being his own tutor and acquired a small studio in Edinburgh. Unlike Peploe's dark work room, this was bright and enjoyed an outlook over the Firth of Forth to the north. Fergusson painted it a pale shade of grey. At this time most of his work was done in watercolour but an encounter with Alexander Roche, one of the Glasgow Boys, converted him to working in oil. Almost all of his work from the 1890s, however, is on a small scale and much of it was done out of doors in the streets and parks of Edinburgh. Fergusson made himself a small box with grooved sides which could hold a small palette on edge and a quantity of 5in. x 4in. panels on which to paint. Equipped with these he felt free to sketch anywhere and gradually developed an accomplished technique to get the best out of his self-imposed miniature scale. Interiors,

still-life compositions, street scenes, seascapes and rural landscapes were all eagerly experimented with until Fergusson felt at ease with his new medium.

Fergusson had assessed the state of painting in Scotland and recognised in the Glasgow Boys the same spirit of invention and exploration that he was himself seeking. Arthur Melville had the greatest appeal for him and, like Melville before him, Fergusson decided that Edinburgh was too limiting a city for a young painter, so in about 1895 (Fergusson's attitude to dates was always rather cavalier) he set off for Paris to further his career. There was an element of self-delusion in his belief that training would be better in Paris. Like Peploe, he enrolled at the Académie Colarossi, but he soon found that its only advantage over the stifling Academy School in Edinburgh was the ready availability of a life model. The teaching, such as it was, contributed little to Fergusson's education and served to confirm his decision that being self-taught could be no shame and in many ways a distinct advantage. He did not meet Peploe in Paris at this time but he saw many of the same paintings that had impressed Peploe in 1894. Certainly, he shared the same enthusiasms for Manet and Courbet and was a regular visitor to the Luxembourg and the Salle Caillebotte where he would have seen the best of Manet, Monet, Renoir, Sisley and Pissarro. Colour does not seem to have been a vital factor in his youthful enthusiasms, however, and like Peploe he was drawn more to the tonal painting of Velazquez, Manet and Whistler. He found more of their followers in the Salon des Indépendants and in some of the dealers' galleries. But Fergusson learned more than Peploe did from the café society of Montparnasse where the artists and sculptors, poets and writers gathered to eat and drink and put the world to rights over an everlasting glass of wine. Fergusson was an outgoing and gregarious character and took to this ambience better than Peploe who remained throughout his life quiet and rather shy, not aloof but never the instigator in a conversation with strangers. Fergusson mixed easily with this crowd of enthusiastic and youthful critics and practitioners. He was an eager participant in these nightly sessions, as his own philosophies and ideas gradually became clearer following his exposure to the latest artistic developments in Paris.

Fergusson returned to Edinburgh after spending several months in Paris and the pattern of his life for the next ten years or so was established following his first visit to France. Most summers would be spent across the Channel until 1907 when Fergusson closed his Edinburgh studio and settled in Paris. Occasionally he would travel further afield – to North Africa in 1899 and Spain in 1901 – and his visits to France were not confined to Paris. He painted at least once alongside the River Loing, possibly at Grez which had been a popular haunt of Melville and Lavery and other Glasgow Boys. *On the Loing* (1898, Glasgow Art Gallery & Museum) clearly shows his commitment to the tonal painting of the Glasgow Boys and the influence of Melville can be detected in Fergusson's decision to travel through Spain to Morocco the following year. There is a hint of stronger colour in some of the Moroccan paintings, such as *On the Beach, Tangier* (1899, Glasgow Art

Gallery & Museum) but it is the subject matter which is closer to Melville than the handling. Many of these works were to be exhibited in London at the Royal Society of British Artists, a body which, because of its associations with Whistler, was not rejected by Fergusson, unlike the Royal Scottish Academy. Whistler was also the driving force behind another early painting, *El Grao, Valencia: Nocturne* (1901, Hunterian Art Gallery, University of Glasgow). The subject, the title and the handling all pay tribute to an artist whom both Peploe and Fergusson recognised as 'the Master', and who was to exercise the same power over both Cadell and Hunter ten years later.

Peploe does not seem to have returned to France until about 1904 but Fergusson would have kept him up to date with what was happening there. Exactly when the two young men met is not known; Fergusson's first mention of his friendship with Peploe is when the latter was working in a new studio at 6 Devon Place, Edinburgh, which he moved to in 1900. It was here that he created the series of great still-life paintings that brought him to public attention in Edinburgh. He had absorbed in full the lessons of Hals and Manet and immersed himself in the technical and compositional challenge of still-life painting. He arrived at a scheme which involved placing the elements of the composition – bowl, vase, melon, apple, coffee pot, cup, flowers – against a dark, almost black background, sometimes sitting on a startlingly white table-cloth, occasionally on a dark polished table. For four or five years Peploe explored the different combinations of dark and light, clear colour against black or white, all handled in a creamy paint applied with a flourish of brushstrokes. The manner of these more finished works was much more painterly than Fergusson's, and at this stage much more attractive. Not surprisingly, these were sought-after pictures, and were exhibited from 1903 at the Aitken Dott gallery in Edinburgh, which soon established Peploe's reputation in the city. He was not limited to still-life painting, however, and continued the practice he had started in the late 1890s of painting landscape *en plein air* and painting from the model in his studio. While his figure painting, either of professional models or well-known Edinburgh characters such as the tramp *Old Tom Morris* (1898, Glasgow Art Gallery & Museum), concentrated on capturing tonal values his landscapes of the period showed a greater freedom of handling and stronger awareness of the potential of colour. He had begun painting out of doors on a visit to Barra in about 1897, with his brother William and a friend R C Robertson, and he was to return several times to the island in the next decade. About 1902 he was working in Comrie, Perthshire, where his sister and her husband lived, and it is in this series of paintings that the beginnings of Peploe's future commitment to colour can first be seen. His rush to capture a particular quality of light or colour in the landscape forced Peploe to work more quickly than in the controlled and measured atmosphere of his studio and his brushwork became more loose and ample as the paint was hurriedly swept on to the canvas boards that he used for these small studies. These were complete paintings in their own right, as Peploe did not take them back to the studio to work up into more studied

works. They were an aide-memoire of a particular quality of light that Peploe sought to recapture in his more slowly painted still-lifes and life studies in the studio.

Fergusson had arrived at a similar method of working but Peploe's Barra landscapes of c.1902-3 are more accomplished than anything he had yet produced. Working on his series of small panels, 5in. x 4in. and 11in. x 14in., Fergusson painted in the streets and public gardens of Edinburgh, recording fleeting impressions of the daily life of the city. He also moved out of the city to paint in Fife, Ayrshire and Peebles. In 1904 he was on Islay, accompanied by Peploe who had enjoyed working in the particular quality of light to be found in the Western Isles. He also produced his own series of still-life paintings in his Edinburgh studio, none of them on the scale of Peploe's largest works and all with a paler background. The same creamy texture of paint, applied with obvious enjoyment in its manipulation, is a shared characteristic of both men, but Fergusson was to take more pleasure in painting out of the studio than Peploe. He had continued to make annual journeys to France and about 1903 discovered the Channel coast from Deauville to Boulogne. Paris-Plage, Dieppe and Berneval became his favourite summer painting grounds and his work became paler in tone, looser in handling and fresher in colour as the years passed. Peploe's Barra landscapes had had an undoubted effect on Fergusson, but he was the bolder and more inquisitive – impetuous even – of the two and it was he who persuaded Peploe to join him in France in 1904 where they painted together in Brittany. Over the next few years they holidayed together at Etretat, Etaples, Dunkirk, Berneval and Le Tréport. Their days were spent painting on the beach and their evenings enjoying the wine, food and company of their French hosts.

Fergusson's results from these excursions were shown in London in an exhibition at the Baillie Gallery in 1905. He wrote his own introduction to the catalogue:

As it is necessary to understand the artist's intention to estimate his achievement,
He would explain: –
That he is trying for truth, for reality; through light.
That to the realist in painting, light is the mystery; for form and colour which are the painter's only means of representing life, exist only on account of light.
That the only hope of giving the impression of reality is by truthful lighting.
That the painter having found the beauty of nature, ceases to be interested in the traditional beauty, the beauty of art.
Art being purely a matter of emotion, sincerity in art consists of being faithful to one's emotions
To be true to an emotion, is to deal with that impression only which caused the emotion.
As no emotion can be exactly repeated, it is hopeless to attempt to represent reality by piecing together different impressions.
To restrain an emotion is to kill it.
What may appear to be restraint may be the utmost limit of one's power.
What may be appear to be utmost limit of one's power may be restraint.
Brightness is not necessarily meretricious, nor dinginess meritorious.

It is absurd to suppose that everyone must be slow to understand: – some have insight.

What is on the surface may explain everything to one with real insight.

That the artist is not attempting to compete with the completeness of the camera, nor with the accuracy of the anatomical diagram.

Genius is insight.

As with many painters, this shows that his philosophy was probably better expressed with his brush rather than with his pen. It does, however, indicate that Fergusson was concerned to show that his work did reflect a personal philosophy and was not purely decorative or hedonistic painting. His rather wordy and sometimes trite introduction obscures a deeply held conviction that artists were philosophers, and that he, Fergusson, had a particular message to convey to the world. His ideas were honed in his regular discussions and arguments in the cafés of Montparnasse and back in Edinburgh he and Peploe would talk over the latest criticisms and reviews and the most recent books on art. Fergusson admitted that it was Peploe who introduced him to written art criticism[1], while Fergusson responded more to the cut and thrust of café and studio debate, Peploe enjoyed a more relaxed and cerebral way of keeping up to date with the latest theories:

Before we met, Peploe and I had both been to Paris ... where we were both very impressed with the Impressionists whose work we saw in the Salle Caillebotte in the Luxembourg and in Durand-Ruel's Gallery. Manet and Monet were the painters who fixed our direction – in Peploe's case, Manet especially. He had read George Moore's *Modern Painting* and Zola's *L'Oeuvre*; I had read nothing about painting. At that time hardly anyone in Britain had heard of Cézanne.. When we met, S J and I immediately became friends and I found great stimulation in telling him about my ideas about art. We discussed everything. Those were the days of George Moore, Henry James [a particular favourite of Peploe's], Meredith, Wilde, Whistler, Arthur Symons and Walter Pater. I remember sitting on the rocks at the extreme north of Islay and reading Walter Pater's essay on Mona Lisa and discussing it with Peploe. At that time I was very interested in French poetry and claimed that without knowing French thoroughly, I could get a great deal out of Gautier's *Emaux et Camées*, merely as a sound composition of words. S J did not admit this, and we discussed it often. We did not know about Druidic incantations which do not depend for their force on what people call making sense.

Another thing we tried to understand was time, starting from the feeling that while you are doing a thing for the first time, you have done it all before. Then we talked about 'form' in painting and sculpture. In those days what wasn't photographic was called decorative; sculpture meant the Greeks and Michelangelo. I had been impressed by the bronzes brought back by the Benin Expedition and shown in Edinburgh. This exhibition was my introduction to Negro sculpture; I liked it then and still like it.

I tell these things to give an idea of what Peploe and I used to talk about. In the days of our early friendship most of my friends were musicians. We were very much interested in the latest music and its relation to modern painting. S J played the piano most sympathetically. I had in my studio one of the first pianos signed by Dettmer. When he came, Peploe always played it with complete understanding of the difference between it and an iron-framed grand.

On fine days I sometimes called at Peploe's studio in Devon Place. When I asked him to come out he would say, 'When it's fine outside, it's fine inside!' Most people don't realise how true that is, in a studio planned, decorated and lit for painting. So we sometimes had tea instead of a walk. But we also had long walks and long talks. Often when I had put some idea forward at great length, he would say, 'I'll give you the answer tomorrow.' And he did.

1905 was a year which was to see the beginnings of distinct changes in the two men's work. From this date Fergusson began to spend longer and longer in France, and his painting became almost entirely French in its subject-matter. Peploe moved to a new studio at 32 York Place, Edinburgh, which had a much brighter aspect and which led to a lightening of tone and an increase in the range of colour in his studio paintings. It was also the year of the Whistler Memorial Exhibition, which they could have seen in either London or Paris. That they did see it can be in no doubt as, for a while, the influence of Whistler became even stronger in their work. For some years Fergusson had painted portraits of his friends and family, perhaps not always as accomplished as Peploe's contemporary paintings of models such as Jeannie Blyth, but a distinct change in style and scale from his more *intimiste* interiors and the *plein air* landscapes. From about 1905 these portraits became much more decorative in effect and composition. There was a clear awareness of Whistler's skill in the placing of the figure on the canvas and its relationship with the background. Fergusson even went so far in his admiration of Whistler as to produce a painting of Dieppe (Pl 21) which in its choice of subject matter, its title and its handling are an act of homage to 'the Master'.

Peploe's so-called 'white period' is also a clear acknowledgment of the impact of Whistler, particularly in the series of portraits of his new model, Peggy MacRae – Whistler seen through Sargent, perhaps. The new studio was, after all, built originally for Henry Raeburn in 1795 and it was where some of the greatest portraits of his career had been painted. It obviously spurred Peploe to greater things and the echoes of its past successes would surely have made their impression on a painter who was so conscious of tradition as he. In still-life, however, Peploe was more his own man and the technique which he had developed over the past few years was perfected in a series of four or five masterly canvases produced around 1905. McOmish Dott, his dealer, was well pleased with his new protégé and although Peploe cared little for the commercial side of being a painter he must have found comfort in the steady income which was now coming his way. With a gap of over five years between his shows at Dott's, Peploe continued to show at the Royal Scottish Academy, the Royal Glasgow Institute and in London at the Allied Artists' Association in 1908 and at the Baillie and Goupil Galleries.

Fergusson also exhibited again at Baillie's in 1908, alongside Peploe, but with a group of works which showed that he was beginning to take a different direction. That summer he and Peploe had paid another visit to the Channel coast and had travelled on to Paris at the

end of the season. Fergusson had decided to settle in Paris and he and Peploe discussed for hours whether he should take a studio at a yearly rent of £12:[2]

So here I was in Montparnasse by chance, but unconsciously accepting the name, as all in order – perhaps because I had been so long accustomed to the name by Robert Burns ... I can look back to nothing but happiness. Difficulties, yes!

My studio at 18 Bd Edgar Quinet was comfortable, modern and healthy. My concierge was most sympathetic. Life was as it should be and I was very happy. The Dôme, so to speak, around the corner; L'Avenue was quite near; the Concert Rouge not far away – I was very much interested in music; the Luxembourg gardens to sketch in; Colarossi's class if I wanted to work from the model. In short, everything a young painter could want.

He became a regular attender and sometime exhibitor at the Salon des Indépendants and the Salon d'Automne and had realised that the future of modern art lay in Paris and not in Edinburgh. Whether or not he saw the first exhibition of Matisse and his friends at the Salon d'Automne in 1905 (when they were dubbed 'Les Fauves') is not clear but by 1907 his work had begun to take on distinct Fauvist tendencies. The low toned palette of *Grey Day, Paris Plage* (c.1905, Pl 28) had given way to a range of strong colour which was applied directly to the canvas in bold brushstrokes with minimal mixing of the colours on the palette. Working at first on his, by now, standard 11in. x 14in. boards, Fergusson produced dozens, if not hundreds, of these new works, experimenting all the while until a clearly defined path appeared. This path took a definite swing in the direction of pure colour, applied with exuberant brushstrokes and with minimal modelling of the subject. Fergusson's colour was rarely as pure and clean as that of Matisse and the other Fauves – there was often a pronounced leaning towards darker tones such as blues, purples, deep red and black. Its application, however, and the way that particular effects were achieved by the juxtaposition of pure colour rather than the mixing on the palette shows how quickly Fergusson adopted the ideas he saw in Matisse's work at the Salon d'Automne. Shadows of green paint, as seen in *Closerie des Lilas* (1907, Pl 31) and *The Pink Parasol: Bertha Case* (1908, Pl 30) are a clear demonstration of Fergusson's understanding of Fauvist technique and principles, but he was not a slavish imitator of all that he found in Paris. One painter who did have a considerable effect on him, however, was Auguste Chabaud, whose use of a strong black outline around the principal elements of his compositions was to be quickly adopted by Fergusson and his friends in Paris. Dark red, black and blue outlines appeared in many of Fergusson's paintings around 1908 and they were to remain a feature of his work until he left Paris for Cassis and the south of France in 1913.

According to E A Taylor[3], a Glasgow artist and designer who was living in Paris with his wife Jessie M King and was a close friend of Fergusson at this time, Chabaud's work had had a particular impact on Peploe and Hunter around 1911 but Fergusson had encountered it first[4]. Many of Chabaud's paintings are related to café society, scenes of café life in Paris in the first decade of the century. Fergusson's own paintings dating from around

1907 are, when they are not views of the streets around his studio (Pl 47), almost entirely concerned with the cafés which formed the centre of his social and intellectual life at this time. The Closerie des Lilas, the Café d'Harcourt, the Concert-Mayol, the Cirque Medrano and the Concert Rouge were the meeting places of the Parisian intelligentsia, where the latest poetry would be recited to a critical audience, and the latest works from the studios of Matisse, Picasso, Braque and the other luminaries of contemporary Parisian painting would be awaited by an eager body of young painters and sculptors.

Fergusson found himself at the core of a small group of Anglo-American artists who had their own regular tables at the Closerie des Lilas and the Café du Dôme. Anne Estelle Rice was the inspiration for many of Fergusson's paintings of this period and for a while the couple were very close, both emotionally and artistically. An American by birth, it was probably she who introduced him to the American sculptor Jo Davidson, whose wife Yvonne also appeared in several of Fergusson's paintings over the next six or seven years. Davidson aroused an interest in sculpture in Fergusson who produced a number of portrait heads in Paris, handled in the same broad masses that had come to dominate his paintings. The fluid, Whistlerian brushwork which had been so evident in his work up to 1907 now gave way to a bolder, forceful technique where the paint is often applied with a brutality quite alien to the work of Peploe at this period. *Café Concert des Ambassadeurs* (1907/8, Tate Gallery) and *Blue Beads* (1910, Tate Gallery) are almost coarse in their heavily applied paint. Yet almost at the same time, Fergusson could achieve a very different effect of colour in paintings which have equally strong brushwork. *The Spotted Scarf* (c. 1908, Pl 32) and *In the Sunlight* (c.1908, Pl 29) are both painted in a flowing style yet they have a delicacy of approach and effect which seems at odds with other contemporary works. What they show is how much Fergusson was aware of all the different developments in Paris, and how he wanted to respond to each of them before arriving at a path that was clearly his own. This barrage of stimuli was what he had hoped to find when he left Edinburgh and he began to urge his friend Peploe to join him.

In Edinburgh Peploe had found his own new challenges. These were most evident in the series of figure studies he began to make in the York Place studio. While his style became more considered in the still-life paintings made after 1905, in his figure subjects his brush took a new direction. His model was now usually Peggy MacRae; according to Peploe's biographer, Stanley Cursiter[5], she was:

a charming, witty and attractive girl, who had the rare gift of complete grace which made her every movement interesting; she dropped naturally into poses which were balanced, harmonious and, better still, she immediately impersonated the figure she was asked to represent... Peggy MacRae fitted perfectly into the pale grey, polished black and the white sofa of Peploe's new setting, and she was the original of many of the figure pictures in pink, grey, and black, and the pale pictures in muted whites, that he painted at this time.

Peploe was not a portrait painter but this series of studies of Peggy shows that, had he wanted to be, he would have achieved some considerable success. Many of these works are on a small scale, rather like Fergusson's little panels, but in one or two of the larger and more finished paintings, Peploe achieves new heights. *A Girl in White* (c. 1907, Pl 22) is one of the best of this series. Its larger scale gives Peploe the opportunity to experiment with longer flowing brushstrokes which lack the speed of handling of the smaller panels. This leads to a more relaxed and calm approach to the subject in one of the most successful paintings of the period.

Peploe continued with his series of still-life paintings, just as he continued to show at the Royal Scottish Academy, although Fergusson had long given up sending his work to the annual exhibitions in Edinburgh and Glasgow. The two men continued to meet after Fergusson had settled in Paris, however, usually by continuing their practice of painting on the French coast during the summers. Peploe was at Paris-Plage with Fergusson in 1907 and accompanied him to Paris to see him settle in to his new studio. The following year he may have returned to Paris-Plage, and even to Paris itself, but in 1910 he decided to follow Fergusson and settle in France for a more prolonged stay. McOmish Dott had been expressing his disapproval at the little panels that he had produced in France, saying that Peploe was straying from the style that was beginning to prove commercially successful and for which Peploe was now well known in Edinburgh. In a last attempt to encourage Peploe to revert to his earlier manner, Dott wrote to Peploe's bride warning her of the consequences of Peploe's persistence in this new mode of painting. Margaret Mackay, whom Peploe had met on one of his painting trips to the Western Isles, was to prove the ideal support to her husband and, at times in the next few years when he despaired of ever getting anything right, she provided the loving encouragement that he came to depend on over the next twenty years.

In 1909, the same year that Peploe had his second exhibition at Aitken Dott, another Edinburgh painter twelve years his junior, F C B Cadell, was having his first show there. Peploe did quite well out of his exhibition, although his dislike of negotiating with his dealer led him to sell to Dott the sixty paintings in the show for £450, which he used to get married and finance his move to Paris. The thirty-five paintings and a number of drawings sold at the exhibition, made it a commercial as well as a critical success. Cadell was less fortunate in his exhibition, with only five paintings finding buyers. Cadell's family background was quite similar to Peploe's but there is no evidence that they ever met before Peploe returned from France in 1912. Cadell was born in 1883, the son of an Edinburgh doctor, and went to school at Edinburgh Academy. Unlike the parents of Peploe or Fergusson, Cadell's family had a keen interest in the arts and did all they could to further his career as a painter. His sister, Jean Cadell, was also artistic and later became a successful actress, her son and grandson following her into the theatre. The young

Cadell, ('Bunty', as he was called by his family and friends throughout his life), displayed a facility for drawing which was encouraged by his parents. Dozens of sketch-books were filled with drawings of family life, pets, illustrations for children's story books and so on, many of which were faithfully pasted into scrap-books by his doting mother. Arthur Melville was a close family friend and Cadell had the good fortune of having him as critic of his work and supporter of his plans to go to art school. Melville, more than any other living Scottish artist, was the link between all the young Colourists. Peploe and Fergusson never met him, and he died before Hunter was to return to Britain from the United States, but he was to exercise a crucial influence on all of them. He was godfather to Cadell's younger brother and Cadell was able to turn to him when he became disillusioned with the teaching at the Royal Scottish Academy. Melville directed him towards Paris, to join the *atelier* system and enrol at Julien's just as he, and later Peploe and Fergusson, had done at a similar stage in their careers. Cadell spent three years in Paris and returned from it having absorbed the doctrine of capturing 'tonal values' that was the mainstay of Parisian training during the 1880s and 1890s. Intertwined with this, however, was a definite feeling for colour that was untypical of most painters of the period. Although it was not yet as refined in its touch as that of Peploe or Fergusson, Cadell's painting on his return from Paris in 1903 shows a clear indication of what was to come. His natural facility, which was rarely to desert him in later years, was enhanced by a more impressionist brushstroke, and although he was not yet intellectually able to understand fully the aims of Impressionism, it is obvious that he had come into contact with it in Paris.

Cadell had early success, having a watercolour accepted at the Paris Salon in 1899 when he was only sixteen and also at the Royal Scottish Academy and Society of Scottish Artists in Edinburgh in 1902. These were not mature or considered works, however, and his development as a painter was unhurried. There was never the intellectual, nor at this time the financial, spur that drove Peploe and Fergusson. All his life Cadell strove to make painting look easy, to make it appear the product of a gentleman rather than a professional artist. Whistler was an example to emulate, as he was for Peploe and Fergusson, but Cadell admired a different aspect of the man:

He [Whistler] was a marvellous painter – the most exquisite of the 'moderns', and he had what some great painters have – a certain 'amateurishness' which I rather like and feel always in Gainsborough. I can best describe what I mean in these words: 'A gentleman painting for his amusement' (of course it must be understood that the said 'gentleman' is a genius as well!)... this quality or defect (whichever you like to call it in great painters) is exceedingly rare.[6]

Cadell sold few works in his youth but it never seemed to matter until his father was taken ill in 1906. Up to that time the young Cadell had used his paintings as a form of barter for long months of hospitality at the country homes of family or friends. After his father gave up his practice in 1906 the family moved to Munich where they remained for two years,

returning to Edinburgh only after the sudden death of Mrs Cadell in 1908. Despite his years in Paris, and his obvious knowledge of Impressionist works and techniques, it was Whistler who remained for him the strongest influence; Whistler, that is, modified by Sargent, Melville, the palette of William McTaggart, and John Lavery.

In 1910 a trip to Venice was financed by an Edinburgh friend and patron, Patrick Ford, who had acquired four works at Cadell's first exhibition at Doig Wilson & Wheatley in 1908. This show had been a considerable success. Thirty paintings were sold, and not only to friends such as the Stewarts whose house at Shambellie in Dumfriesshire had become a second home to Cadell. The income from this show, and a small legacy from his father who died in 1909, allowed him to buy a studio at 130 George Street, Edinburgh. Much of his time, however, was now spent at the Ford house at North Berwick. Ford was an old school-friend and soon became an avid collector of Cadell's work and a loyal supporter. Later that year, when his show at Dott's sold only five works, Ford was the purchaser of two of them. One of these, *White Peonies and Black Fan*, 1909, displays a clear awareness of what Peploe had been doing in his studio at York Place. Peploe and Cadell, if they had met at all, do not seem to have known each other well and Cadell's knowledge of Peploe's work probably came from exhibited pictures rather than from a close friendship. Like others of this date, this painting combines the elegance of Peploe's earlier dark still-life paintings with the paler tones of his figure subjects to produce a bright and decorative composition. While it displays some of the uncertainties of youth, however, there is in its flickering brushwork and bright tints a foretaste of the work to come over the next few years. Cadell would have been hoping for great things from his exhibition and its commercial failure had a profound effect on him. Perhaps it convinced him that he had had enough of Edinburgh, and like Peploe he decided to leave the city, although it must be said that he, more than any other of the Colourists, seemed most at home in Edinburgh society. So, with £150 in his pocket from Patrick Ford (to be reimbursed by first choice from the paintings on his return), Cadell set out for Italy.

The year 1910 saw all four Scottish Colourists working in Europe at the same time. Peploe and Fergusson were together in Paris, Cadell spent the summer in Venice and Leslie Hunter was flitting between Glasgow, London, Paris, Berlin and any other city where his work as a newspaper and magazine illustrator took him. Hunter was working as a freelance and while the other painters cannot be said to have been well off at this date, Hunter lived a hand-to-mouth existence tottering between absolute poverty and the luxury of having enough money to know that he could pay for a room for the night and his next meal. This was very much of his own choice as, after his death, his brother wrote to his biographer, T J Honeyman, explaining that Hunter had access to family money which would have ensured that he need never go hungry. Life had not always been like this for him. In April 1906, while living in San Francisco, he had been about to have a

one-man show of his work when, on the eve of the opening, the great earthquake destroyed both the gallery and all of his work in it. It was the kind of ill-luck which seemed to follow Hunter most of his life, often exacerbated by his own lack of care either for his health or the feelings of those who loved and supported him the most. His American friends, with whom he had grown up as a young boy and man in California, might have described him as one of life's losers but he was also one of life's great fighters. Sadly, he rarely won any of the bouts that punctuated the twenty-five years that he was to live after returning to Scotland from California in 1906.

Hunter's father was a pharmacist with a practice on the Isle of Bute, where his son was born in Rothesay in 1877. The Firth of Clyde is probably one of the wettest inhabited areas of Scotland and its climate was certainly a contributory factor in the death from tuberculosis of two of Hunter's elder brothers. Their father, with his medical background and close contact with the medical profession, knew enough about the disease to realise that the rest of his family was at risk and in 1892 decided to emigrate to California. The orange groves around the small town of Los Angeles attracted the Hunters as they attracted thousands of other settlers both from the east coast of the USA and from Europe. Here, in an ideal climate, William Hunter thought his family would be safe from the illness which had brought them sadness and loss in Scotland. Its menace would be further kept at bay, he reasoned, by an outdoor life which would give the family the utmost exposure to the health-giving rays of the sun and the warm breezes from the desert to the east. From rural pharmacist to orange grower must have been a daunting step at his time of life and it was one which he took not without some misgivings. Seven years later, desperately homesick for Scotland, he returned to his homeland where he died in 1900. His son, Leslie, now twenty-two, decided that he would stay behind in California. He was now an American, he argued, his friends were here and the future was surely to be found in California's great city, San Francisco. While the rest of his family returned to Scotland, young Leslie moved north from Los Angeles to the Bay with an elder brother to keep a watchful eye over him.

San Francisco at the turn of the century was the revelation for Hunter that Paris had been for Peploe and Fergusson a few years earlier. While the city lacked the latest in artistic fashion from the European capitals, it offered a certain quality of life not unlike that of the cafés of Montparnasse. The intellectuals and free spirits of the west coast were drawn to it by the city's easy-going attitude, not just to the arts it must be said, but to life in general. As one of America's greatest ports it attracted the usual cosmopolitan mixture of traders, sailors and immigrants that were to be found in all such cities, but the climate and the city's links with the Orient across the Pacific Ocean gave it a peculiar flavour that was unmatched anywhere else in the United States. Hunter was overwhelmed by the freedom and stimulus that the city offered and he soon established a place for himself in its thriving artistic community.

He had been self-taught as a painter. In later years, when asked by a young boy if he

would give drawing lessons, Hunter replied: 'Go home, stake a claim on the kitchen table, place an apple on it or anything else you like and put down on paper exactly what you see. That is the kind of lesson I had.' Every spare minute when he was not working on the farm was spent with pencil and paper and it was this persistence which convinced his parents that he should be allowed to stay behind in California to further his studies. In San Francisco, however, Hunter did not attend any formal classes; he scraped a living as an illustrator, working both for newspaper and book publishers, using the friends he made in the city's artistic community to get new commissions. He counted Jack London and Bret Harte among them and with the introductions that these and others of his new circle were able to give him Hunter began to make a name for himself as an illustrator. The *Overland Monthly* seems to have used him most frequently, commissioning illustrations for several Bret Harte stories which would have had a wide following.[7] It was a precarious existence, however, with no certainty as to when the next pay cheque would arrive. Hunter learned to live as frugally as possible; as poverty dogged him most of his life it was a skill which he was to continue to develop for the next thirty years.

Despite the vitality of life in San Francisco, it was not a city which was renowned for the quality of its artistic endeavour at this date. Hunter began to experiment with paint rather than pen and ink, and he must also have begun to hear of the achievements of painters in France during the last half-century. Whatever route this news took, according to his biographer[8] it had sufficient impact to persuade Hunter and a small group of fellow American painters to make the long journey to Paris. Where the money came from to finance this adventure is not known. How long he spent in the city is also uncertain but he was there at a time that the great exhibitions of the Post-Impressionists were fresh in everybody's memory – 1904-5. He and his friends seemed to follow the routines of Peploe and Fergusson from a decade earlier. Although they did not enrol in any of the ateliers they became frequent visitors to the galleries and museums of Paris and, of course, to the cafés of Montparnasse. The Dôme and the Rotonde were apparently his favourite haunts. There is some evidence to suggest that Hunter's visit to Europe was longer than has previously been thought, and that it included a lengthy stay in Scotland. Throughout 1903 and 1904 and the beginning of 1905 Hunter was contributing illustrations to the *Society Pictorial* (later the *Scots Pictorial*). Several of these illustrate news stories such as the visit of the King and Queen to Edinburgh and Glasgow and, to be relevant in their publication, they must have been done on the spot, rather than from photographs sent out to Hunter in California. If he *was* in Scotland for as long as two years he could well have seen work by Peploe and Fergusson and must have discovered at first hand paintings by the Glasgow Boys.

We can only speculate as to the effect on his work of what Hunter saw in Paris. He was still making his living as an illustrator, presumably sending back drawings of Parisian life to the many editors with whom he had contacts in the States. He was reported to be never

without a pencil and paper at his hand but there is no account of the direction that his painting was taking. What little we know of his work at this time is from a few illustrations which survived from the years before the earthquake of 1906. They show that Hunter was more affected by the work of Steinlen and Forain than by modern draughtsmen, such as Toulouse-Lautrec. There is a suggestion that his painting of the period owed more to Degas and Manet than to Cézanne, Gauguin or Van Gogh, who were all having a great influence on the work of his Parisian contemporaries.[9] Hunter was back in San Francisco in 1905, having called at New York on his return. The following year saw the offer of a one-man show, which would presumably have included much of the work produced in, or inspired by, Paris. This exhibition would have been an important pointer to the influences at work on the young man but not a single painting or sketch survived the disaster which hit the city the day before the show was due to open. Hunter had been spending a few days outside the city with friends and he returned to find his paintings and his home and few possessions destroyed. These must have been contributory factors to his decision to return to Scotland later that year to live with his mother in Glasgow.

He came back to Scotland, of course, without the benefit of an artistic success in California and began to put together a living from illustration again. He had vowed earlier that illustration was finished for him, but he knew of no other way of supporting himself. Glasgow soon proved to be short of commissions, however, and Hunter set off for London. The city became a base for frequent visits to France. Hunter had no real ties to keep him settled anywhere and was still leading a hand-to-mouth existence. Whenever any cheques came in the rent was settled and he would dash over the Channel to Paris. Now he was painting much more regularly and the commissions from editors began to offer a slightly more assured income. It is still difficult, however, to place any form of chronology over these early paintings except to say that they reflect much more the influence of Dutch and French painters of over a century earlier than they do of the more modern painters who were beginning to have such a profound effect on Fergusson and Peploe. It seems that Hunter never met his fellow Colourists in Paris – at least, no such record survives – but he did encounter E A Taylor, who was definitely in the Fergusson/Peploe circle in Paris around 1910. Taylor is one of the few reliable witnesses to Hunter's state of mind and manner of working. He had first met Hunter in London and his recollections of Hunter's chronic untidiness and obsessive industry paint a picture which was to become more recognisable as the years passed by:

I found him in a little room (I could not call it a studio) in a street off the Tottenham Court Road. A most awful-looking landlady came to the door, and with her naked arms directed me up a flight of narrow stairs to the very top of the house, and there was Hunter. There was hardly room for both of us in the room, which was very untidy. He told me he was busy doing illustrations for *Pearson's Magazine*, but I never saw the illustrations and rather fancy he had no commission to do them but was just doing them on chance.[10]

Later on, in Paris, Taylor was to encounter Hunter in one of his more paranoid moods in an escapade involving a British Embassy official. Taylor and Hunter, along with a friend, tried to obtain an introduction from the Embassy to gain access to a private collection in Paris. Hunter found the official's interest in his citizenship rather alarming. (He does not seem to have been sure whether he was a naturalised American or whether he remained British.) He blustered his way through the interview and then went into hiding, half-expecting the arrival of the gendarmes to carry him off to join the army. It was an incident which gives us some insight into Hunter's psyche; ten years later this paranoia often gained the upper hand and led Hunter to behave in sinister and mysterious fashion, often falling out of circulation for weeks at a time. His friends learned to stay clear of him in these moods, but perhaps with more help and understanding of his predicament he might have been persuaded to seek treatment for both the physical and mental problems which beset him in the 1920s.

Hunter's earliest surviving paintings, like those of Peploe and Fergusson, are still-lifes. They follow an identifiable tradition that was well known and popular in Scotland, where Hunter would probably have first seen the works of Kalf, Bonvin and Ribot in dealers' galleries and perhaps in some private collections in Glasgow. Alex Reid, a leading Glasgow dealer, began to buy the occasional painting from Hunter and made the promise of a show when there were enough pictures of suitable quality. Reid introduced Hunter's work to a group of collectors who were to become his stalwart supporters in later years, but at this date there was little to suggest the way his work would develop. Gradually, Hunter's work became less bound by tradition and more spontaneous, and the little sketches that Peploe and Fergusson had made in France began to have their counterparts in his own work. These views of the beach at Etaples are the only pointer towards later developments and while Fergusson, Peploe and Cadell were, in many ways, to achieve some of their greatest heights before 1914, Hunter remained an enigma.

Peploe is usually considered to be the most conservative – staid, even – of the four Colourists but by 1910 even his more conventional attitude to life was in need of some further stimulus. He was beginning to have some success and was making a reputation through his exhibitions at Dott's in Edinburgh and Goupil's and Baillie's and other venues in London. His name was put forward as a member of the Royal Scottish Academy but his election failed. Suddenly he became tired of Edinburgh and its artistic narrowness and decided to join Fergusson in Paris. His friend had no doubt been pressing him for some time to leave Edinburgh. Paris was a great stimulus to Fergusson and his work had developed apace, while Peploe's own style had changed but slowly back in Scotland. In 1910 Fergusson was a different man from the painter who in 1907 had agonised over committing himself to a year's rent on a studio in Paris. He had blossomed. His

friendships with Anne Estelle Rice, Jo Davidson and French artists such as de Segonzac gave him an artistic and intellectual stimulation that Peploe seems to have missed in Scotland. Above all, he could see the latest paintings from the studios of Picasso (who also became a friend), Matisse, Derain and the other immortals of that hectic decade in Paris before the outbreak of war in 1914. Their impact upon Fergusson was inestimable, but gradually he began to make his own way and around 1910 he began to fashion a style that was indubitably his own. It was in this same year that his great friend Peploe and his new wife joined him in Paris and the two men immersed themselves further into the vibrant life of the city. Fergusson's own words best describe their life together:

After the last of our early painting holidays in France, S J went back to Scotland and I went to Paris and settled there. Of course we wrote to each other a great deal. I wrote long letters trying to explain modern painting. Something new had started and I was very much intrigued. But there was no language for it that made sense in Edinburgh or London – an expression like 'the logic of line' meant something in Paris that it couldn't mean in Edinburgh. I find today that most painters don't understand what happened in Paris before 1914 – though hundreds of books have been written about it. This was why I was so glad when, after a few years, Peploe came to live in Paris with Margaret, his charming, sympathetic wife.

By this time I was settled in the movement. I had become a Sociétaire of the Salon d'Automne and felt at home. Peploe and I went everywhere together. I took him to see Picasso and he was very much impressed. We went to the Salon d'Automne where we met Bourdelle, Friesz, Pascin and others. He started to send to the Salon d'Automne. I was very happy, for I felt that at last he was in a suitable milieu, something more sympathetic than the RSA. He was working hard, and changed from blacks and greys to colour and design. We were together again, seeing things together instead of writing about them.

Things I really like – perhaps I should say love – often make me want to laugh. One day Peploe and I went to see the Pelliot Collection. As we wandered through it we were suddenly halted, fixed by an intensity like a ray, in front of a marble head of a Buddha, white marble, perhaps, with a crown of beads painted cerulean blue. I can't remember anything in art with a greater intensity of spiritual feeling. We both stood for what seemed a long time, just looking. Then I laughed. I apologised to S J for breaking the spell. With his usual understanding he said, 'At a certain point you've either to laugh or cry.'

This was the life I had always wanted and often talked about. We were a very happy group: Anne Rice, Jo Davidson, Harry and Bill McColl, Yvonne and Louis de Kerstratt, Roffy the poet, La Torrie, mathematician and aviator. Other good friends in the Quarter were E A Taylor and Jessie King, who made a link with the Glasgow School.

We used to meet round the corner table at Boudet's restaurant. We were mothered by the waitress, Augustine, a wonderful young woman from the Côte-d'Or, very good-looking with calm, live, dark eyes and crisp, curly, black hair – very strong and well made, a character as generous as the finest Burgundy; a perfect type of that great woman, the French paysanne. When you came in far too late, tired and empty, Augustine would go across to the butcher and demand through the bars, a bon chateaubriand à quatre-vingt-dix, cook it perfectly herself and present it to you as if you

had a perfect right to be an artist. This with such grace that you did not feel in the least indebted. Looking back, we realise it is not possible for us to express our indebtedness; what we can do is to say that every picture we painted at that period is partly Augustine. Her health, in the best burgundy! God bless her. Then there was Madame Boudet at the pay desk, sonsie and easy to look at – and very understanding. When we couldn't pay we did our signed and dated portraits on the back of the bill. After dinner we went to L'Avenue for coffee and music. La Rotonde was then a 'zinc' with seats for three only.

It was in these pre-war days that Middleton Murry and Michael Sadler came over and asked me to be the art editor of *Rhythm*. Peploe contributed to it. Later Murry came with Katherine Mansfield. We were all very excited with the Russian Ballet when it came to Paris. Bakst was a Sociétaire of the Salon d'Automne and used all the ideas of modern painting for his décor. Diagilev made a triumph, surely even greater than he had hoped for. No wonder S J said these were some of the greatest nights of his life. They were the greatest nights in anyone's life – Sheherazade, Petruchka, Sacre du Printemps. Nijinski, Karsavina, Fokine. But we didn't spend all our evenings at the Russian ballet; there was the Cirque Médrano, the Concert-Mayol and the Gaieté-Montparnasse ...

As I think about Peploe, I remember a day when we were painting in a wood near Paris-Plage. The light on the tree trunks set me wondering. What paint should I use to express it? When Peploe came up we agreed that it needed something like pastel. That was the beginning of our awareness that oily paint is not for everything. There were many beginnings like that which each of us, in his own way, developed in his painting. Our friendship and our shared experiences are like the willow-pattern plate that brings my mother back to me. When things are really important, it becomes impossible to express them except by some extraordinary release over which we have no control.

I am writing too much – just as though I were talking to Peploe; but it is difficult to be brief about a wonderful friendship that lasted a lifetime. It was, I think, one of the best friendships that has ever been between two painters. [11]

Their first summer together in France was spent at Royan on the Atlantic coast, where the Peploes' first child, William, was born. Comparing the work of the two painters it can be seen how Fergusson's years in Paris had changed his work. Peploe reacted immediately to the bright sunshine and sparkling light reflected off the water in the harbour. His palette is clear and fresh and his paint much looser in its handling than it had been in Edinburgh a few months before. Greys and dark blues are replaced by yellows, reds and greens. His short stay in Paris had introduced Peploe to Fauvist technique but he had not yet grasped it as whole-heartedly as Fergusson. His brushwork, always fluid yet controlled, became more vibrant but it never succumbed to the extremes of fauvism. In many ways these Royan paintings of Peploe equate with Fergusson's paintings of about 1907-8, such as *In the Sunlight*. Fergusson's own work painted at Royan that summer shows a move away from a purely painterly handling to something rather more analytical. There is a tightening of his brushwork and a more obvious awareness of geometric forms in his painting – the sails and hulls of the boats in the harbour become triangles and cylinders against the rectangles of harbour wall and sky. It is the first conscious attempt to create mood through pattern,

and gradually colour and pattern took a more symbolic role in his painting. His colour is more solid and less worked on the canvas as he began to define his own terms of reference for the new paintings which were to be produced in the latter part of 1910 and over the next two or three years.

Despite his outward gaiety and bonhomie, Fergusson was a deeply serious man. He was obsessionally precise in his personal habits, his tiny bare studio being kept scrupulously clean and tidy and whenever he moved studio he took great care to create a new watertight setting for his most valued personal possession – a rubber folding bath. Those endless nights in the Montparnasse cafés had a serious side for Fergusson, for he was well read and liked to keep up with the latest developments in literature as well as painting. It was no doubt this seriousness which attracted him to a young Englishman and his rather intense girlfriend during one of their visits to Paris. Fergusson's involvement with Middleton Murry and Katherine Mansfield stemmed from a first meeting at the end of 1910 at the Café d'Harcourt. Murry recorded this encounter in his autobiography[12]:

[a man in a] rakish bowler hat, his blue collar, his keen shaven face, and his fresh bow tie... My neighbour was not a Englishman, after all, but a Scot: and a painter to boot. His companion was a buxom and charming woman, with a fresh complexion, and smiling eyes of periwinkle blue: she was an American painter [Anne Estelle Rice]

Fergusson's account of the early meetings is rather different:

Further down the Boul Miche was the wonderful Café d'Harcourt, where they had a lively Hungarian band that used a metal tray with knives and forks and spoons on it, to reinforce, very successfully, their music. But for me the great attraction was the girl frequenters. They were chiefly girls employed by dressmakers and milliners and wore things they were working at, mostly too extreme from a practical point of view, but with that touch of daring that made them very helpful – they were a great help to me.

I made what was considered a very bad break, by taking a perfectly respectable girl artist to this café – the café was not concerned about respectability – L'Avenue was where you took respectable girls, but my girl friend survived it. We always came down to the d'Harcourt after dinner to make sketches of these charming girls, who were quite pleased to be drawn and didn't become self-conscious or take frozen poses. Well, one night my artist friend and I sat beside a very good-looking lad with a nice girl – they were apparently and quite rightly pleased with each other. We were sketching people round while they were beside us, so neither looked at them nor heard what they were saying, but I remembered the lad vaguely and with sympathy.

In my studio in Paris, not the original one by this time, I had to arrange some way of having my morning bath at the front door. I had floor space of about four feet square beside the wash-basin and I had covered the walls with solid linoleum up to about a foot high, quite watertight. I did the putty part myself to make sure, so, with a rubber bath I always carry with me – even going to the highlands of Scotland – and a basin, I could splash as much as I liked. Often I had to open the front door, slightly, if I was in the nude, to explain to callers. When Epstein wanted to do something about the Wilde monument, for example.

Well, one of these times I looked out to find a couple of young men. They wanted 'to talk about things'. I told them to come back later and I'd be very pleased. They did and introduced themselves as Middleton Murry and Michael Sadler. At once I got the feeling that I had seen one of them before. It took some time, but presently I got it – one was the lad I'd seen at the d'Harcourt with the girl: he was Middleton Murry who was to become a great friend. A lad I admired for his honesty and artistic intelligence.

They had come, they said, because they had seen my picture in the Autumn Salon called Rhythm. They had decided to start a magazine and wanted to call it Rhythm and use my picture as a cover. Of course I said I'd do anything I could to help them, but I didn't think Rhythm was a good title – it was (at that time) a word hardly ever used and to most people meant nothing. Some such word as 'Quest' would be better, I suggested. But no, they wanted Rhythm, so I was immediately with them solidly and agreed to become Art Editor. I adapted my picture to make a cover. My only condition was that it would be cheap, not a de-luxe magazine. I wanted any herd boy to be able to have the latest information about modern painting from Paris, which was then undoubtedly the centre of modern painting. They agreed and Rhythm duly appeared at 1/-, well printed and presented. From all accounts it was a success.[13]

Fergusson's lifelong belief that the exactitude of dates was unimportant is demonstrated here. His painting Rhythm (Pl 41) was not exhibited until the autumn of 1911 and so Murry could not have seen it before their first encounter. Indeed, it seems quite possible that it was not even painted until after the appearance of the first issue of the new periodical edited by Murry, called Rhythm. The title of this little magazine was, however, suggested by Fergusson. If it was not the painting of the same name which attracted Murry to Fergusson it was probably his realisation that here was a painter who had a serious commitment to the new art that was beginning to appear in Paris combined with an intellectual capacity and sufficient journalistic sense to be of use to him in his new project. Murry was still an undergraduate at Oxford in 1911; Fergusson was approaching forty and had spent several years in Paris close to the heart of the new work. He was also an accomplished illustrator, having earned a living in Paris not from the sale of his paintings but by providing drawings of newsworthy European events for publication in American newspapers. Fergusson's own skills as a draughtsman and illustrator were to be combined with his talents as an art editor and designer. His innumerable contacts among the young painters of Paris helped him to persuade Picasso, Derain, de Segonzac, Gaudier-Brzeska, Jessica Dissmorr and Peploe to provide drawings for inclusion in the magazine[14].

The large painting of a female nude that is linked to the cover design for Rhythm was one of a series of such paintings. Until 1910 Fergusson had painted very few nude studies. This was probably partly to do with his being basically self-taught which meant he rarely had the opportunity to study from the model. Even at Colarossi's in the 1890s Fergusson had produced little in the way of such work, partly because he spent so little time there and partly because he was probably impatient to try his hand at 'real' painting rather than sit around the studio making endless numbers of sketches for some grande machine. The

34

paintings of women – all clothed – that he had made since then had all been of friends or acquaintances rather than professional models. The girls in the large fashionable hats borrowed from the millinery studios where they worked might be ideal sitters in the Café d'Harcourt or back at his studio but they were not going to pose in the nude. So his models for these nude paintings of 1910-12 were probably professional models as Fergusson never mentions them in any of his letters or other writings. They were not flattering paintings. The handling of the paint often shows that they were a struggle for Fergusson. His thick layers of paint show that innumerable alterations were made and the spontaneity of the street scenes and landscapes has disappeared entirely.

Fergusson believed these paintings to be of some intellectual importance, both for himself and in the development of painting in general. They were considered, serious works, by no means trivial or rushed in execution. In many ways, Fergusson came closest to abstraction in these paintings for they are concerned not with the beauty of the female figure (of which Fergusson was an ardent admirer) but with form, line and colour. Cézanne and Gauguin both combine to endow these works with solidity of form and the symbolism of colour. Gradually the shapes become more stereotyped and stylised and the brutality – ugliness, even – of *La Force* (1909, Private Collection) only slowly softened into the more sensitive *Torse de Femme* (1909, Glasgow Museum & Art Gallery) before being immersed in the greater sense of pattern that we see in *Rhythm* (Pl 41) and *At My Studio Window* (Pl 38). These pictures mark the end of Fergusson's reliance on other painters as an intellectual and material stimulus. His concern for pattern and balance in his compositions, achieved both through form and colour, denotes a synthesis of all that he had seen in Paris in the preceding decade. They are in many ways the first truly original works that any of these four artists had yet produced (excepting the small group of major works that Peploe had painted in York Place in Edinburgh). For Fergusson they formed a foundation for his painting for the next fifty years but more immediately they heralded a group of still-lifes and portraits, less heroic in concept, but equally accomplished in achievement.

It has been said that Peploe's work of this period – 1910-14 – is full of *joie de vivre* but lacks gravitas.[15] Certainly, Peploe produced nothing on the scale of Fergusson's nudes while he was working in France but his work cannot be dismissed as trivial. Peploe was undergoing the revelatory journey that Fergusson had taken in 1907-9; its effect was such that much of the progress that he had made in Edinburgh was cast aside and he prepared almost to start again, with a new palette, new subject-matter, and, above all, a new light. The still-lifes and studies of models painted in Edinburgh were replaced almost entirely by landscape painting. Almost all of Peploe's work of the period seems to have been painted outside and it has a spontaneity of colour and handling that rivals Fergusson's own similar work. Gradually, however, changes did appear as Peploe began to make his own judgements on the new painting he saw around him. Again, pattern and colour symbolism became his goals just as they had become Fergusson's but there is a new element to be seen in the

works of 1911 that was not often seen in Fergusson's painting. The staccato brushwork and flattening of perspective, the heightened awareness of the picture plane is often referred to as Peploe's 'cubist' period. It is not, however, 'cubist' in the sense of the analytical or synthetic forms that can be seen in the work of Picasso and Braque. It is more a reworking of certain types of brushwork to be found in some Divisionist painting, a dependence on optical mixing of primary colours to create depth, first seen in the paintings made in the summer of 1911 on the Ile de Bréhat (Pl 42). Some still-life paintings, painted in France in 1911-13 and in the few years after Peploe's return to Scotland in 1913, display this same concern for the simplification of forms and the removal of the illusion of depth in the composition. These works, where Peploe was experimenting with the symbolic and spatial power of colour as well as the visual complexities of two-dimensional compositions, form the basis for his extended search for the perfect still-life composition in the 1920s. Without Fergusson, without Paris, it is doubtful whether he would ever have approached success in his long quest over the next two decades.

As Peploe had tired of Edinburgh, Fergusson soon began to agitate to leave Paris. The Peploes had returned to Scotland in 1912, where the new French paintings had been poorly received by both Peploe's dealers and his earlier patrons. Throughout his life Peploe preferred to sell his work outright to his dealers rather than offer it to them for sale on commission. He hated the commercial side of his life and he was lucky to have supportive and professional agents such as Reid and Aitken Dott to whom he could leave the sale of his painting. McOmish Dott found the French work disappointing and unsaleable. Earlier in 1912 he had been able to offer Peploe only a fraction of what he was paying for pictures before the artist left for France, but now he refused to show them. Peploe turned to Cadell and the Society of Eight and in 1913 he showed his latest work with the Society, but it found little favour. In the summer of 1912 Peploe wrote to his wife, who was in Lochboisdale[16]:

I am very lonely. I have no one to talk to. I can't bother other people with my enthusiasm. No one can call me a bore. As I wired to you I have unpacked my French things and the studio is like a conservatory. They stand all round the room – the place is flooded with them. I was quite excited opening the bundles and coming on the canvases. I wished to have someone with me to see them. And this morning I was busy looking out more drawings – at present there are sixty lying on the floor and they look very weel – make quite a show. But I don't think I'll send them all to Nevill [proprietor of the Stafford Gallery, London]... As I told you he sold four the private view day. I wonder what price he got. When I look around my studio just now I feel rich – I can't help believing that some day these things will bring in money, only I must be more businesslike and not chuck them away. Ressich sent me £4 for a drawing; it was priced at £3 so at any rate he is honest.

In 1913 Peploe was persuaded back to France by Fergusson who was planning an excursion to the south. It was almost a repetition of their holiday of 1907, Fergusson deciding not to return home with Peploe but to settle in Cassis instead . All of Peploe's

Parisian friends joined the expedition, Anne Estelle Rice taking her husband-to-be, Raymond Drey. It was the first of several such visits to the *Midi* for Peploe; he returned to Cassis with Cadell in 1924 and alone in 1928. For the next year Fergusson drifted along the French Mediterranean coast, eventually settling at Cap d'Antibes. There he was joined in the summer of 1914 by the young Margaret Morris, an English dancer whom he had met in Paris the previous year.[17]

This was our life in Paris till the Grand Prix. Then, where should we go for the summer? One year we went to Royan where Bill, Peploe's elder son was born. Another year we went to Brittany. But I had grown tired of the north of France; I wanted more sun, more colour; I wanted to go south to Cassis. I told S J but he didn't think it was a good idea – too hot for young Bill. I was sorry, but decided to go without him. One day in the Boulevard Raspail, S J saw on the pavement just near his door, a paper with the word 'Cassis' on it. He decided to take the risk. We arrived to find it quite cool and Bill didn't suffer at all. We had his birthday party there and, after a lot of consideration, chose a bottle of Château Lafitte instead of champagne. Château Lafitte to me now means that happy lunch on the verandah overlooking Cassis bay sparkling in the sunshine.

My studio in Paris was being pulled down so I decided to stay in the south somewhere on the coast between Cassis and Nice. I took a house and settled in Cap d'Antibes. The Peploes went back to Scotland and, very soon, the 1914 war drove me back to London. After that we saw much less of each other. But whenever I came to Scotland to see my mother, the next person to see was S J. We resumed our walks in Princes Street as though the break had been hours instead of years. We laughed a great deal and got a lot of fun out of everything. One summer afternoon we went to the Zoo and laughed with the seals, but were suddenly checked when an eagle looked at us as though we were mud. We were depressed to see the elephant in his loose box. That's how it was with us. We enjoyed simple things – a good meal, a good picture, the light on a cloud.

Both Scotsmen responded to the light and colour of the south of France in the way that Van Gogh and Gauguin had done thirty years before. What could be more different from the cool light of Scotland? All four of the Colourists painted much of their best, and certainly most of their brightest work, under the brilliant light of the Mediterranean sky. After the war Fergusson was to spend most of the next twenty years there, Peploe made repeated visits, Cadell found new inspiration and Hunter found release from the spectres which haunted him in Scotland. France liberated the Colourists and nowhere more so than the Mediterranean coast. Fergusson more or less built himself a little house and studio, ably helped by Margaret Morris, and left only at the last moment after the outbreak of war in 1914. He returned to Britain, first to Chelsea where Margaret Morris worked and had a small theatrical club, and then to Edinburgh to see his family and the Peploes. For a short period, all four Colourists were in Scotland again.

Cadell's visit to Venice in 1910 was, for him, the revelation that Royan and Cassis were for Fergusson and Peploe. Almost overnight he shed much of the gaucheness which had dogged his Edinburgh work and responded to the light and freedom of Italy. The

paintings he made in Venice range from interior views of dimly-lit churches to the brilliant colour of the cafés in St Mark's Square. Red, green, white and blue dominate these *plein-air* paintings, all applied in a creamy paint with vibrant brushstrokes to catch the flicker of sunlight on glass, marble and mosaic. Cadell's iconoclastic spirit was revived, if not born, in the summer of 1910. His paintings totally reflect his happiness and sense of well-being but they were not well received on his return to Edinburgh. The Ford family took six works in repayment of the advance that had been made to Cadell before he left Edinburgh and Patrick Ford bought another four. Of those that Dott exhibited only six – three oils and three watercolours – were sold. Perhaps this had something to do with Dott's reluctance to pay well for Peploe's similar French paintings; the Edinburgh public were not ready for this kind of work and Dott was not prepared to take the risk personally. For Cadell himself, it was the last he had to do with dealers for some years, but his social contacts and his own outgoing personality made it easier for him to sell his work privately than it was for the shy Peploe, who would rather not meet his collectors any more than he had to. In contrast, Cadell thrived on the dinner parties, soirées, exhibition openings and gossip of Edinburgh's New Town and Morningside.

Cadell was not a rich man, although he had a small income from his father's estate, and there is no doubt that this had some bearing on his choice of subject-matter. Like the other three Scottish Colourists, he was dependent on the sale of his pictures for a living. The grand interiors of the New Town houses and flats, and their elegant occupants, became his stock-in-trade. With fashionable portraits of Edinburgh hostesses leaning against their marble fireplaces or grand vistas of their well-proportioned drawing-rooms, Cadell took his place as the perfect recorder of that glorious period in well-to-do British society that preceded the First World War. In Scotland, no one could paint a better domestic still-life of tea cups or coffee pots which, moreover, succeeds on all levels – as a first-class work of art, as an elegant piece of decoration and as a peerless account of the gentility of middle-class life in Edwardian Edinburgh. The facility which Cadell had discovered in Venice served him well over the next five years. It would, however, have been all too easy for him to slip into the role of providing his clients with exactly what they wanted and leave behind his own exacting standards as an artist. The 'amateurishness' which he so admired in Gainsborough and Whistler had to be worked at and Cadell rarely allowed his standards to slip. These are not comments which one feels compelled to make about any of the other Scottish Colourists. Because Cadell painted pictures that were sought-after and successful his motives and intellectual standards have been questioned. The only real difference between Cadell's aims and achievements and those of his three fellow artists is the degree of commercial success that he achieved. What he did, he did very well, and I doubt that he would have chosen a different route had his paintings not sold after 1910. His idols were different, admittedly, as he did not despise the later work of Glasgow Boys such as Lavery in the same way that Fergusson did. He recognised a

special quality in Lavery's work, and others of the Glasgow Boys, that had remained despite his popular and social success. The painterly handling in Lavery's more private pictures, those painted for his own pleasure and satisfaction, was recognised by Cadell as a valid and challenging achievement. He had a similar natural facility and it would have been simple to take advantage of it and become a factory for 'easy' and undemanding pictures. Much of his work of this period can be taken at face value as successful decoration but there is another side to it which betrays the complexity and professionalism of Cadell's approach to modern painting.

In 1911 he exhibited and sold a painting of an interior at the Royal Glasgow Institute. It was probably the first of many such paintings, usually of his own studios at 130 George Street, Edinburgh (from 1909) and 20 Ainslie Place, Edinburgh (from 1920). These grand Georgian rooms, with their handsome fireplaces, well-proportioned doors and windows, flooded with light from the cool skies over Edinburgh, became the real subjects of his painting for the next five years. The early success of these pictures, and the offer of a few portrait commissions, helped Cadell to overcome the financial and spiritual failure of the Dott exhibition of his Venice work. The fluidity of brushstroke and heightened colour that he used so well in Venice were not abandoned on his return to Scotland. He could find the same intensity of colour in the flowers which appear in his still-lifes or the colours of his sitters' dresses; the sparkle of light on water is replaced by the reflections in silver teapots and cut-glass vases. Of all the Colourists, Cadell was the first to find that Edinburgh could offer both the colour and the light that they had all first sought abroad.

White dominates almost all of these canvases. The white walls of his George Street studio appear in several paintings, usually entitled *The White Room*. Reflections, either from a mirror or from pieces of glass or silver offered him both the challenge of capturing their shimmering appearance and also innumerable titles for his paintings. Sometimes the reflections show people in his studio, whether professional models, such as Peggy MacRae (who had been a favourite of Peploe's), or the Edinburgh ladies who were part of the social milieu in which Cadell moved. One of these, Miss Don Wauchope, was to appear in many of his paintings; she was an acknowledged beauty whose elegant and distinctive features are recognisable in several of the large studies of women in interiors painted now and through the 1920s. Cadell was a gregarious and witty man, an ideal dinner-party guest whose charm and flamboyant personality meant that he was in constant demand on the Edinburgh social circuit. Like Lavery before him, he realised that no harm could come of using the middle class as subject-matter for his paintings. Cadell was able to combine this highly saleable aspect of his work with a strong desire to push forward the boundaries of modern painting in Scotland. I am sure that the content of his paintings sugared many a bitter pill of style and technique and that Cadell used the camouflage to experiment further over the next five years. He certainly did not think of himself as material for the stuffy Royal Scottish Academy and worked hard to bring

together the work of like-minded artists in a small exhibiting society that he founded in Edinburgh in 1912.

The Society of Eight had as its prime motive an annual exhibition of consistently high-quality work, more focused than the wide spectrum of painting seen annually in the big exhibitions in Edinburgh and Glasgow. He was joined by Patrick Adam, David Alison, James Cadenhead, John Lavery, Harrington Mann, James Paterson and A G Sinclair. Each artist was allowed to exhibit up to twenty works in their premises at 24 Shandwick Place, Edinburgh. Cadell reserved his best work for these exhibitions and eschewed both the traditional dealers' one-man shows and the more limiting spaces of the Royal Scottish Academy and the Glasgow Institute where he could show only two or three pictures at a time. Paintings such as *The White Room* Pl 56), *The White Teapot* (Pl 54), *Crème de Menthe* (Pl 52) and *Carnations* (Pl 49) show Cadell at his most intuitive and inspired. They seem effortless in their execution and convey exactly the qualities of texture, light and occasion that so impressed their creator. Of all the Colourists, Cadell now had the most assured income. His pictures were not expensive by Edinburgh standards – *Crème de Menthe* was priced at £100 at the Glasgow Institute, and the largest and most ambitious of the series, *Afternoon* (Pl 51), was sold for £80 at the RSA in 1915. They provided him with an independence from dealers, however, and it was not until towards the end of the war, when George Davidson and Alex Reid bought a number of pictures from him, that he returned to selling his work through galleries.

Cadell served for much of the war as a private soldier in the Royal Scots, 9 Battalion, which he joined in 1915. His first application to enlist was rejected on health grounds but Cadell worked hard to get fit for a second medical. At the end of 1915 he was serving in the trenches in France, resisting all exhortations from friends and superior officers to apply for a commission. Eventually he succumbed and was transferred to the Argyll & Sutherland Highlanders, 8 Battalion, as a Second Lieutenant at the beginning of 1918. His insistence on remaining in the ranks is surprising but he must have found aspects of the life congenial. Certainly, he did not behave like a regular private: there could not have been many of his fellow soldiers who had their tailor make up a private's uniform in quality cloth to replace the scratchy standard issue. Nor were there many who made sketches of their daily life in uniform, which were sold profitably for the benefit of the Red Cross and then reproduced in a book, *Jack and Tommy*, in 1916 by a London publisher, Grant Richards. These quick sketches of soldiers and sailors on duty and on leave have something of the quality of the many sketches that Fergusson made in the Paris cafés before the war. Worked fast in pen and ink and colour washes, they highlight Cadell's sophisticated sense of humour and perhaps reveal some of his reasons for remaining a private as well. The Tommies and the Jack Tars are seen through sympathetic eyes,

queuing for their medicals, meeting their girls in the street; their officers are viewed with detachment, as distant from the artist (who was in many ways one of them) as they were from their own men.

Cadell spent his leave in Edinburgh, giving parties at 130 George Street at which Peploe, who had become a close friend, could sometimes be expected to appear. What he did not manage to do in these brief escapes from the army was visit Iona, an island which he had discovered in 1912. For the next twenty years Cadell spent almost every summer there. Its simplicity of life – primitive almost – was obviously a welcome change from the style and pace of life in Edinburgh. But its great attraction was its light and the rapidly changing colours of sand, sea and sky caused by the wind blowing in the clouds from the Atlantic. The fields, hills, farms and beaches of Iona never failed to offer Cadell some new subject. He seems to have been at his happiest sitting at his easel, with Peploe at his side painting yet another view of the Dutchman's Cap, Cathedral Rock, the Abbey or Ben More in the distance rising up out of Mull. He became a 'weel-kent' figure on the island, remarked upon as much for his eccentricity as his talents as an artist. 'Himself', as he was nicknamed by all the young boys, drew inspiration and solace from the tranquillity of the island. Every summer it reinvigorated him for the season in Edinburgh, never more so than after his discharge from the army in 1919. He immediately made for Iona to begin painting again for the first time in over two years. Not only did the island raise his spirits, it provided him with the means to move to a new studio in Edinburgh at 6 Ainslie Place. Suddenly, the still-lifes and studio interiors were not selling and it was only the calm and restful paintings of Iona that found buyers in exhibitions at Reid's and the RSA. Like many a soldier home from the war, Cadell found that much had changed.

The war years saw Fergusson shuttling up and down the country between visits to his family and the Peploes in Edinburgh and Margaret Morris in London. He and Margaret had fallen very much in love, but Margaret was still living with her mother and aunt in London. Fergusson found rooms in Chelsea near Margaret's little club where her pupils put on weekly concerts for the growing circle of artists, musicians, writers and poets who fluttered like moths around Margaret's light: Bernard Shaw, the Sitwells, Ezra Pound, Gordon Craig and Wyndham Lewis among them. Soon Fergus and Meg (as they became to their close friends) welcomed Charles Rennie Mackintosh and his wife Margaret to their coterie. Mackintosh was as poor as Fergusson, with fewer prospects, but the two of them stimulated each other and a close friendship grew up. Both had to face up to the fact that the war had cut them off from realising the opportunities they had and contacts that they had developed before 1914. Fergusson had been included in the Doré Galleries' Post-Impressionist and Futurist Exhibition in 1913 and had a one man show there at the beginning of 1914. He was recognised as being in the vanguard of British painters who had

responded to the latest developments in modern painting in Paris. He continued to paint, mainly landscapes in Scotland and some portraits in London, usually of Margaret's friends. These were not commissioned works but more in the tradition of his studies of the milliners' girls in Paris before the war. Gradually his style changed and a new maturity can be seen in these paintings of Kathleen Dillon and Margaret (see Pl 73). They are less dependent on French painting and the coarseness of the big French nudes of 1910-12 has all but disappeared. Fergusson had had a long time to think about what he had achieved in France and the directions he wanted to take, but he was obviously missing the bright light of the south of France. His palette began to drift back towards strong and deep colour, rich rather than brilliant. The paintings of Kathleen Dillon and of Margaret in her various dance costumes show this most clearly but, gradually, new elements began to appear in his work. They were first seen in some of the landscapes painted in Scotland during the War: paler tones and lighter colours and a more feathery brushstroke. Fergusson was still experimenting, however, for in another series of works, painted in the Naval Dockyard at Portsmouth in 1918, the solidity of colour returns, accompanied by a new emphasis on pattern in the composition.

Fergusson was not an Official War Artist; nor could he ever be called a close follower of Wyndham Lewis and his fellow Vorticists; but in the series of pictures of ships and submarines painted in 1918 he responded to the mechanistic symbols of war in an almost Futurist manner. He did not adopt the broken, superimposed images of the Futurists or Vorticists but he recognised in the powerful destroyers and battleships and the stealthy submarines some of the menacing imagery of modern warfare (See Pl 69). All the same, these are not polemical paintings. Fergusson was not as involved in the tragedy and violence of war as Paul Nash, William Roberts or Lewis and his few paintings of warships moored at the quayside did not represent the futility of modern warfare that many of his fellow artists experienced and recorded on paper and canvas.

Fergusson faced the coming decade, I believe, with some reluctance. More and more involved with Margaret Morris in London he found less opportunity to return to Paris and France. He joined Margaret at the summer schools she arranged for her pupils in Wales and Devon, and also at Dinard in 1920, painting the dancers in the classroom and the gardens where Margaret loved to perform. He encouraged Margaret to paint and perhaps she encouraged him to dance; although she displayed some talent for a brush and paint there is no record of Fergusson's achievements as a performer in the Margaret Morris Movement.

Fergusson was not alone in his apparent confusion as to the future of his painting. Peploe had decided to return to Edinburgh from Paris in 1912, but had gone back to France for the summer at Cassis in 1913. Doubtless, his concern for his young family played some part in the decision to leave as autumn approached and the international situation worsened, but like Fergusson he soon missed the spur of working in France.

Like Fergusson he also painted a series of landscapes in Scotland, mainly of Kirkcudbright and the countryside around it, from 1915 to 1919. This small country town had long been an artists' colony, its mild climate, good light and fraternity of fellow artists, including E A Taylor and Jessie King whom Peploe had known in Paris, attracting more painters to it during the war years. Some of the earlier pictures are reminiscent of the French work of 1913, with strong, hot colours and vigorous brushwork. As the memories of France receded and Peploe came to terms with painting in Scotland again this high key was replaced by a more subdued palette and a greater emphasis on line and draughtsmanship.

A similar pattern can be seen in his still-life paintings. There is a short series which shows Peploe experimenting with some of the new ideas he had seen in France. They are very much his own response, but the critics saw in them a drift towards the more extreme of recent movements. Peploe showed some of these paintings in the Society of Scottish Artists in Edinburgh in 1913, when a critic writing in *The Scotsman* described them as 'cubistic'. They were not at all like the cubist works of Picasso and Braque, however, and were more a response to the painters who had so much influenced them, Van Gogh, Gauguin and Cézanne. Also, despite his awareness of the work of the Vorticist group centred around Wyndham Lewis (Peploe owned both copies of the Vorticist journal *Blast*), Peploe looked beyond them to these earlier artists who were concerned as much with colour as form. His palette is strong and clear and there is an obvious sense of structure in the composition of these paintings (see pls. 61 & 62). Peploe has not made an attempt to suggest form through the simultaneous display of an object's different facets, as was done by the Cubists, but has emphasised the formal and compositional relationships between the different elements in the arrangement. There is a flattening of the perspective and a simplification of modelling with a consequent emphasis on pattern. Both the patterns made by the shapes of the objects in these paintings – jug, fruit, bowl, chair – and the flat decorative patterns of the pieces of cloth used as drapes in the background combine to create an overall abstract design which is the true subject of the painting. Gradually, this sense of pattern making became less extreme and Peploe began to explore the spatial relationships between objects by widening his field of view beyond the table-top to encompass more of his studio. Unlike Cadell, who later made the studio itself the subject of the paintings, Peploe is extending the pre-1907 still-life paintings out into the studio; the studio is an incidental, it is not the *raison d'être* of the painting. This concern with pattern, with the introduction of strong two-dimensional shapes into the background (as in *Flowers and Fruit, Japanese Background*, Pl 62) perhaps owes something to the paintings that Fergusson made in Paris around 1912. Fergusson was close to Peploe during the war years in Edinburgh and they must have resumed their intense discussions and sessions of mutual criticism. If they did, it seems likely that Peploe was making the larger contribution because it was at this time that his painting began to develop independently of what Fergusson was doing at the time. Isolated in Edinburgh, with Cadell in the army

and Fergusson spending much of his time in London, Peploe was able to consolidate all the work of the previous decade and put it into the context of what he had seen in Paris. By the end of the war he had arrived at a mature style.

Leslie Hunter spent the war years working as a labourer on his uncle's farm at Millburn in Lanarkshire. Hunter was not a pacifist, according to T J Honeyman who came to know him well[18], but neither was he a fighter. He did not want to get involved in the war but realised that a contribution was expected from him, which he provided through his work on the farm. All the time he continued to paint. The dark palette of the early still-life paintings had now gone and the bright colours of the little Etaples sketch began to appear in larger, more finished paintings. Some of these were bought by the Glasgow dealer, Alex Reid, for his gallery, La Société des Beaux-Arts. In 1916 Reid gave him a one man show which was well received by at least one of the local critics:[19]

Leslie Hunter's pictures... are great!... when [the writer] finds a wallfull of pictures that are arranged in such a way as these, he feels the influence of a man of courage, individuality and ability... He has three or four examples of still-life that are superlatively strong. Such work is bound to live, for they show a mastery of form and colour that takes one back to the triumphs of the Dutchmen. It is with his later works that he has taken his courage with both hands. He has pictures titled *Sur la Plage*. They are dabs of colour, one may say, but the artist knows what he is doing, and his arrangement is never at fault. He knows what to leave out, which is the true test.

With the exception of a number of portrait commissions, accepted towards the end of his life, Hunter was to paint only still-life and landscape until his death in 1931. For much of the war years it was still-life which occupied him, as he began to formulate his own ideas on the future of modern art. He spent much of his free time while employed by his uncle not only in painting but in reading all he could about the artists whose work inspired him. he kept a little note book where he recorded the colours of palettes used by Whistler and William McTaggart. Quotations from Van Gogh and Gauguin were carefully chosen which confirm his own developing beliefs: 'Everyone must choose his own way, and mine will be the way of colour', now became Hunter's own maxim.

There is a basic line of development in Hunter's painting of still-life from the earliest known works through to the pictures which were completed shortly before his death. It is not a straight line, however, for there were many turnings, much retracing of steps over ground which had already been gained but then lost through doubt and uncertainty. Hunter was not an artist whose development can be charted easily like that of his three fellow Colourists. He was by no means as consistent in his work; some of it can be described in no other terms than 'bad'; other pictures take him forward in giant leaps as everything comes together in a seemingly effortless and intuitive way. Gradually,

however, one can identify a move away from the formula of arranging the various props against a curtained background towards a more original and individual series of compositions. In parallel, the handling and colour values of his paintings changed, inspired by the differing light of, successively, Fife, Venice, Loch Lomond and the south of France. From 1919, when he first began to visit Fife, Hunter seems to have been searching for a quality of light that he had grown up with in California. He never quite found it, but the power that the light peculiar to all of these locations had over his landscape painting is echoed in his still-lifes. As his palette became brighter there followed a more relaxed handling, a greater fluidity of paint and often a lightness of touch, which is in stark contrast with some of the overworked paint, muddy colour and tortured brushwork to be found in his less successful work. The Dutch and French still-life paintings which had so influenced Hunter's earlier painting formed the basis for many of his compositions, varying the formula of flowers, fruit, and blue and white Chinese vases placed against a dark green or blue, and occasionally red curtain. As he became more confident he would break away from this restricting format but his experiments were not always successful.

One element which particularly distinguishes Hunter's work from that of his fellow Colourists is its freedom and verve. Throughout the 1920s Fergusson, Peploe and Cadell all moved towards a tightened, less fluid handling of paint and a narrower range of colours. In contrast, Hunter's painting became more and more energetic. He attacked every new canvas, pouring emotion, impatience and enthusiasm into each fresh work, sometimes learning little from the last. This energy and impetus, violence almost, was too often uncontrollable and Hunter often missed the mark because of hurried decisions and rash brushwork. When hand, eye and imagination came together – no matter how fortuitous it might seem or look – Hunter was rarely equalled. Peploe, the most rational of the Colourists and not a man given to exaggeration, could favourably compare Hunter's painting to that of Matisse. Hunter probably looked for no greater praise.

His confidence grew from the reactions to his work of half a dozen influential collectors: Matthew Justice and John Tattersall in Dundee, John Ressich, William McNair, Ion Harrison and William McInnes, all of Glasgow, were to provide him with spiritual and financial support for most of the rest of his life. Alex Reid always had his paintings in stock and he was reasonably successful at selling them. Hunter never seemed to use the money properly, however, and life was a constant struggle with both his painting and his psyche. In 1922 he used some of the funds accrued from sales to visit Florence and Venice, calling at Paris on the way. He found the light in Italy a revelation, making him depressed with the new work that he had just completed in Fife. Hunter had stayed at Largo and Ceres, a corner of Fife that has for generations been a weekend and summer holiday retreat, particularly for middle-class Glaswegians. He was regularly visited there by patrons from both Glasgow and Dundee and his work took on a new aspect, brighter, more controlled and with a greater awareness of the effect of bright colour and high tone. His Fife

landscapes proved a commercial success and they were, in many ways, the best things he had painted so far. They were more ordered in their composition, less abstract than the seemingly endless series of still-lifes and they found a ready market.

Venice came as shock, for although he was fascinated by the play of light on water he realised that it had spoiled for him the cooler light of Fife. He wrote at the beginning of 1923 to Matthew Justice[20]:

I was disappointed in Ceres this time. I found it did not suit my palette as Italy did. Italy, too, fulfilled that vague nostalgia for California, that a trip out there might have cured. Florence is the hard difficult stuff. Venice is more superficial, water and buildings and shipping – studies of which the earthquake interrupted in San Francisco.

Had I departed in November, I would like to have spent a few months in Paris drawing the figure. What I'll probably do will be to go over the ground I went last year, and make sure of a number of completed pictures. I would like to devote myself to line and form for a while. The instinct for the former is even rarer than that for colour. I know Reid père liked my Venetian watercolours very much. They were, I thought, only rough notes done in the fashion of my early work, done spontaneously and the only training I ever had.

The second Italian visit, in 1923, started off with a short stay in Paris, where Hunter was accompanied by John Tattersall. He travelled on to Florence alone, however, meeting a friend there before going on to Venice. Again he was reminded of California by the landscape around Florence but he was prevented from capitalising on the association by a sudden and severe breakdown in his health. Throughout his later life in Glasgow Hunter was regarded as an 'odd' character. He was certainly neurotic, about both his work and his health, but he could never be persuaded to pay proper attention to looking after himself. Eating, bathing, changing his clothes were distractions which came between him and his painting. E A Taylor had already reported the disarray and untidiness of Hunter's little room in London. In his Glasgow studio palettes, brushes, studio props and even paintings would be lost for weeks on end underneath the general detritus of living. Hunter's notes about the ordered composition of Whistler's and McTaggart's palettes seem entirely unrelated to his own practice of applying more and more paint to his palette; then when it was so encrusted that it became unusable it was discarded in favour of a fresh palette, thrown into a corner until some Herculean clearing-out of the studio was performed. In Italy he collapsed and was at last persuaded to return home and rest.

California still haunted his thoughts and he paid a short visit there, perhaps less than three months, in the spring of 1924. No pictures have survived from that visit (if any were ever painted) and he spent much of the rest of the year in Fife and increasingly at Loch Lomond. Here he painted a series of studies of the gardens leading down to the waterside, of the many little bays, some with house-boats untidily moored like floating shanty towns. They were some of the largest landscapes Hunter had produced so far. The experience of working on a single theme over such a short period gave him new impetus and he threw

himself into the work with refreshed gusto, casting off his earlier illness as if it had never happened. The colour and sparkle of light on the surface of the loch is sometimes the only – or true – subject of these paintings. In others the brightly coloured house-boats or the overgrown gardens of the houses leading on to the loch are the centre of the artist's vision. People rarely appear in these paintings and watercolours. It seems as if the loch-side villages, with the boats tied up in the shallow waters, are no more than ghost towns, with the boats lying abandoned, leaning over at alarming angles or settling gently on to the bed of the loch. Hunter produced dozens of studies here and the place held a special attraction for him, forcing him to return, shortly before his death, when he produced another series. Needless to say, not every picture was successful, but Hunter had the good sense to suppress the work which did not come up to his standards. There is one story, possibly apocryphal but not at all out of character, which has Hunter standing on the bridge in Balloch where the River Leven flows out of the loch, throwing rejected canvases over the balustrade to be carried away by the river below.

Those paintings which he chose to keep did not meet with universal approval, however, although one was later bought by the French government for the Luxembourg collection, which did much to enhance his reputation. This was already growing quickly through the exhibitions which Reid had arranged, both at his own gallery and at the Leicester Galleries in London in 1923 and 1925. Peploe and Cadell were shown alongside him in London, with Fergusson joining them for the later exhibition. In 1924 all four painters had been shown at the Galerie Barbazanges in Paris as 'Les Peintres de l'Ecosse Moderne'. Reid arranged a contract whereby Hunter was paid £600 per annum for three years, in return for suitable pictures, and it would seem that all of his problems were resolved.

Harrison and McInnes, Justice and Tattersall were almost alone, however, in remaining faithful to Reid and Hunter in buying his new work. The Loch Lomond landscapes were not easily repeated and Reid began to have trouble extricating saleable paintings. The old psychoses returned and Hunter was often reported to be involved in violent and noisy arguments in his studio late at night. When his neighbours called to remonstrate or to prevent a breach of the peace they found him to be alone. His imaginary assailant or tormentor was himself. He would disappear for days at a time, sleeping in his studio rather than return at the end of the day to his sister's house in Glasgow. After his breakdown in Italy she had taken him in and her simple care – providing him with regular meals and clean clothing – had brought about a marked improvement in both his mental state and his artistic output. Perhaps this enforced domesticity was something he needed to rebel against. Perhaps he felt that Glasgow should be as cognitive as France had been. Whatever problems had troubled him, he decided that leaving Glasgow would be a cure for them. At the end of 1926 he set out again for the Mediterranean, this time for the south of France.

Fergusson was already in the *Midi* and Hunter met him several times at Cassis and

Antibes. Peploe was also at Cassis in 1928 and Hunter renewed his old friendship. Reid's advances, of course, paid for all of this but Hunter was unable to repay them by producing the kind of work that the gallery had hoped for. An exhibition planned for Reid's new gallery in London – formed by the amalgamation with the Lefèvre Gallery – fell by the wayside, to be replaced later in the year by an exhibition of sketches, mainly ink and watercolour. Hunter made hundreds of these, encouraged by Fergusson and Peploe, as a way of getting to know the landscape and the special qualities of the light there. Reid admired them as far as they went, but he expected to see more paintings, either still life or landscape. It was a long time before they materialised in sufficient numbers for an exhibition. When they did appear they showed that Hunter's work had entered a new phase. There was still a high percentage of unresolved work but studies of flowers and lobsters, the café scenes and the views of the hills around St Paul were some of the best work that Hunter was ever to produce.

These works were not well received by the London critics, however, and the worsening economic climate did not make for large numbers of sales in Glasgow. Hunter decided that he would follow Fergusson's and Peploe's example and show in the United States. Hunter was convinced that the success which had eluded him in Britain would be there for the taking in the States. In April 1929 an exhibition of his work opened at the Ferargil Galleries in New York. The introduction to the catalogue was written by Will Irwin, an American writer and journalist who had been part of Hunter's circle in San Francisco and who was now a well-known columnist. Having this kind of contact was certainly an advantage as the press gave the show good coverage, encouraged no doubt by Irwin's recommendations in the catalogue:

Leslie Hunter, as I review the good old days, seems to be all-pervasive. I knew him first in San Francisco, and we lived the carefree Bohemian life and were unaware of it. I moved to New York; and he came down Broadway as accustomed as a piece of scenery. Paris – and there was Hunter sketching on a street corner. London – and Hunter hailed me from the next table of a Chelsea restaurant. Glasgow – and Hunter, finding my name at an hotel in an obscure newspaper paragraph, called me up on the telephone. I have no doubt that if I ever visit Damascus I shall find him there ahead of me. And always the same Hunter; Scotch from his accent to his walk, quietly friendly, quaintly witty.

I had laughed with him many times over these recurrent meetings of ours before I realised how much the boy I knew and starved with in San Francisco was coming to mean in modern art. When in the first decade of this century painting shook off the Victorian shackles, he found himself. Reid, the famous Glasgow dealer, a leader in the modernist movement, 'brought him out'. Reid it was who introduced Degas, Manet and Renoir to Great Britain. Tradition says that he was one of the few men whom the crusty Degas would admit to his Studio. He sold most of Whistler's paintings. And Reid's verdict that Hunter is 'a more powerful colourist than Matisse and equally refined' carries authenticity.

Hunter belongs to that school which Paris calls 'les Ecossais modernes'. This group of late has

given exhibitions at the Leicester Galleries in London and the select Barbazanges Gallery in Paris; in both instances the force and purity of their colour attracted sensational attention. Fergusson and Peploe of this modern group have already exhibited in New York; but although Hunter grew up in California this is his first appearance in an American gallery. He lives and paints, now, on the Côte d'Azur; and that richly coloured country is the inspiration for most of these landscapes.

It was to the Côte d'Azur that Hunter returned in the summer of 1929. America had been a successful interlude for him, more satisfying in the fulfilment of a long-held ambition than in financial terms, but there was little doubt that he would be welcomed back. St Paul held him now and he set about producing the kind of paintings that had eluded him on his earlier visit. The intensity with which he threw himself into his painting caused him again to neglect the necessities of life and he soon returned to his haphazard routine of eating and general unkempt appearance. Much of Hunter's strange behaviour in Glasgow had been put down to his weakness for a drink but the problems he suffered went much further than that. Hunter was not an alcoholic but he did begin to spend a lot of his time in St Paul either shut away in his studio or in the café run by a M Roux, the Colombe d'Or. Roux helped many a poor painter in the 1920s and 1930s, accepting pictures as settlement of their bills. His relationship with Hunter, however, who had money enough to pay his way, seems a little less than straightforward. After Hunter's death Tom Honeyman, his dealer and biographer went out to St Paul to try and sort out Hunter's financial position and recover the many paintings which Roux was supposed to have taken in payment of debts. They were not forthcoming and Honeyman's gentle protestation was rebuffed by presentation of Hunter's unpaid bills. Certainly, up until the 1970s there was a slow release of paintings from the south of France, anonymously turning up in Paris and London sale-rooms and dealers' galleries. They were a continuing reminder of Hunter's impact on the small French village where even one of Roux's waiters spoke English with a broad Glasgow accent. 'We have no salt,' complained Honeyman to him at lunch one day. 'Ma Goad! Nayther ye huv,' came the unexpected reply.

These bouts of isolation in his studio ended abruptly towards the end of 1929 with Hunter mistaking a bottle of turpentine for some other more innocuous liquid. He was admitted to hospital in Nice and eventually returned to Glasgow in the care of his sister, with whom he lived for the rest of his life. Her care was not enough to prevent him returning to his old ways and his new studio in Glasgow soon resembled the shambles that he had created wherever he had lived or worked. By 1930 he was still not well enough to return to St Paul and he began painting again at Loch Lomond. His reasoning was that his earlier work there had been both artistically and financially successful and the light was the closest to that of the Midi that he had encountered in Scotland. His work did not sell in sufficient numbers to ensure a steady income, however, and although he still had the support of collectors like McInnes – who might buy Matisse one week and Hunter the

next – he lived a precarious life. Honeyman and his friends tried to interest him in portraiture but, although Hunter was intrigued by the challenges that this new medium presented, he was not the man to adopt the manner or turn of phrase which might charm sitters or distract them from the appalling mess in his studio. One peripheral benefit from his dabbling in the new medium was making the acquaintance of the impresario, C B Cochran, who was supervising one of his new productions in Glasgow. Honeyman made the introduction and Cochran bought one of Hunter's flower paintings; Hunter got a commission to paint Cochran's portrait and also began to produce a series of sketches of the show, *Evergreen*.

He followed Cochran and the production to London, in the hopes of getting more time to finish both, and he spent most of 1931 there. He seems to have regained much of his old vitality and was considerably cheered by the joint exhibition with his fellow Colourists in Paris that year. He wrote to Honeyman in great excitement[21]:

I got off the Cochran portrait all right on a fresh canvas. He came up to the office I have in the Palace building, with his advertising man, at 11 pm one night, and with blue lights posed for about three-quarters of an hour. And I painted it all in making a likeness like a pen drawing. He is very pleased with it and wrote Sacha Guitry and Mistinguett and others to see the Paris show.
It was a great opening and the French Government have bought the Loch Lomond picture for the Luxembourg. I believe they are going to hang all the foreign pictures in the Jeu de Paume. What about prophets without honour, etc.

I am taking your advice and my nerves are much better.

I am certain that I should come to London for good. Ressich thinks so too. I don't think Glasgow is any good now and if Reid's give it up then that will be the end of it. London is the place for you also...

When is the portrait show to open? I must finish one or two things for it. Then I must have another shot at Loch Lomond. Hyde Park is full of glorious material. It's a wonder nobody seems to have noticed it.

P.S. Have you a good cure for indigestion?

It was R B Cunninghame Graham, the Scottish radical aristocrat and widely travelled horseman, who introduced Hunter to Hyde Park and he produced a fine series of watercolours of Rotten Row in 1931. He returned to Glasgow for the summer, painting again at Loch Lomond. His lifelong love of flowers resulted in some particularly strong still-lifes that summer. He returned to London in the autumn, but his health was not good and the request to Honeyman for an indigestion cure masked a more serious problem. He came back to Glasgow towards the end of the year and it was obvious that his health had further deteriorated; his sister, Mrs Jeannie MacFarlane, could do nothing to force him to change his ways. In December 1931, he finally collapsed and was admitted to hospital for emergency surgery but his illness was discovered to be beyond cure. He died the following day, the first of the Colourists to die in this decade.

While Hunter in the 1920s had been basically establishing a career, the other Colourists had been consolidating theirs. For Peploe the 1920s were to be the most successful decade of his life. He had an exhibition every year, some years two or more, alternating between Aitken Dott in Edinburgh and Alex Reid in Glasgow. Reid arranged other exhibitions for him in London, at the Leicester Galleries, and in Paris with the other Colourists; and at the beginning of 1928 he showed in New York at the C W Kraushaar Art Galleries. These exhibitions all followed much the same pattern, consisting of a series of still-life paintings shown alongside landscapes of Iona and occasionally of Cassis and Antibes or Dumfriesshire.

Peploe set himself as a target the perfect still-life painting. It had been his first love and his first serious achievements had been in still-life. His temperament made him ideally suited to the task. His calm reasoning and thoughtful manner enabled him to make a careful analysis of the problems which face the still-life painter and he set about resolving them in a series of works which includes many of his most satisfying paintings. In a letter of 1929, written to a fellow artist, he said, 'There is so much in mere objects, flowers, leaves, jugs, what not – colours, forms, relation – I can never see mystery coming to an end.'[22] To many people these paintings can be repetitive and dull but, when viewed as sequential steps along a path to sought-after perfection, they can be seen as stimulating and highly individual. Peploe regarded them as serious works, requiring a considered intellectual effort allied to a careful hand and a sure sense of colour and pattern. There were some mistakes, it is true, and some paintings are obviously more successful than others, but taken as a whole Peploe's contribution to the genre of still-life painting is probably without equal in British art in the twentieth century. Walter Sickert, who had been invited by Reid to write an introduction to the catalogue of the 1925 exhibition at the Leicester Galleries in London, had a high opinion of these new paintings:

[in his earlier work] Mr Peploe had carried on a certain kind of delicious skill to a pitch of virtuosity that might have led to mere repetition, and his present orientation has certainly been a kind of rebirth. He has transferred his unit of attention from attenuated and exquisite gradations of tone to no less skilfully related colour. And by relating all his lines with frankness to 180 degrees of two right angles, he is able to capture and digest a wider field of vision than before. And time, as the poet sings, is an important element in the gathering of roses. And it is probably for this reason that, obviously beautiful as was Mr Peploe's earlier quality, his present one will establish itself as the more beautiful of the two.

The early works of the decade use strong, clear colour and are reminiscent of the experimental paintings produced just before and during the war years. They were all painted into a white gesso ground, which increased their reflective qualities, but gave the painter little opportunity for reworking or major corrections in difficult passages. The tulips which had appeared so frequently in the 1914-18 pictures are still to be found, but

gradually they were replaced by roses and fruit. This led to more static compositions, the arabesques of drooping tulip stems being replaced by the more regimented and upright roses and the sure spheres of apples and oranges. There is usually an overall even light which casts little shadow and often enhances the two-dimensional aspects of the composition. Peploe was not, however, trying to re-create the flat, patterned compositions that had first appeared in the French paintings around 1912-13 and there is rarely any questioning of the realities of pictorial space or testing of its confines in these later works. Did Peploe ever achieve his perfect still-life? There are some which, no doubt, he considered to have approached perfection but there was always for him the lure of the next painting. If not, what else drove him to repeat or experiment with the same formulas for over fifteen years? Perfection must have been in sight many times but perhaps it was always just too far away to grasp.

Most summers Peploe left the city to join his friend Cadell on Iona. Like Cadell he found the island offered him a release from the tensions of life in Edinburgh; it also provided an opportunity to relax with his growing family while, at the same time, offering a totally different inspiration. Peploe treated Iona as systematically as he did his studio still-lifes. While Cadell found subjects to paint wherever he looked on the island, Peploe was much more methodical and limited in his outlook. Most of his Iona paintings are of the island's many bays, particularly at the north end, with the pale sands and intense blues and greens of the sea usually seen under skies flecked with cloud. Rarely is the sun to be seen and, as was shown in Cadell's letter quoted below, both artists found cloudless skies poor subjects for painting. Although not pursuing landscape painting as a quest, in the same way as still-life, Peploe did bring his analytical mind to bear on one aspect of the island. Over the years that he visited Iona (and there were few years between 1920 and 1934 when he missed a visit) Peploe produced a series of paintings of Ben More seen from Iona that seem to be his quintessential statement about landscape painting. The vista of Mull and its distant central hill became a dominant theme for Peploe. Cadell hated this particular view, and rarely painted it, but Peploe reserved his largest canvases for it and his most atmospheric Iona paintings are usually views of the Ben seen across the Sound between the two islands.

Iona forced Peploe to adopt a different palette from the warmer colours he used in the still-lifes of 1920-5. The blues and greens of grass, sea and sky were rarely countered by hot reds or oranges. In 1924, looking for a different light from the cool clarity of the Western Isles, Peploe spent the summer in Cassis with his family and Cadell. Here he found an excuse to use warm colours in his landscape paintings and he enjoyed painting the trees and foliage that treeless Iona had denied him for the last few years. The following year he was painting at Sweetheart Abbey in Dumfriesshire and found new inspiration in the trees and rolling pastures of its lush farmland. Gradually the warm colours of Cassis disappeared from his landscapes as greens, whites, blacks and greys took their place. Even on

a visit to Antibes in 1928 there is a greater emphasis on the darker tones to be found in the deep shadows underneath the palm trees, on the blue-greens of the foliage and rust and pink in roofs and tree trunks rather than on the hot reds of flowers and bright blues of the Mediterranean sky. In later visits to Iona this tendency becomes even more noticeable. There is a distinct lowering of tone in the Iona paintings produced at the end of the 1920s which is matched in the still-lifes produced in the studio.

Red roses, oranges and red apples were replaced by lilies, pears and lemons with muted colours and darker tones. Glass vases gave way to pottery jugs, white table-cloths to dark foregrounds. The crisp brushwork of the early 1920s became softer, less defined but more energetic in its application. The field of view narrowed, with less and less of the studio being seen or even hinted at in these late still-lifes. Some of the more acidic colours and harsher tones which had appeared in Cadell's work in the late 1920s were also to be found in Peploe's paintings. It was as if both artists were reacting against the brighter colours and deft brushstrokes of their earlier painting. There is almost a deliberate clumsiness about these later pictures. It has been described as a form of expressionism but it can also be seen as a lack of control. It certainly seems an unusual step for Peploe to have taken; whether it was inspired by a kicking over of the traces or was, in his eyes, a logical progression it is hard to say. Certainly, Peploe had reached a stage in his life when he did not need to please his public and there was no need to follow tried and tested schemes in his pictures. His two sons, Willie and Denis, were growing up, his own health was not good and he may have been driven to search for new expression in these late works. His recognition was assured, particularly following his election to the Royal Scottish Academy in 1927, and of all the surviving Colourists he was the only one to maintain a comfortable living in the 1930s. The exhibitions he had been given throughout the 1920s had almost all been successful and he had a supportive band of wealthy collectors who had ensured his financial security. He could afford to experiment and was probably the best-suited in temperament to strike out on new paths at this stage of his life, in his mid-fifties

Alone of the Colourists, he was to become a teacher. In many ways he may seem to have been the least suited to develop a rapport with young painters but for the last eighteen months of his life he taught part-time at Edinburgh College of Art. He was immediately successful, drawing the young painters close to him in a way that those who knew only his shy manner would never have predicted. Like many young people they probably realised that the commitment which Peploe had made to his profession was something they could learn from. Unlike many of their tutors, he was a painter who had had first-hand experience of many of the developments in Paris which were now legendary and it would have been a rash young artist who would have spurned his careful advice or rejected his current painting as irrelevant. His health was not of the best, however, and he could easily be depressed by changes in the world that he had come to accept as immutable. Stanley Cursiter tells a story of Peploe's horror of discovering, during a visit to friends in Perthshire

in 1934, that a track in one of his favourite painting grounds had been tarmacked over. Depressed and disillusioned by the march of 'civilisation' he returned abruptly to Edinburgh, after painting a last picture at Rothiemurchus. A move to a new studio at the corner of Queen Street and Castle Street, closer to his house in India Street, had done little to improve his spirits and a steady decline in his health prevented him from putting it to serious use. An operation was required to remove his thyroid gland; it left him tired and depressed and he died in Edinburgh on 11 October 1935.

The paintings that Cadell had made on Iona in 1919 had found ready buyers, although there was little demand for his still-lifes. The proceeds from these sales enabled Cadell to move house again, this time to 6 Ainslie Place where he occupied the lower half of a house in one of the most handsome of Edinburgh's New Town streets. Cadell was in the best of spirits, looking forward to resuming his career as a painter. This memoir by Stanley Cursiter, who knew him well at this time, gives a perfect description of the man and his approach to life[23]:

Among [Peploe's] brother artists his greatest friend in these later years was F C B Cadell, who on his return from military service had taken a house in Ainslie Place. He painted the front door a beautiful violet-blue and the surrounds a soft grey; small round trees stood on the doorstep in emerald green tubs. The interior decoration was in keeping and struck a gay and joyous note. In the dining-room a great chandelier of cut crystal threw sparkling flecks of prismatic colour or little bands of spectra on the walls, but these were no gayer than the volatile conversational quips of Cadell when he acted as host at his own table. Cadell was in many ways the complete antithesis of Peploe. He was only of medium height and stout, his face was large and round and ran to chins – someone described him as like a vegetable marrow. He was voluble and even boisterous. He loved bright clothes, shepherd-tartan trousers, lemon-yellow waistcoats, cobalt blue scarves. His costumes ranged from court-dress on state occasions to a kilt-of-many-colours on the island of Iona... He was very witty and wrote Rabelaisian verse with great facility. He had many ups and downs and reversals of fortune which he accepted with boyish good humour.

It was in this house, sparely furnished with fine pieces made by Whytock & Reid, that Cadell again began to entertain. The ladies with their fashionable large hats, fur coats and smart black dresses reappeared in his paintings. Obviously reminiscent of the paintings of other women made before the war, there is a basic change of emphasis in these pictures. Leaving aside the changes in style over the years, in these paintings the role of the women sitters has been substantially changed. While they were the centre of attention in the earlier works, seen against the backdrop of the studio and drawing room interiors, after 1920 their respective roles are reversed, with the women becoming props while the real subject is the grandeur of the rooms in which they are placed.

These figures were not included in the hope of winning commissions for portraits of

Edinburgh ladies sitting in their own drawing rooms. Cadell was not really a portraitist and during the 1920s his most inspired figure studies are those he made of young men on the beach at Iona, a fine-looking Negro he met in the early 1920s, and his manservant, Charles. The ladies served at first as an excuse to work on carefully controlled compositions using the lines of perspective created by looking from one room in his house through to another. The structure of the paintings, the flow of space between the separate apartments, the geometry of line and colour were all dictated by the Georgian proportions of doors, windows, dados and shutters. As the compositions became more concerned with recession and the intersection of quite definite planes of door and wall, Cadell gradually changed his brushwork and his palette in an attempt, I think, to emphasise the abstract concept of his design. The more personal flourish of the the pre-War paintings was replaced by a block-like application of paint. The colour became more solid, less fleeting, for the artist was now more concerned with static arrangements of furniture, fabrics and architecture and not the momentary flash of light. Reflections are still very much part of these paintings, partly because Cadell could never resist painting them but also because they enhanced the spatial complexities of the pictures. Charles would have been kept busy polishing the black painted floors in Ainslie Place but his efforts were well-rewarded by both artist and collector.

These paintings were popular and successful, but not without their opponents. Fortunately for Cadell he found two or three patrons for whom he could do no wrong. One of these, George Service, a Glasgow ship-owner whom he had first met on Iona, bought over 130 pictures from Cadell and his dealers. Cadell was a frequent guest, both at his large house in Dunbartonshire just outside Glasgow, and also on his yacht when it went off sailing around the Western Isles, calling at Iona every summer where Cadell was left alone to work. He was a popular and welcome guest, a witty and acerbic talker who was happy to 'perform', even in strange company, and who often took his painting materials with him for the weekend. These weekends occasionally drifted into weeks and on occasion into months. This was particularly so in the 1930s, when Cadell was neither in the best of health nor the best of finances, and Ion Harrison, who became his chief patron in the 1930s, often found himself acting as host to Cadell for weeks on end. The painter never outstayed his welcome, however, his conversation and humour and the quality of the work he produced more than repaying the hospitality of his hosts. It was on these visits to the Harrisons in Helensburgh that the portraits of Mrs Harrison and of the principal rooms at Croft House were painted. These were not rooms with the proportions of his New Town studios but they were flooded with a west coast light that must have reminded Cadell of his trips to Iona, which he was rarely to visit in the 1930s.

The solidity of paint and brushwork in the paintings of Ainslie Place found their way, naturally, into the Iona paintings. In 1920 Cadell persuaded Peploe to come with him to Iona and the two men painted side by side for the summer, an experience they were to

repeat annually for the next ten years or so. Their paintings of Iona can be very different. While both artists were drawn to the bright clean beaches with their dazzling white sand and blue shallows, Peploe found a more majestic and brooding side to the island. Ben More, on the adjacent island of Mull, captured his attention and all of his larger works painted on Iona show the mountain in its differing moods. Cadell was more interested in the daily life of the island and its beauty in the sunlight. Red-roofed farm buildings, white-walled crofts, the cool light of the Abbey nave and the brilliant greens of the coastal fields were what attracted him. He looked out to sea, not inland towards Mull, and painted the Dutchman's Cap, a rocky island with a pronounced silhouette. The clouds in his pictures are rushing in from the Atlantic not gathering around the hills of Mull to the east and Argyll beyond. He loved the island most when the light of the sun was so quickly changed by these banks of cloud as they were driven across the sky to deposit their rain on the mainland. He needed to work fast to catch the fleeting nuance of light in a shallow pool or the changing tones of the sands as they were dried by the wind and the sun. He was never happier than when challenged by the unpredictable Iona weather and when the sun shone he rested and when it rained, unlike Peploe, he managed to resist the lure of Ben More. He could tease Peploe about his friend's preoccupation with the mountain:

How are you. It must have been rather awful in a way in Edinburgh all June if the weather there was as fine as it was here. But you didn't really lose much from the painting point of view. Little colour, not much wind and a cloudless sky for the most part. Though lying about doing nothing but benefiting the health was very pleasant. I have painted a few watercolours, four or five panels… and a portrait of myself done in a disused mirror and not completed. Anything to escape the horrors of Ben More![24]

Surprisingly, Cadell suddenly felt the need to return to the bright light of the Mediterranean, and in the spring of 1923 he painted in the south of France. The following year he was back in France at Cassis, accompanied by Peploe whose suggestion it was to return to the coast where he and Fergusson had painted so well in 1913. In Cadell's Cassis paintings the planar compositions of the Edinburgh interiors were transferred to the white walls of the houses and hotels as they climbed up the streets to the hills behind the town. The light gave a new intensity to his colour, deep blue skies contrasting with the pinks and whites of the houses, the reds of roofs and the lush greens of the vegetation. It was an image that he brought back to Scotland with him and the same intensity of light can be found in some of the Iona paintings of 1925-8.

These sold readily and in 1926 his records show that eighty-three paintings of Iona found buyers. For some reason this was not enough to provide Cadell with the money he needed to live in Edinburgh. His dealers had again failed him, or he them, for he sold little through them in the mid- to late-1920s. The work he showed at the Leicester Galleries exhibitions, organised by Reid in London before he merged with Lefèvre, was well received by the critics but his paintings did not find buyers. There were highlights,

however, first when Glasgow Art Gallery bought *A Lady in Black* (Pl 124) from the Glasgow Institute in 1926, where it was priced at £180. Two years later he did well again at the Institute when *The Orange Blind* (Pl 122) was bought by the Hamilton Trust, again for Glasgow Art Gallery, this time for £150. This must have made up for the bitter disappointment of his show at Reid's Glasgow gallery where he sold only one watercolour for £10. Reid wrote to him abjectly, saying that he had never experienced such a failure. He was not blaming Cadell for he went on to say how poorly the Institute had done that year, *The Orange Blind* being one of the few sales there, and how he worried about the future of art sales in Glasgow. The following year he closed his Glasgow gallery and consolidated his operations in London, confirming his worst fears about the state of the market in Glasgow and closing a door which the Colourists had always found open and welcoming since before the war.

Cadell was not entirely despondent, however, or at least if he was it does not show in his paintings. For some years, Reid had not been buying his paintings outright and Cadell had resorted to selling large groups of paintings at auction in Glasgow and Edinburgh. Even reducing his prices by half and holding special exhibitions in his studio had not really stimulated sales. Iona continued to sustain him during the summer, both spiritually and financially, as it was still only the landscapes painted on the island that he found easy to sell. In 1927 he travelled to Iona via Auchnacraig on Mull and painted a group of works where the intensity of the light rivals that he found in the south of France (which he visited again with Peploe in 1928). There is a hint here also of the more acid colours that Cadell was beginning to use. They had first appeared in some of the interiors, in the golds of pier tables and gilt-framed mirrors, alongside a new use of cool purples and blues, usually seen in the linings of coats and cloaks and as upholstery on gilt chairs. Two particular shades of green also made increasingly frequent appearances; one was icy and clear and the other more blue, a sea green, almost dull in tone. These cooler colours, just as solid in their application, were accompanied by a marked emphasis on linear structures in his compositions. The edges of tables, backs and stretchers of chairs, stark silhouettes of cups and vases against unmodelled backgrounds, all took on a new emphasis in these later paintings. These paintings did not sell either and in 1928 Cadell had to move to the upper floors of the house in Ainslie Place, having sold the lower, grander and more valuable ones to his upstairs neighbour. Even this economy was not a sufficient tightening of the belt and following the commercial failure of other exhibitions in Paris, London and Edinburgh, he moved to slightly less-fashionable quarters at 30 Regent Terrace. Here the unsold canvases collected again, despite small shows in Glasgow and Edinburgh, where little was sold. The Society of Eight, the Royal Scottish Academy and the Glasgow Institute were now his only real outlets and they alone could not satisfy even his, by now, relatively modest needs. Another move in 1935, to the northern edge of the New Town, Warriston Crescent, brought temporary respite but his clients were not fond of the latest work.

These are almost abstract in their concern for pattern and colour. The objects in the still-lifes are perfectly recognisable but there is very little in the way of modelling or perspective, only a symphony of shapes – Chinese bowls, black fans, a simple red chair, a black and gold Chinese screen – with their colours blocked in, in flat colour now more limited to bright primaries with the dull tones and cool shades of the late 1920s paintings banished. They are in many ways the most personal statements that Cadell ever made; he was concentrating on the basics as he had come to see them and the grand studio props which he had managed to keep from his Ainslie Place days have now become no more than shapes and colours on a canvas. There is no wide prospect of a studio or drawing room, the boundaries of the composition seem as limiting as Cadell's life and reputation.

Yet at the same time he was suddenly admitted as a member to the Royal Scottish Society of Painters in Watercolour and then to the Royal Scottish Academy. Just after he left the army he was nominated twice for the Academy and lost to other painters, so he wrote to withdraw his name from consideration. In 1935 the honour, such as it was, came too late to alter people's attitudes to him and his work. In any case, he was suffering from the intrusion of a malignant tumour in his head. For some months he had suffered from minor accidents, all seemingly caused by sudden loss of balance. These minor bumps and scrapes had affected his spirit rather than his painting but they were obviously symptomatic of a much more serious illness that was hidden until 1936. By then the illness no doubt affected his work and he was depressed both by it and his lack of success and recognition. One of the most poignant indications of his condition occurred after the death of his great friend, Peploe, in 1935. In August 1936 he applied for financial assistance to the Alexander Nasmyth Fund for the Relief of Decayed Scottish Artists. His annual income was given as an average of £280-300; to the question 'cause of present difficulties' he answered: 'Failure of purchases – death of patrons & difficulties in connection with my house in Ainslie Place, since disposed of.'[25]

At the beginning of 1937 he underwent a major operation on the growth in his head from which he seemed to make a reasonable recovery. The cancer had spread however, and in the autumn he was back in hospital for more surgery on his bowel and head. He died on 6 December 1937.

Throughout the 1920s Fergusson was based in London, living in Chelsea with Margaret Morris. The various summer schools that Margaret arranged for her pupils and followers took Fergusson to France for most summers that decade, usually to the the south coast where the dancers could be assured of good weather. It was an arrangement which no doubt suited Fergusson for he was surrounded by young women who provided him with an endless supply of models. His work changed the most radically of all the Colourists. The bold colours and brushwork of the pre-1919 paintings gave way to a softer, more

feathery application of the paint, accompanied by a restricted palette and a pronounced lowering of tone. The pictures are still concerned primarily with light but the colour has been muted, or at least its spectrum restricted to a narrow range of white, orange, brown, green, grey, yellow and red. A series of paintings which Fergusson made in 1923-4 form a transition between the full-bodied colour of earlier work and the later painting of the 1920s and 1930s. These paintings were produced after Fergusson had returned from a tour of the Highlands with his Glasgow friend John Ressich. In Ressich's car the two men had set out from Glasgow on 29 May 1922, returning to the city on 10 June. Fergusson made dozens of sketches and watercolours which had to be put aside until after he returned from that year's summer school at Pourville. Returning to London at the end of the summer he locked himself away for six months to produce a series of twenty or so paintings recording his memories of the Highlands in summer (see Pl 127–8). There is still strong colour in these pictures but on the whole Fergusson is more aware of the power of tone than in his earlier work. The paint is by no means as thick or fluid as in his earlier painting, with a certain dryness or scratchiness of surface that was to become more apparent as the decade wore on.

Ressich kept him in touch with all the latest developments in Scotland, and acted as intermediary between Fergusson and Alex Reid. Fergusson's Highland paintings had been shown at Aitken Dott in Edinburgh and at Reid's in Glasgow in 1923 and Ressich wrote to Fergusson[26] with news of Reid's plans for an exhibition of the Colourists in Paris the following year. Ressich had also been writing letters to the *Glasgow Herald*, campaigning for public recognition of the Colourists' work; it was not a campaign which found much favour among the establishment at the Glasgow Art Club:

The stage is set – a climax reached.
You would get the *Herald* following my last two letters. Reid senior, who hitherto has hung back is now definitely FOR the idea of accepting the three of you [Peploe, Hunter and Fergusson] as a GROUPE ECOSSAIS (his own christening). The local press is agog: all-round interest has been created – in short the moment has come – hence my letter in the *Glasgow Herald*.
 Our work is bearing fruit.
 Reid senior is back at work full fight, cursing the Englishman, and more important still – a Paris dealer has just been here staying with him. I may not have got his name quite correctly but it is something like Bignon [Bignou], 8 Rue de la Boétie, which Hunter tells me is THE street now. He saw your stuff and wants to come in too and has I gather definitely offered to give the combined show in the Barbazanges Gallery ... some time between April and July...
 Now my *Herald* letter was timed to click with the ART CLUB dinner on Friday last at which the new Lord Provost was the guest. Out of malice afore-thought, Hunter and I appeared and in the big room before and after the dinner I manoeuvred us into a conspicuous position (The Reds!) ... Everyone was talking about my letter. I was presented to the Lord Provost (a very good type); people ... came up and asked to be introduced – splendid – then the Provost's speech when he came to municipal interest in the pictures, the decent man practically said 'yes' to me letter. All the

lay members were raising a cheer for it while the 'artists' – the Domes of Silence with their chinchilla moss – nursed their belly-ache and muttered and scowled at Hunter and me. Poor old Hunter can hardly keep his feet on the ground.

Fergusson would have been delighted with the news and would have raised a smile at the discomfort of the artist members of the Art Club; he never had much time for the institutions of the art world. When he came to live in Glasgow in 1939 he made a point of keeping clear of the environs of the Art Club, preferring to set up his own rival establishment, the New Art Club, with the aid of Margaret Morris and her circle of young dancers and musicians. This was partly the result of Fergusson's stubborn belief that he was right and everyone who did not agree with him was wrong but there were parallels to be drawn between the Art Club establishment of the 1920s and that of the 1940s and 1950s. Some would find little difference in it today. *Plus ça change* ...

The Barbazanges exhibition took place in Paris in 1924 and the following year Fergusson appeared with the other Colourists at Reid's show in the Leicester Galleries. In 1926 he became the first of the Colourists to show in the United States with an exhibition at the Whitney Studio. Two years later he showed in Chicago and again that year at the Kraushaar in New York. The catalogues for these exhibitions show the same works appearing time and again. Fergusson achieved critical approval but there were few buyers for his paintings. His income throughout this period was never high; indeed, he never had any real money for the rest of his life, living very much a hand-to-mouth existence with Margaret. He never had the consistent support of collectors such as Blyth, Tattersall, McInnes and Harrison, from whom he was geographically distant, and he found no similar figures in London. George Davidson, a wealthy businessman who had operated the Kodak franchise in Europe at the turn of the century, was the closest to a real patron that Fergusson was ever to have. Davidson does not seem to have been deeply interested in Fergusson's work per se, however, but his philanthropic support of Margaret and Fergusson and the summer schools throughout the 1920s gave them food and shelter while he was alive. Living in France, at the summer schools throughout the 1920s and permanently from 1929-1939, Fergusson was able to cope with this precarious existence. After returning to Scotland in 1939, and settling in Glasgow, he found life much more difficult. There were exhibitions of his paintings in Glasgow in the 1940s and 1950s, but sales were not really substantial. This was partly because Fergusson always priced his work at what he believed it to be worth, rather than take the advice of his dealers. The consequent high prices kept him out of reach of the young but less well-off collectors who began to appreciate his work after the end of the war in 1945.

It was the early paintings, however, which were most sought-after. The later landscapes of wooded French valleys, the paintings of Margaret and her friends and pupils on the beaches and in the gardens of the south of France did not find a ready market. Occasionally, Fergusson would break out of the limiting routine he had set himself. One

way was through sculpture, which he had produced in small quantities ever since meeting Jo Davidson in Paris in 1907. He both carved and modelled, with the most interesting pieces being produced in the 1920s. One of these, *Dryad* (Hunterian Art Gallery, University of Glasgow) was carved from a 3 ft batten, just under 3in square, and was inspired by a climbing plant which was given to Fergusson in Chelsea by Charles Rennie Mackintosh. Walter Sickert, in his introduction to the Colourists' exhibition at the Leicester Galleries in 1925 described it as 'the best effect to which a batten two inches and three-quarters square has up to now been stripped'. In the same year, 1924, Fergusson produced one of his most powerful sculptures, *Eastra, Hymn to the Sun* (Pl 136). The head was cast in brass, shining to represent the power of the sun. It is almost mechanistic in its simplification of human forms to spheres and cylinders and is one of the most powerful of Fergusson's later works. It is also a key to the understanding of them. Occasionally, this interest in pattern and form for its own sake re-appeared in his painting, as in *Megalithic* (Pl 130), but such bright colours and formal shapes were rare. Despite the lowering of tone and the more restricted palette that he used in his post-1930 work, Fergusson is concerned with the warming glow of the sun and its health-giving powers. His paintings show Margaret and her friends enjoying life under its beneficial rays. Indeed, much of this philosophy probably came from Margaret, whose vegetarian regime and belief in the life-enhancing power of dance and movement were the foundations of her school of dance, the Margaret Morris Movement.

Many people, however, considered Fergusson's later work repetitive or to have lost the bite of the pre-1914 paintings. In some ways, Fergusson carried on painting too long as he was unable to maintain the rigourous quality of his earlier works. After the last of his three friends had died – Cadell in 1937 – he carried on painting for over twenty years. Much of this later work is a reworking of earlier ideas and demonstrates a lack of intensity and the intellectual rigour that is so much a part of his early paintings. His last years were spent at the centre of a coterie of young dancers, musicians, writers, actors and artists who were as much, if not more, attracted by the charisma of Margaret Morris, who did a lot to revitalise dance and drama in Glasgow after 1945. In old age, throughout the 1950s, he would escape from Glasgow to paint in the south of France for the summer, preparing himself for the long, dark, wet winters ahead. On 30 January 1961, Fergusson died, at the age of eighty-six, in the flat in Clouston Street that he and Margaret had made into a centre of artistic achievement in his adopted Glasgow.

After their deaths each of the Scottish Colourists was honoured by a Memorial Exhibition in either Edinburgh or Glasgow, or sometimes both. None of these four exhibitions, however, was shown outside Scotland and the high reputations that each artist had acquired did not stretch across the border. This seems all the more strange when it is

remembered that all these painters had been well exhibited in London in the 1920s and 1930s, particularly at Reid & Lefèvre, and three of them, Fergusson excluded, were shown in the exhibition of Scottish Art at the Royal Academy in 1939. Why Hunter, Cadell and Peploe were not given retrospectives by Reid's in the 1930s is not known. Tom Honeyman (who did much to further their standing and preserve their memory) was active in Reid's London gallery at this time, but he failed to convince his superiors of the need for such shows. After the war, when Honeyman had left Reid & Lefèvre, there were no more exhibitions of the Colourists, save for a small one of Peploe's oils in 1948. In Scotland things were different, and a series of exhibitions in Glasgow and Edinburgh, throughout the 1930s, 1940s and 1950s did much to reinforce their achievement and make their work available to younger generations of painters. Their paintings gradually entered museum collections throughout Scotland; the National Gallery in Edinburgh and Glasgow Art Gallery held retrospectives during the 1940s of all except Fergusson (whose career was recorded in the Scottish Arts Council's Memorial Exhibition in 1961). Their paintings were regularly bought by a large group of Scottish collectors, reinforced by others in the south who were introduced to their work by the Leicester Galleries, The Fine Art Society and Anthony d'Offay from 1960 onwards.

But artists like the Scottish Colourists are judged by their influence as much as their artistic achievements. The Colourists learned much from the Glasgow Boys. They admired their independence of spirit and continued their fight in Scotland to paint the subjects which attracted them, rather than pander to the market or convention as defined by the academic bodies which still held great sway in the years before 1914. Unlike the Boys, however, the Colourists had no great sense of ambition. None of them aspired to the knighthoods, wealth or social position that were proffered to the most successful of the Boys – Guthrie, Lavery, Henry, Hornel, Walton, Pirie and Cameron. This effectively meant that they played on a small stage, despite the efforts of others to promote them in London and Paris during the 1920s and 1930s. It has to be said that their influence was therefore restricted to Scotland, to the younger generation of painters who came to maturity between the wars and after 1945. Their lack of exposure outside Scotland after 1945 meant that they would have been known only through word-of-mouth which, even when it was carried by such influential and loquacious painters as Robert Colquhoun and Robert McBryde, was little substitute for consistent display of their work.

The Colourists, on the other hand, were much more advanced in their understanding of what was happening in Paris between 1900 and 1914 than almost any of their English contemporaries. English painting, however, chose to follow a different path from the gestural handling and brilliant colour of the Fauvist movement. Roger Fry's Post-Impressionist exhibitions had concentrated more on the 'significant form' of painters such as Cézanne while the more emotive painting of Van Gogh and Gauguin was given less emphasis. In the 1930s the avant-garde artists in England were much more interested

in and aware of the impact of Surrealism, Constructivism and the work of German refugees such as Gabo, Pevsner and Schwitters than they were in the work of Matisse and Picasso in the earlier years of the century. In Scotland, where a feeling for the tactile qualities of paint and a love of colour were better established, these four Scottish Colourists were held in some degree of awe and reverence not only because of the quality of their work but also because of their direct links to Matisse and Picasso. This admiration spread beyond the group of younger painters such as Anne Redpath, William Gillies, John Maxwell, William McTaggart and others, primarily based in Edinburgh, to an ever-widening circle of collectors who had known the Colourists or who had discovered their works in galleries and museums throughout Scotland after 1945. If this recognition was not given in appreciation of their painting, it was for their boldness of spirit and sense of adventure. There seems to be in the Scottish character a sense of responsibility, caution and respect for convention that is balanced in almost equal amount by an element of irresponsibility, rebelliousness, even aggression. The latter qualities are all too often suppressed until they erupt, perhaps with uncontrolled vigour, this lack of control sometimes ensuring that little is achieved by the outburst. The Colourists were capable of harnessing this underlying aspect of their nature. Their achievements came from the expression of emotions which – if the Kirk and the Establishment were to be believed – were uncontrollable once unleashed. Hunter, perhaps, overstepped the fine line between control and chaos too often but in the other three painters the balance between order and disorder, aggression and convention, passion and Calvinist restraint was maintained sufficiently to allow them to achieve much that fellow Scots aspired to and often failed to achieve and which many English painters, working on a less emotional plane, perhaps never experienced at all.

Too often their work has been dismissed by critics as insubstantial, as decorative paintings produced to satisfy a market. If that is so, how is it that the market did not respond with the enthusiasm that is attributed to it? Only Peploe maintained enough sales to sustain a normal life, and even those could not be taken for granted. None of their paintings was begun without each artist believing that he was embarking on a serious statement. There is an intellectual capacity behind each of these painters that has been diminished by critics over the years. They have cited many grounds to support their denial of these four men: facility of handling; over-bright colour (supposedly to appeal to popular taste but rarely used with the skill and confidence of these four painters); limited range of subject-matter; prolific output. Most of these criticisms, as I hope I have shown, bear little substance. Certainly they were prolific and that is, in my opinion, their most serious fault. All the criticism levied at them may be upheld by pointing to the not inconsiderable number of works which failed to reach the high standards set by each painter. But it was by producing

such a quantity of work that the Scottish Colourists hoped to make the right decisions about their painting. It is apparent, time and time again, how one painting out of many in a single series can point the way to new developments. Often these were explored before the problems, encountered in the previous work, had been resolved but these painters were driven by the excitement of discovery. None of them were to forget the impact of their close involvement with the artistic life of Paris before 1914. What they saw and learned there was sufficient to inspire them for another thirty years or more. Their example and independence, as well as their work, was in turn to inspire generations of young Scottish painters long after their deaths.

Source Notes for the Introduction appear on p172.

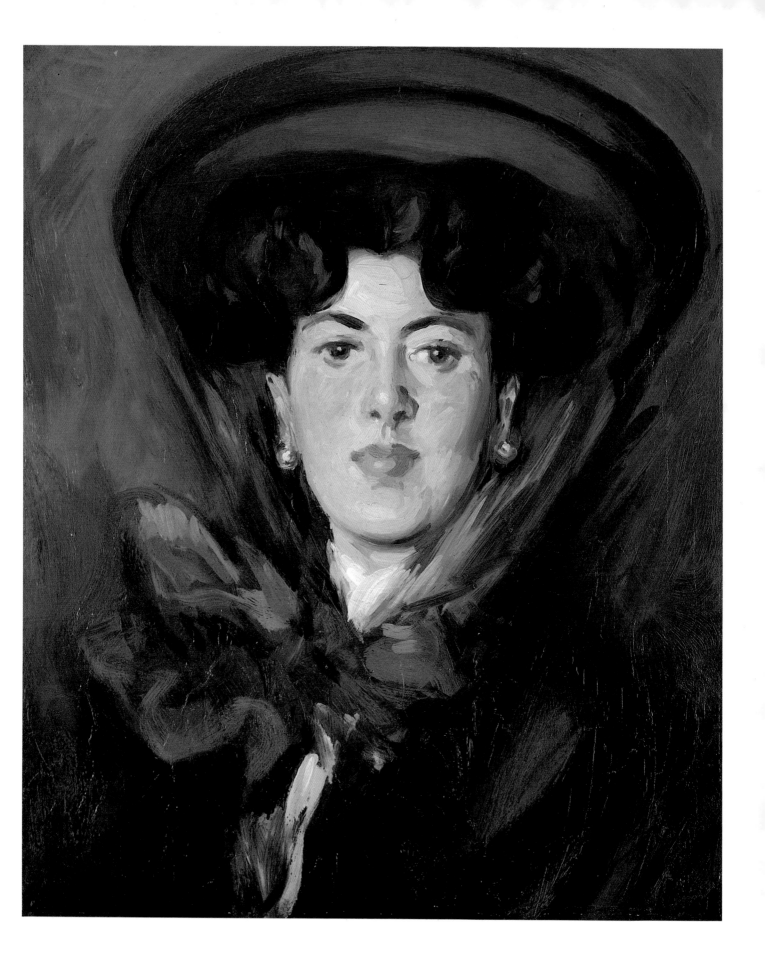

1. J D Fergusson *Jean Maconochie c. 1902* Oil on canvas 60.5 × 50.5

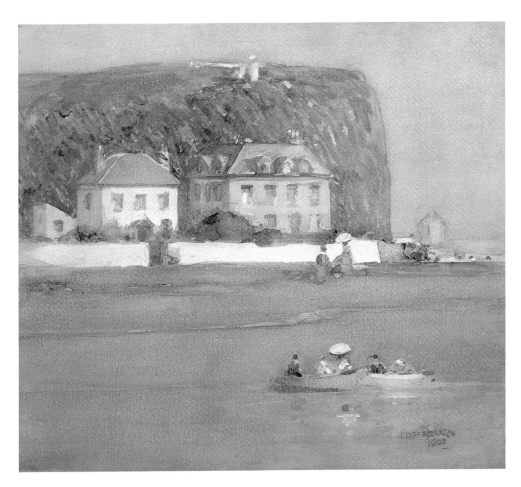

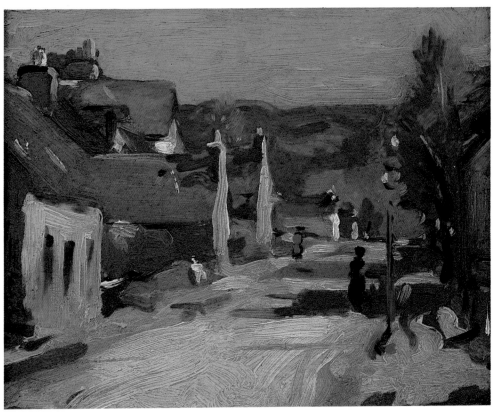

2. J D Fergusson *The Ha' Craig* 1900 Watercolour 38 × 43
3. S J Peploe *Comrie* c.1902 Oil on panel 24 × 32

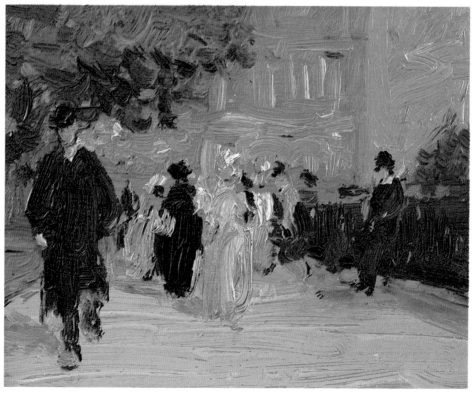

4. J D Fergusson *In the Garden* 1902 Oil on board 14 × 10.5
5. J D Fergusson *Princes Street, Edinburgh* 1902 Oil on board 11 × 13.5

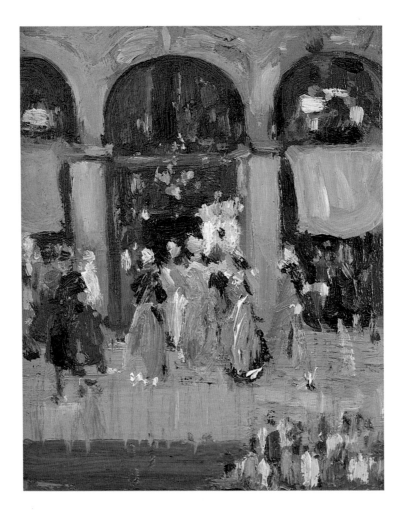

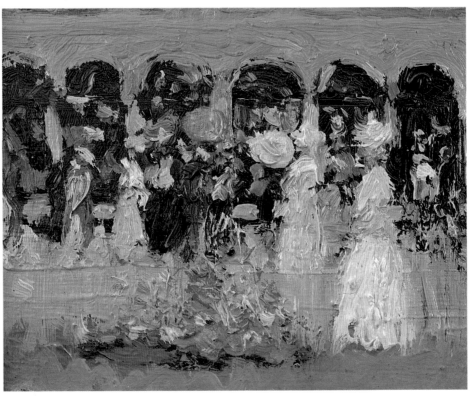

6. J D Fergusson Jenner's, Princes Street, Edinburgh Oil on board 14 × 11
7. J D Fergusson Stanley's, Princes Street, Edinburgh 1902 Oil on board 11 × 14

8. J D Fergusson *Girl on a Bicycle* c.1902 Oil on board 14 × 10.5

9. J D Fergusson *Carnations and Narcissus* 1903 Oil on board 35 × 27

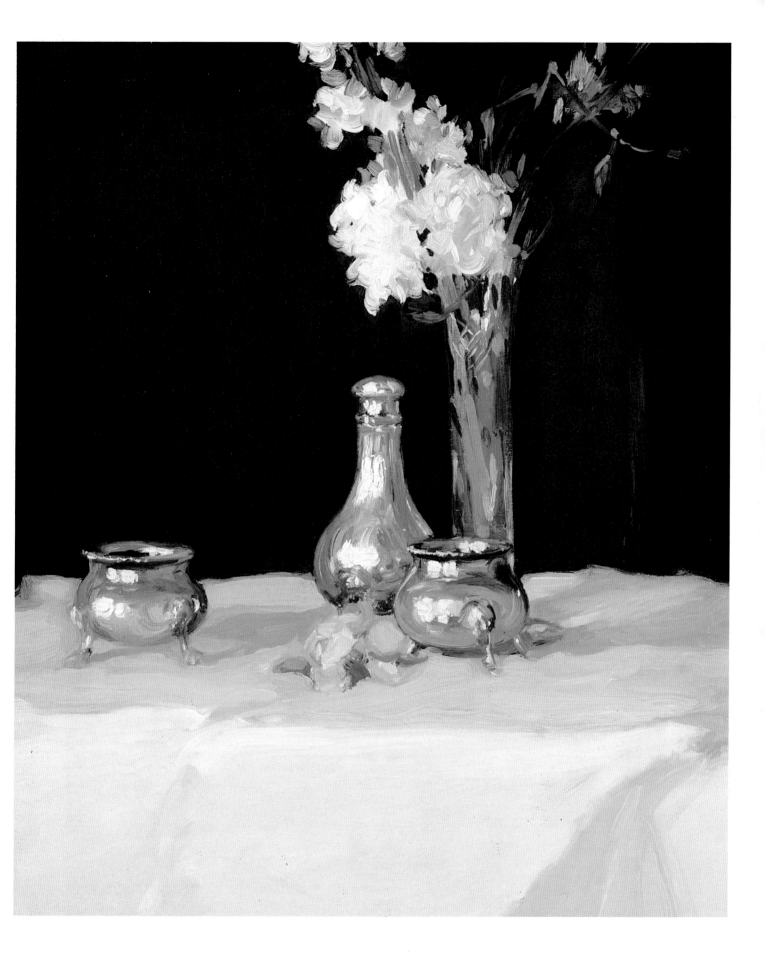

10. J D Fergusson *Jonquils and Silver* c.1904 Oil on canvas 49 × 43

11. S J Peploe *Evening, North Berwick* 1903 Oil on panel 16 × 24
12. S J Peploe *Landscape, Barra* c.1903 Oil on canvas 28 × 35

13. J D Fergusson *Paris-Plage* c.1907 Panel 24 × 19
14. S J Peploe *Paris-Plage* 1907 Oil on panel 19 × 24

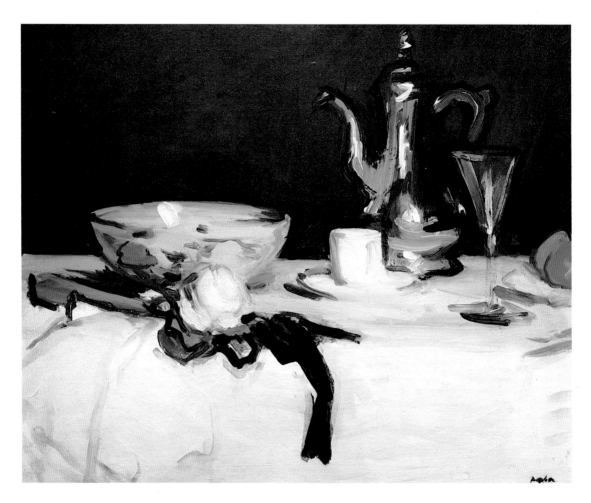

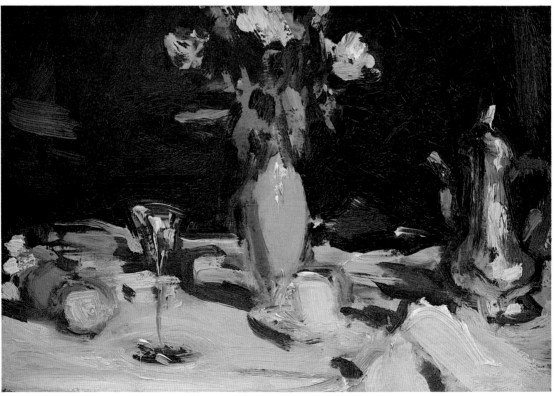

15. S J Peploe *Still Life with Coffee Pot* c.1904-5 Oil on canvas 51 × 61

16. S J Peploe *Pink Roses and Fruit* c.1905 Oil on panel 16.5 × 24

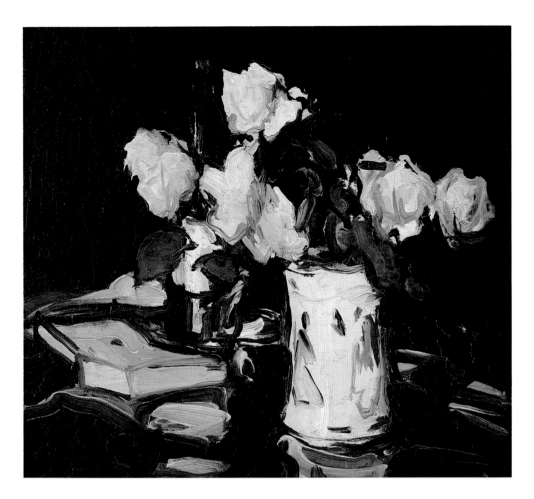

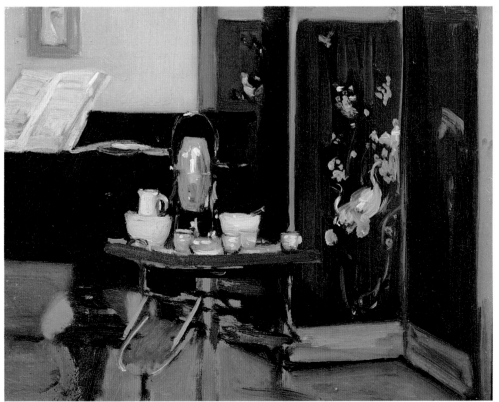

17. S J Peploe *Roses in a Blue Vase, Black Background* c.1904–5 Oil on canvas 40.6 × 45.7
18. J D Fergusson *Afternoon Coffee* c.1904 Oil on board 35.5 × 28

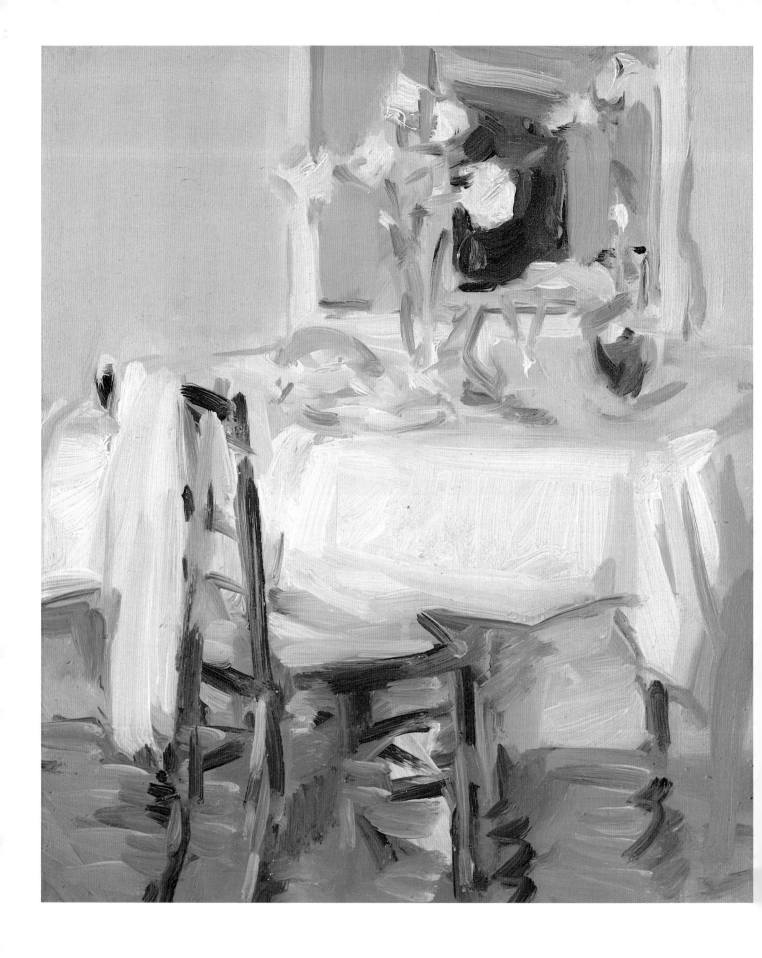

19. S J Peploe *Interior with Roses in a Vase on a Table* c.1906-7 Oil on canvas 38 × 30.5

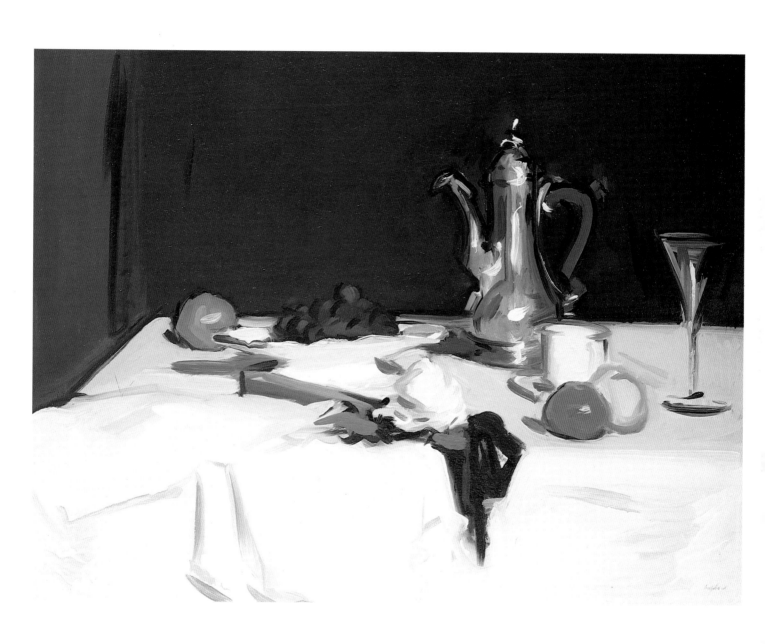

20. S J Peploe *Still Life with Coffee Pot* 1905 Oil on canvas 61 × 82.5

21. J D Fergusson *Dieppe, 14th July 1905: Night* Oil on canvas 76.5 × 76.5

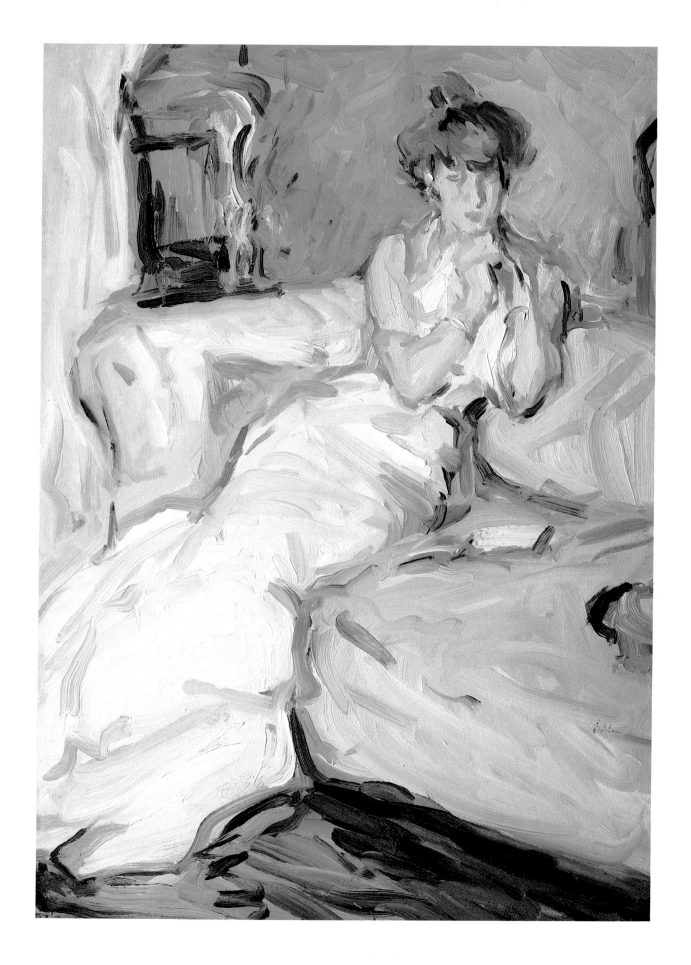

22. S J Peploe *A Girl in White* 1907 Oil on canvas 106.5 × 81

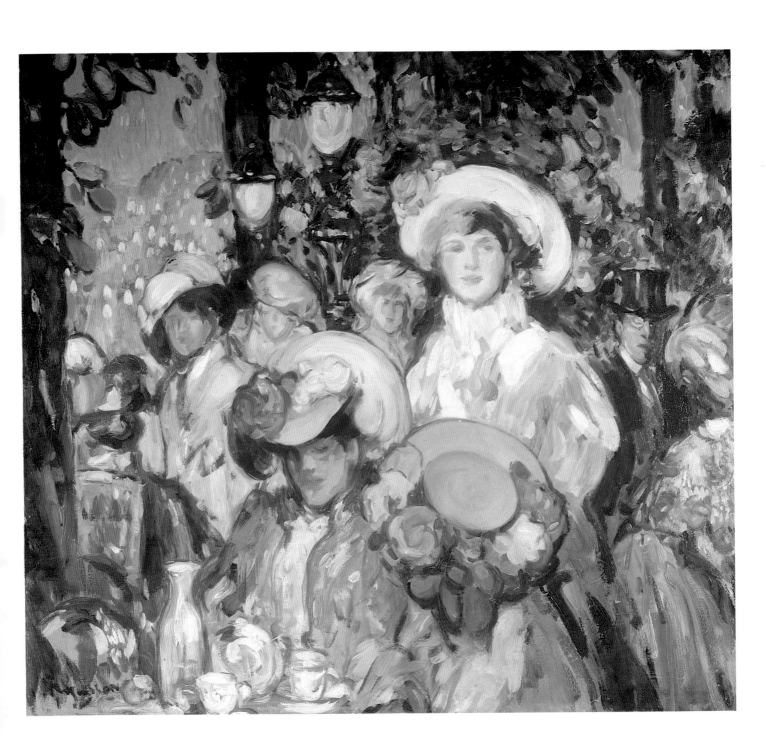

23. J D Fergusson *The Café in the Park* c.1906-7 Oil on canvas 101 × 127

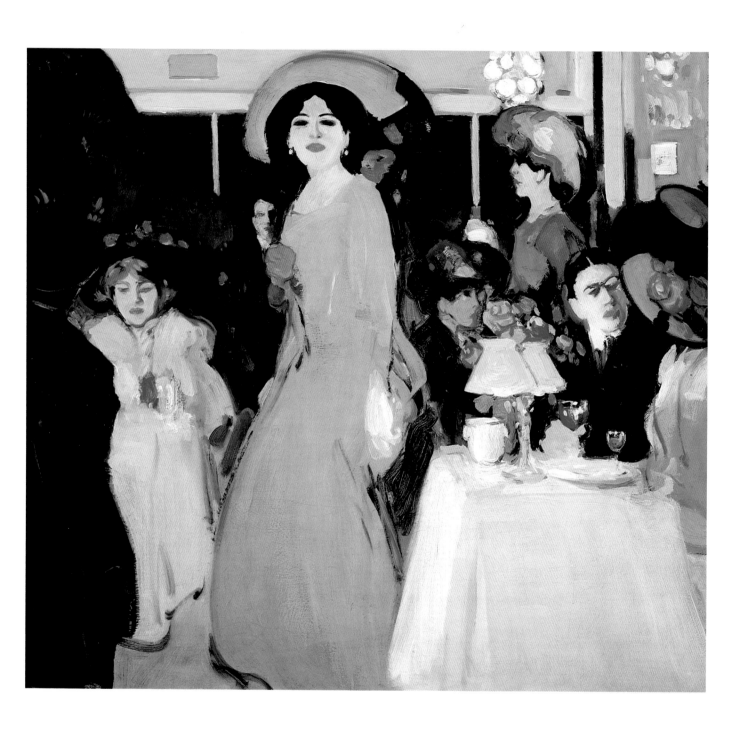

24. J D Fergusson *La Terrasse, Café d'Harcourt* c.1908-9 Oil on canvas 108.6 × 122

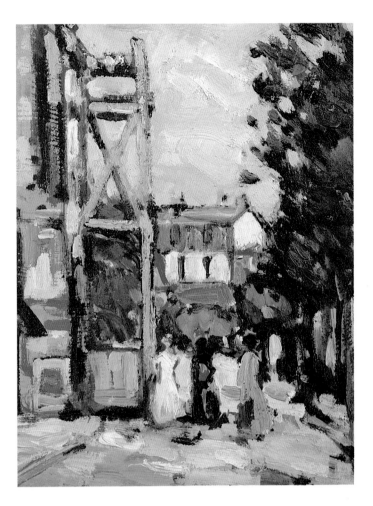

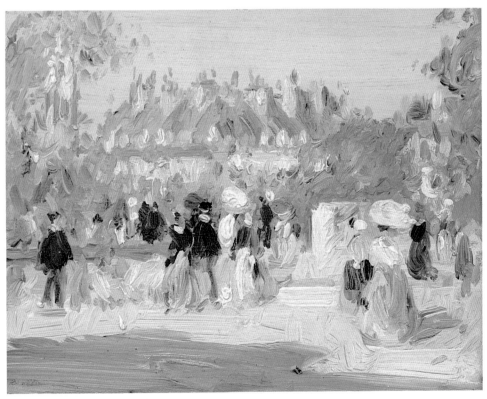

25. J D Fergusson *Boulevard Edgar Quinet* c.1907-8 Oil on board 35.5 × 28

26. J D Fergusson *Pont des Arts, Paris* 1907 Oil on board 19 × 24

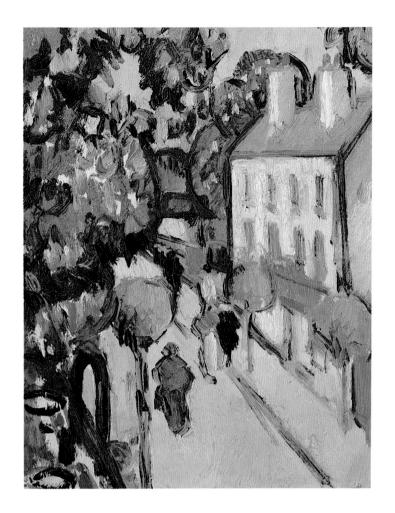

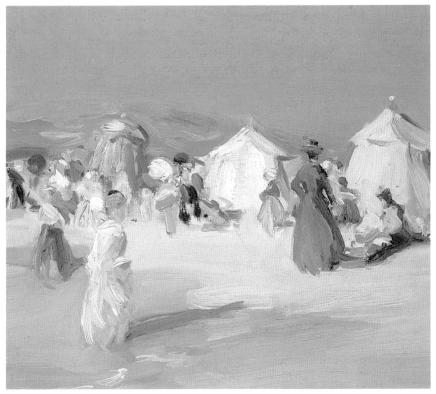

27. J D Fergusson *Carantec* c.1908-9 Oil on board 35 × 27
28. J D Fergusson *Grey Day, Paris Plage* 1905 Oil on canvas 35.5 × 45.7

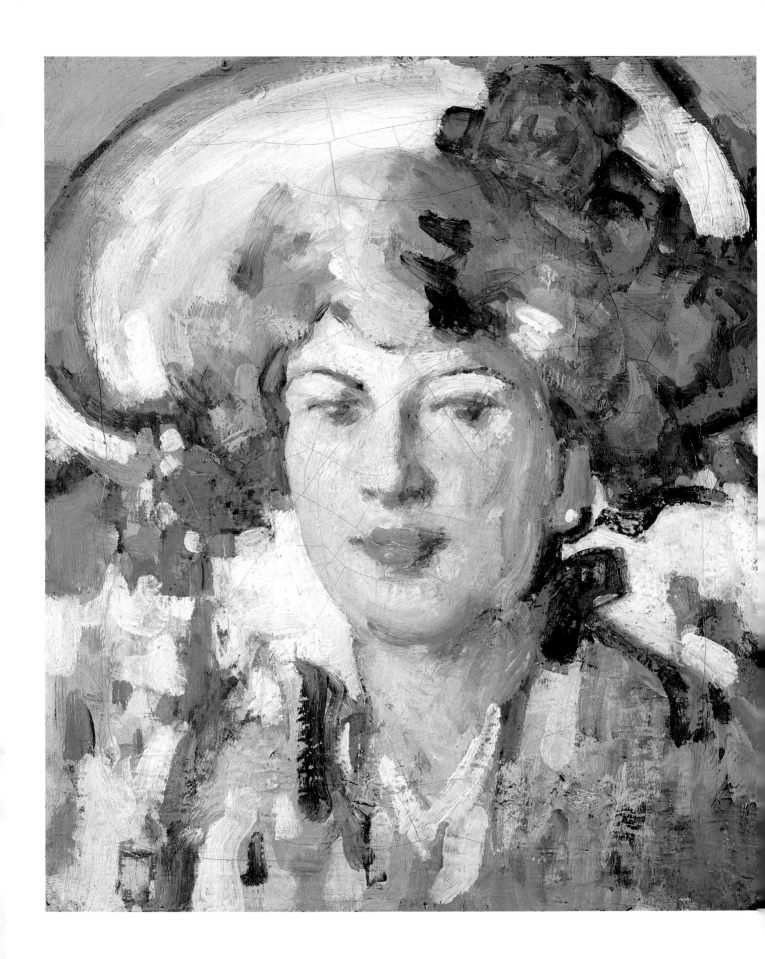

29. J D Fergusson *In the Sunlight* c.1908 Oil on canvas 44 × 38.5

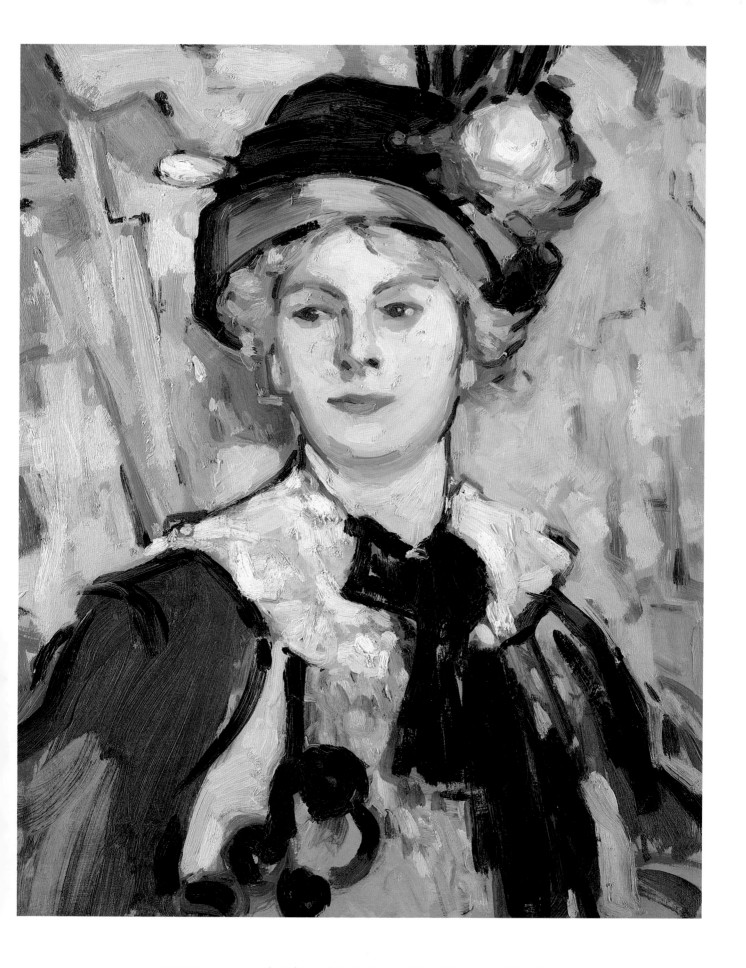

30. J D Fergusson *The Pink Parasol: Bertha Case* 1908 Oil on canvas 75 × 63

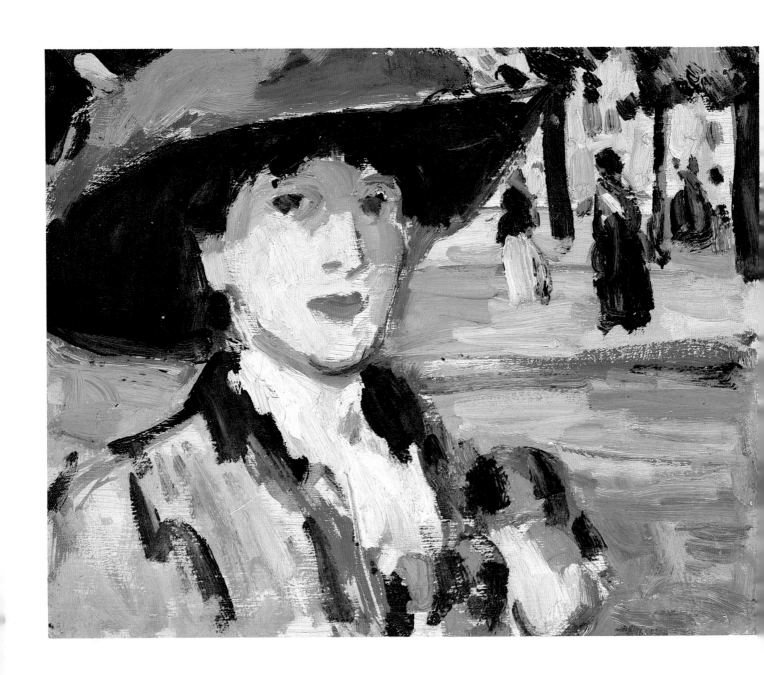

31. J D Fergusson *Closerie des Lilas* 1907 Oil on panel 27 × 34

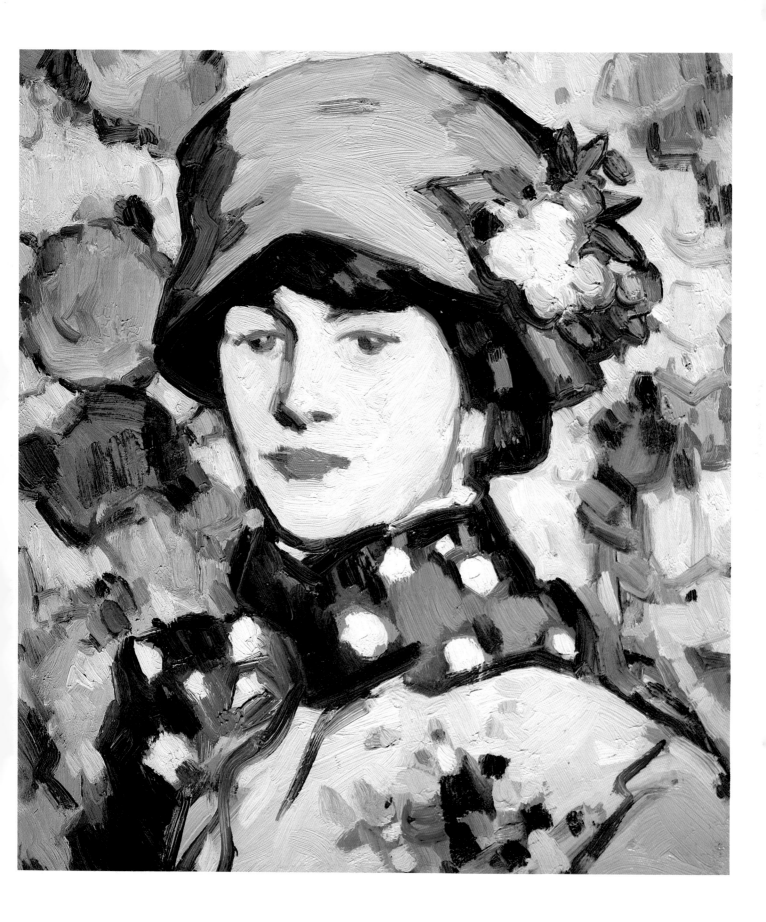

32. J D Fergusson *The Spotted Scarf – Anne Estelle Rice* 1908 Canvas 51 × 45

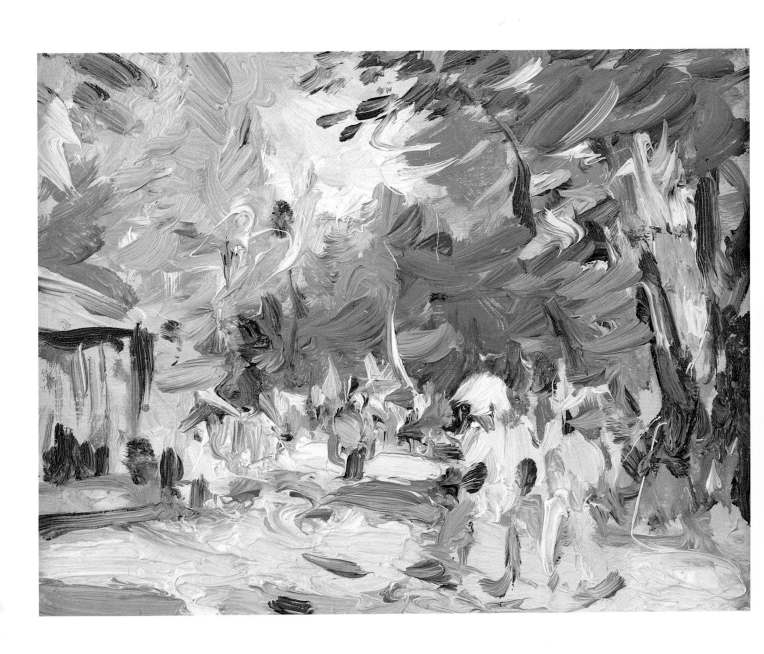

33. S J Peploe *Park Scene* 1910 Oil on panel 19 × 24

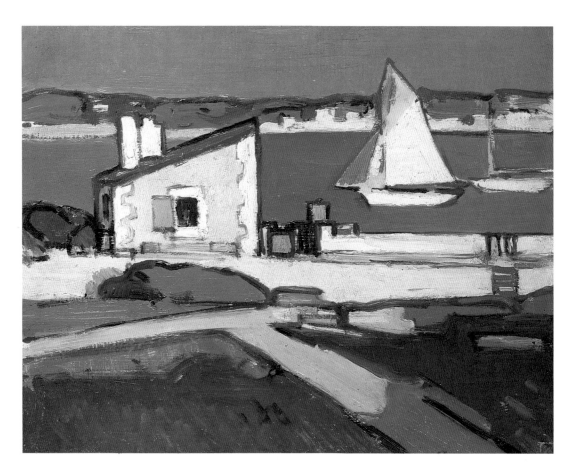

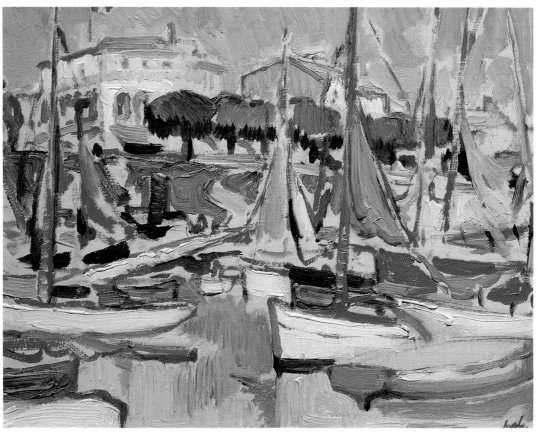

34. J D Fergusson *Royan* 1910 Oil on canvas 27 × 35
35. S J Peploe *Royan* 1910 Oil on board 29 × 33

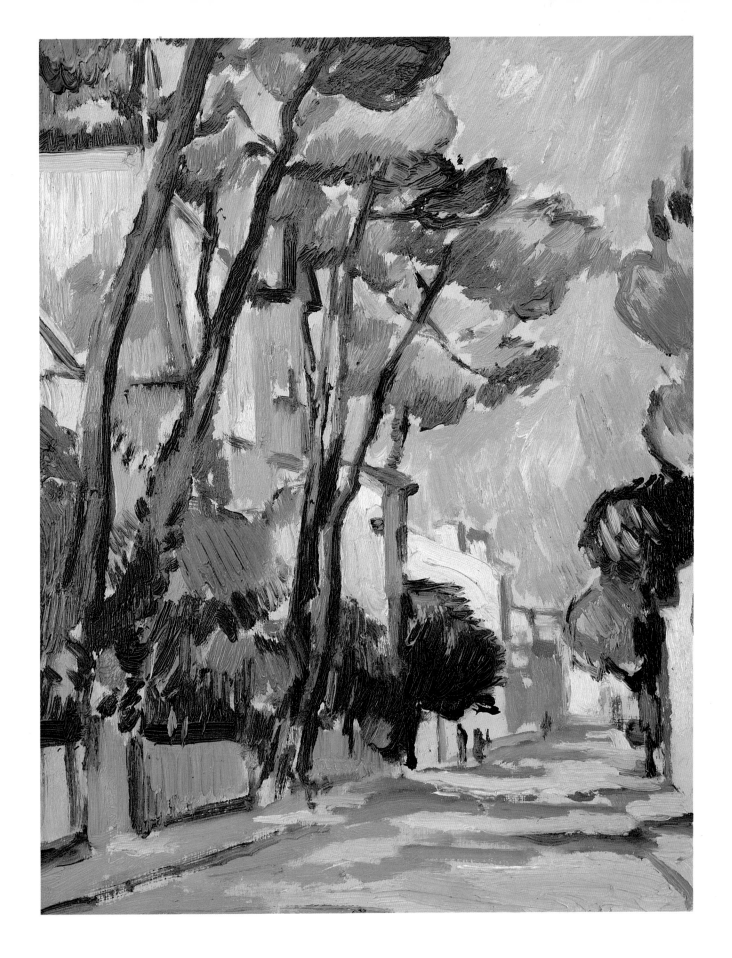

36. S J Peploe *Street Scene, France* c.1910 Oil on canvas 34 × 26.5

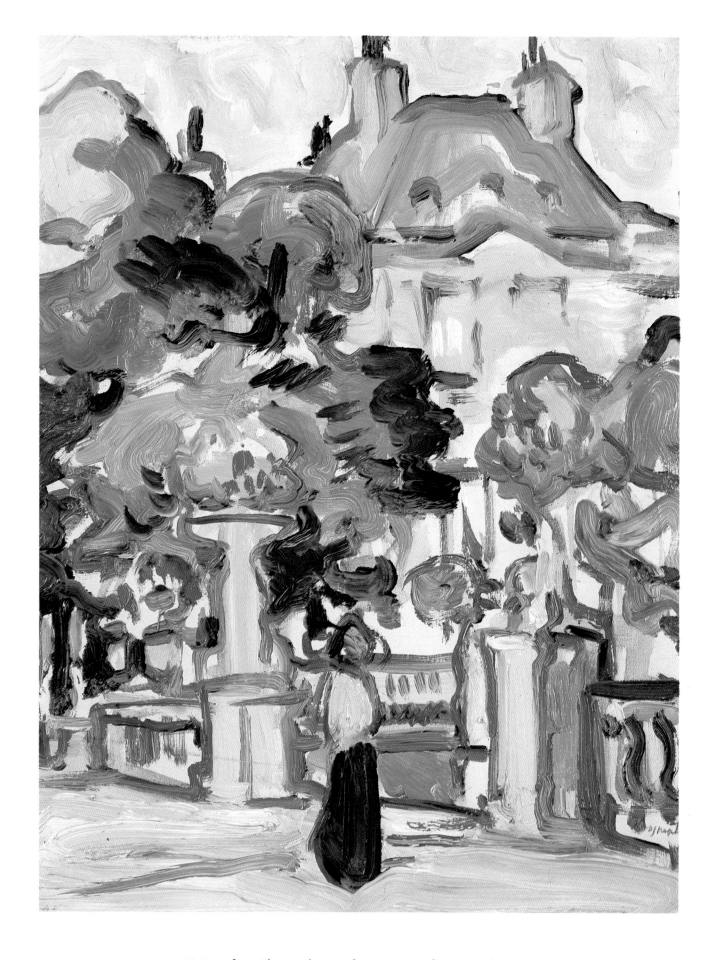

37. S J Peploe *The Luxembourg Gardens* 1910 Oil on panel 35.5 × 28

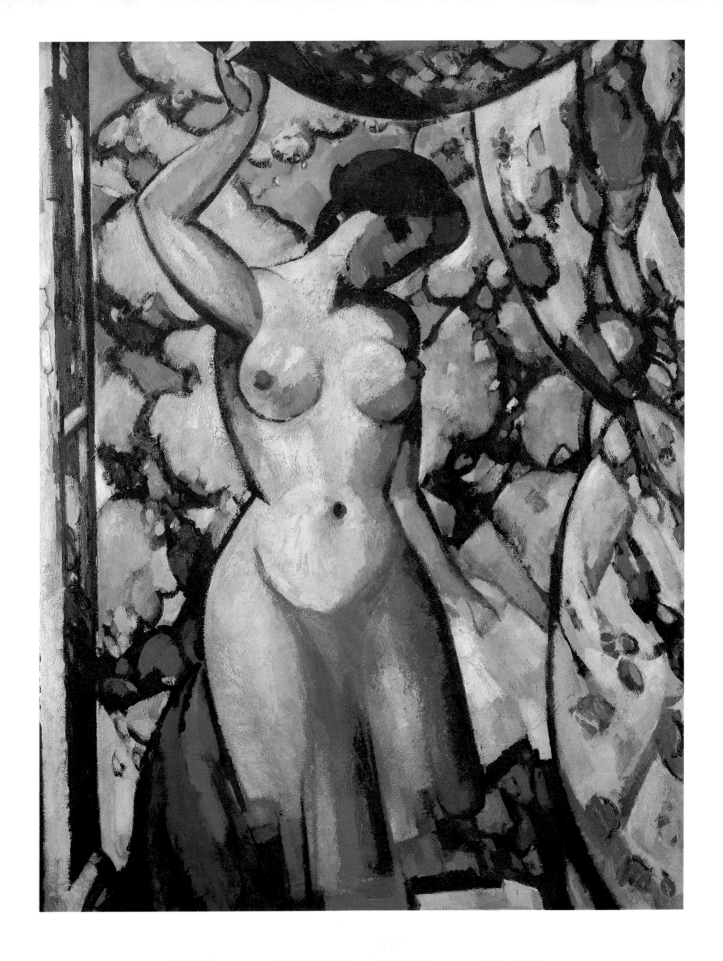

38. J D Fergusson *At My Studio Window* 1910 Oil on canvas 158 × 122.5

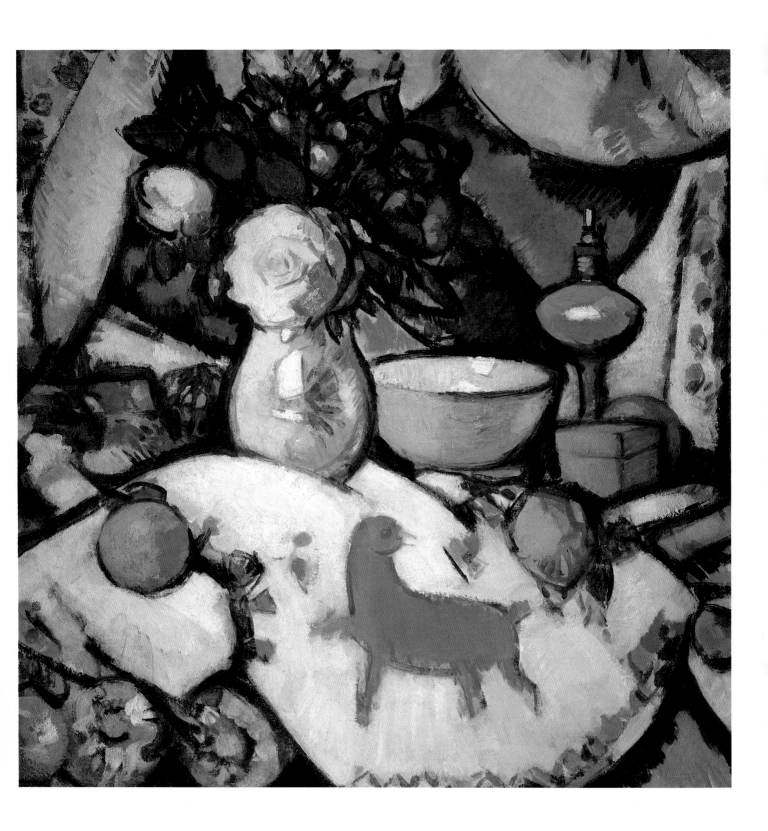

39. J D Fergusson *La Bête Violette* 1910 Oil on canvas 77 × 77

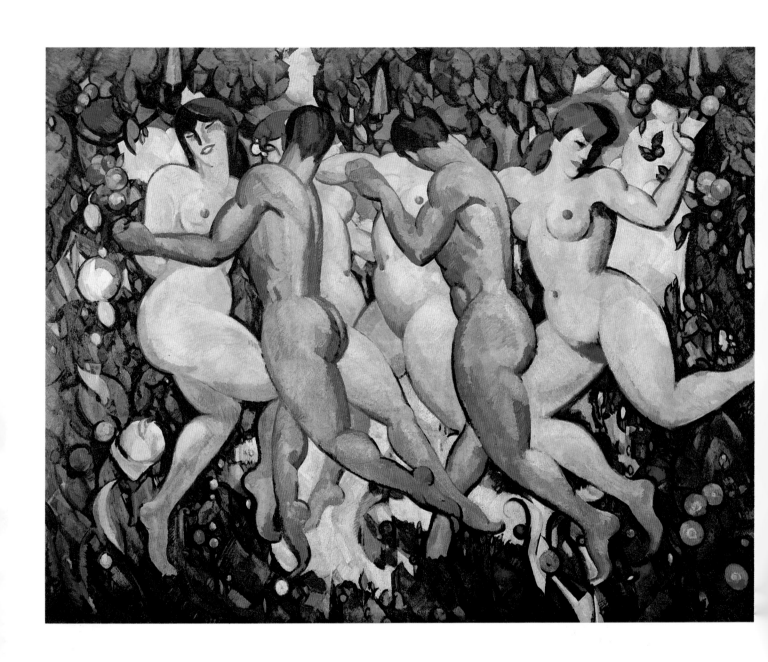

40. J D Fergusson *Les Eus* 1911-12 Oil on canvas 213 × 274

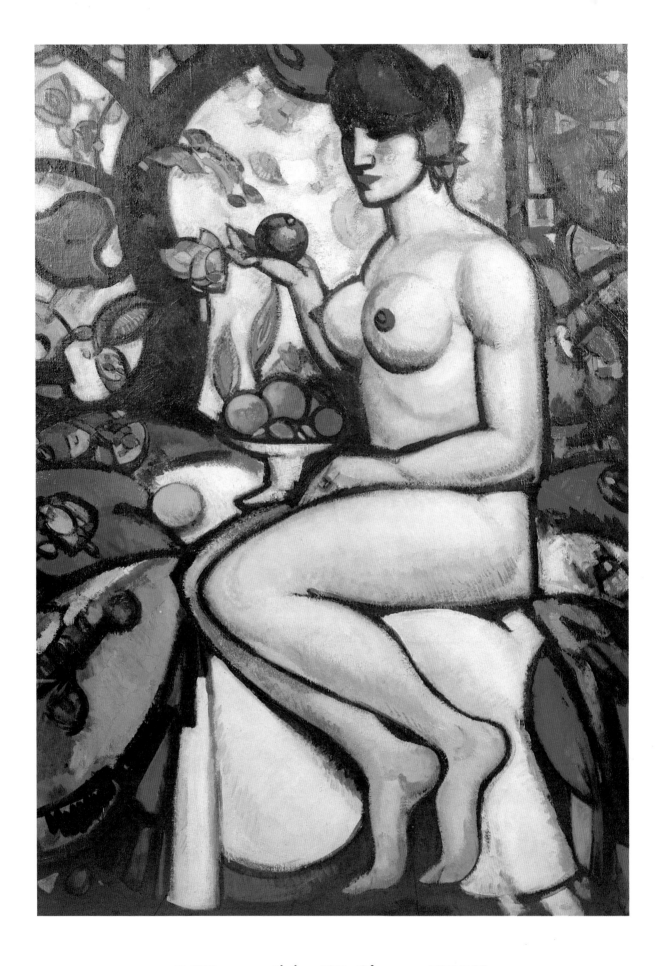

41. J D Fergusson *Rhythm* 1911 Oil on canvas 163 × 115.5

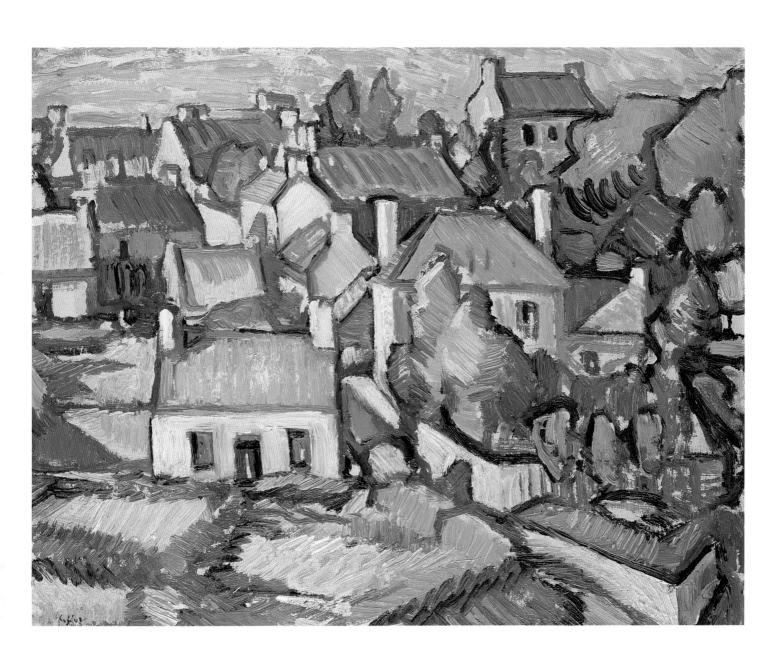

42. S J Peploe *Ile de Bréhat* 1911 Oil on panel 32.5 × 40

43. S J Peploe *Landscape at Cassis* 1913 Oil on board 33 × 40.5
44. J D Fergusson *Cassis from the West* 1913 Oil on board 26.5 × 35

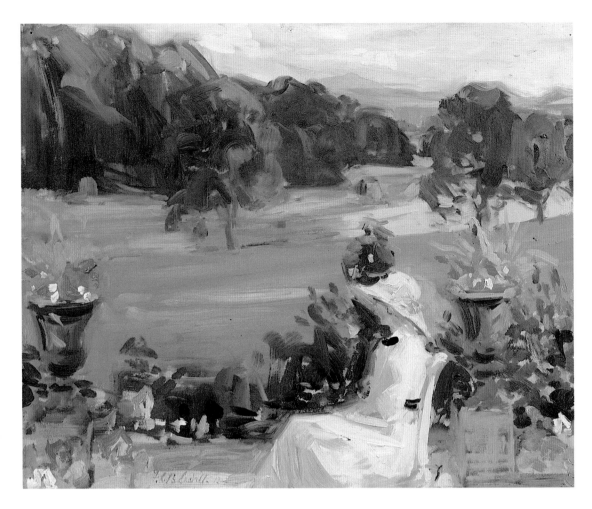

45. F C B Cadell *Jean Cadell at Dalserf House* 1912 Oil on panel 38 × 46
46. F C B Cadell *Sails, Venice* 1910 Oil on panel 46 × 38

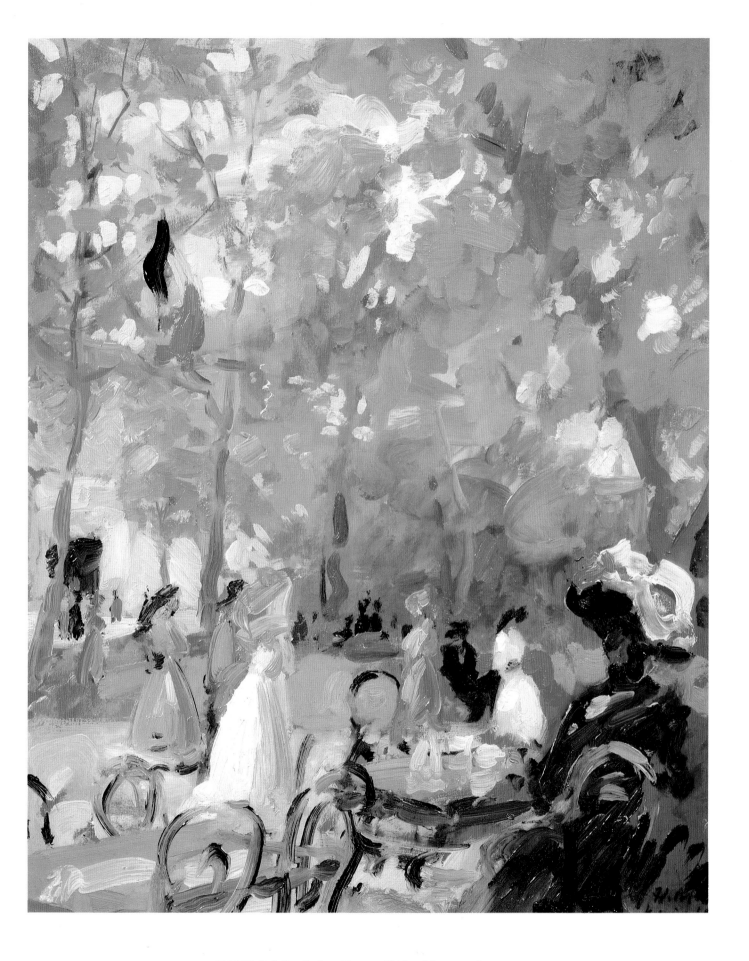

47. F C B Cadell *Gardens, Venice* 1910 Oil on panel 46 × 38

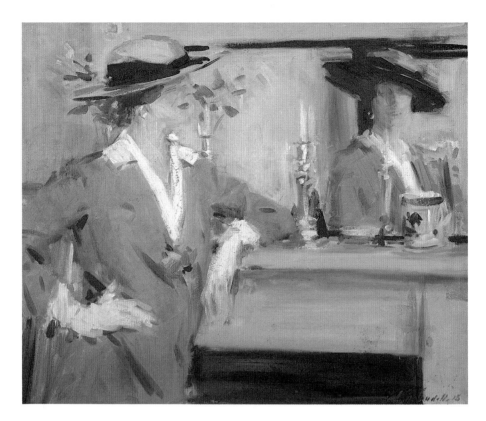

48. F C B Cadell *Reflections* 1915 Oil on canvas 63.5 × 76
49. F C B Cadell *Carnations* 1913 Oil on canvas 76 × 63.5

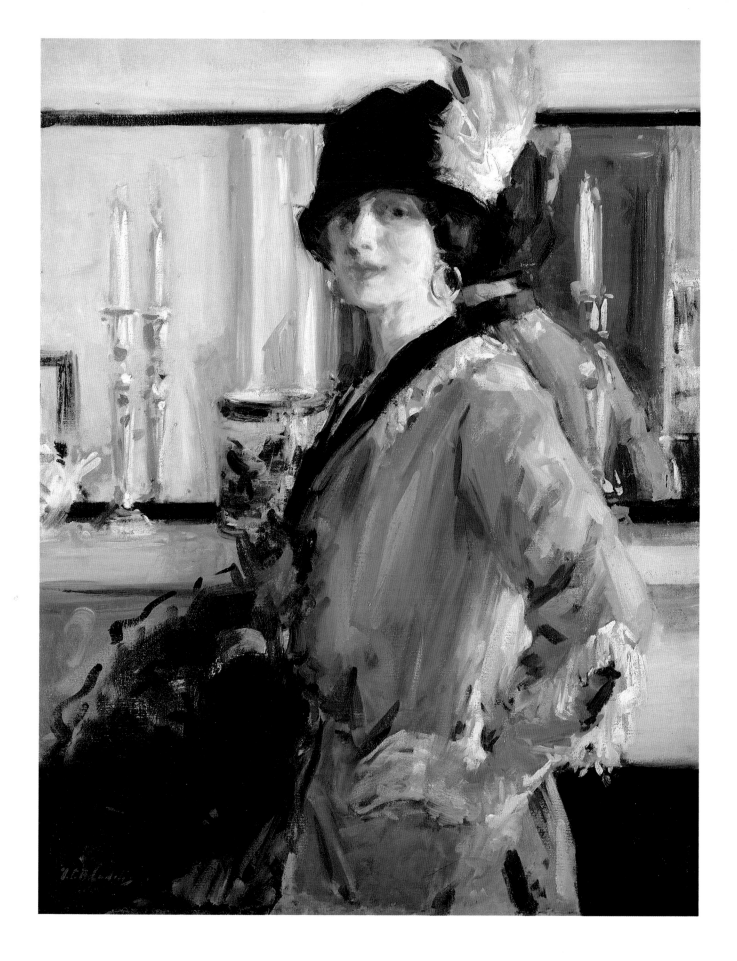

50. F C B Cadell *The Black Hat* 1914 Oil on canvas 107 × 84

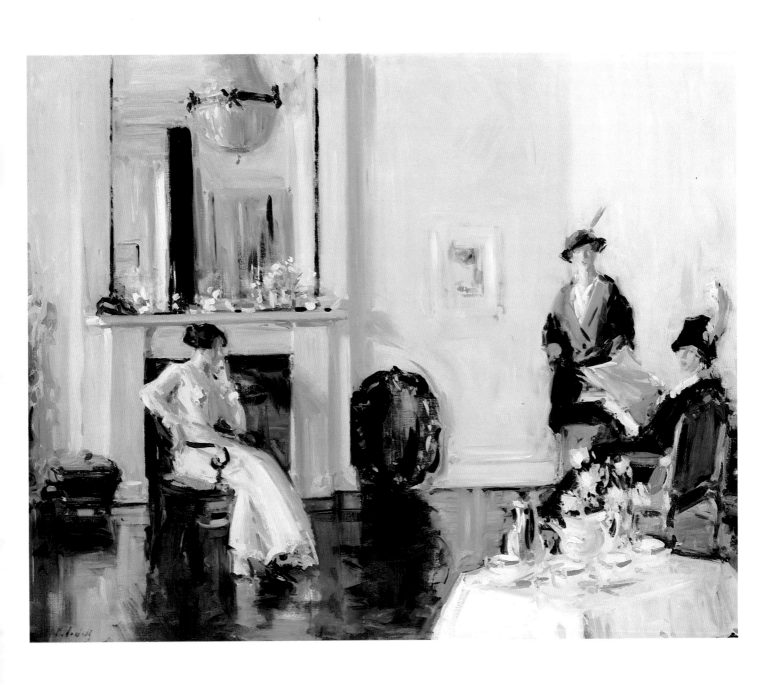

51. F C B Cadell *Afternoon* 1913 Oil on canvas 101.5 × 127

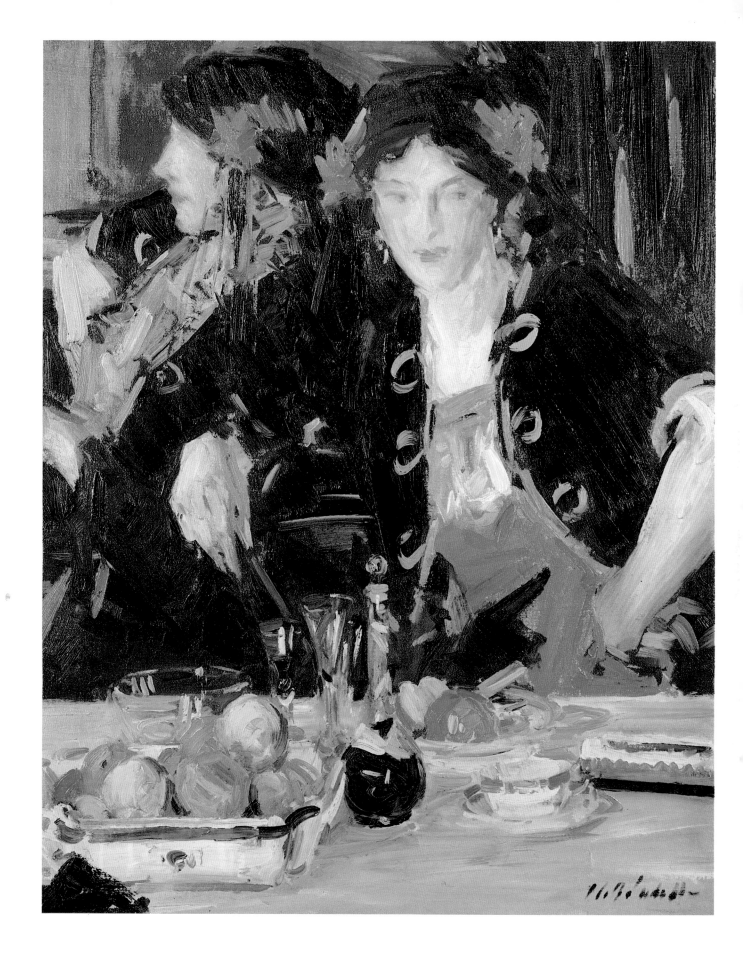

52. F C B Cadell *Crème de Menthe* 1915 Oil on canvas 107 × 84

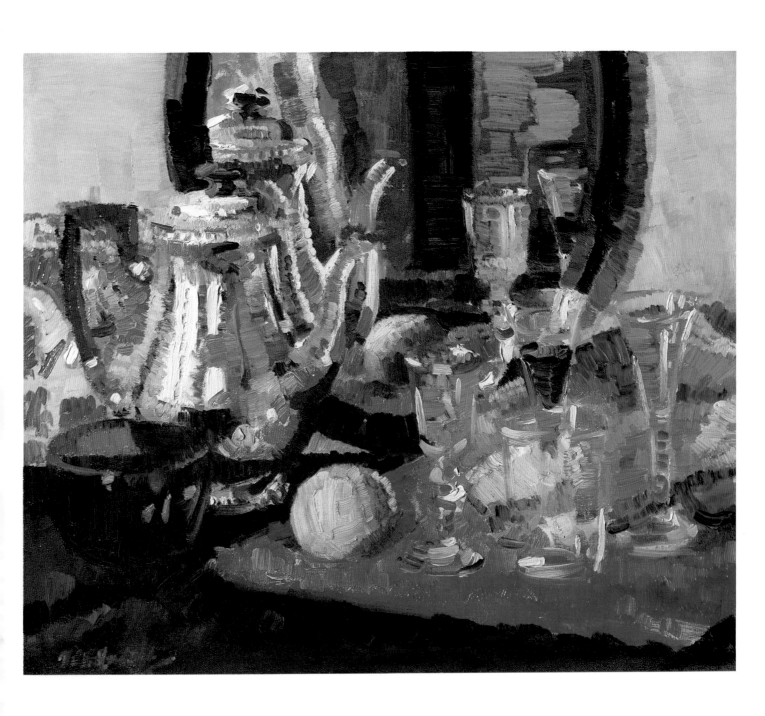

53. F C B Cadell *Reflection: The Silver Coffee Pot* 1913 Oil on canvas 51 × 61

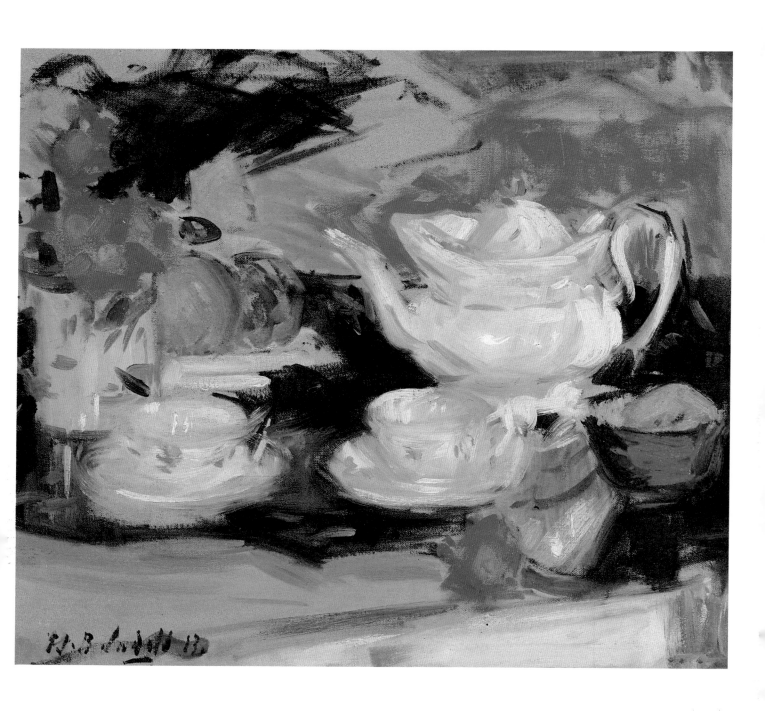

54. F C B Cadell *Still Life with White Teapot* 1913 Oil on canvas 48 × 61

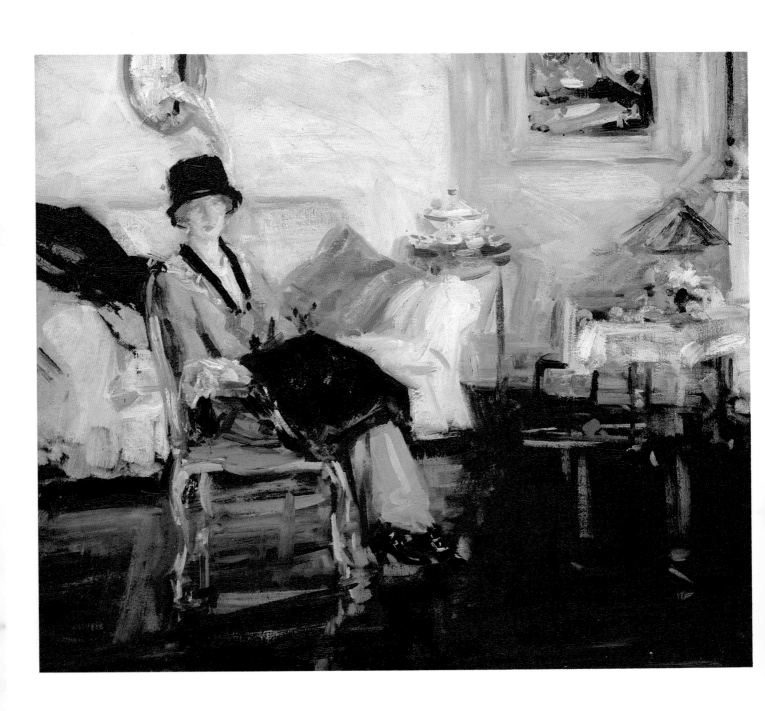

55. F C B Cadell *The White Interior* 1914 Oil on canvas 63.5 × 76

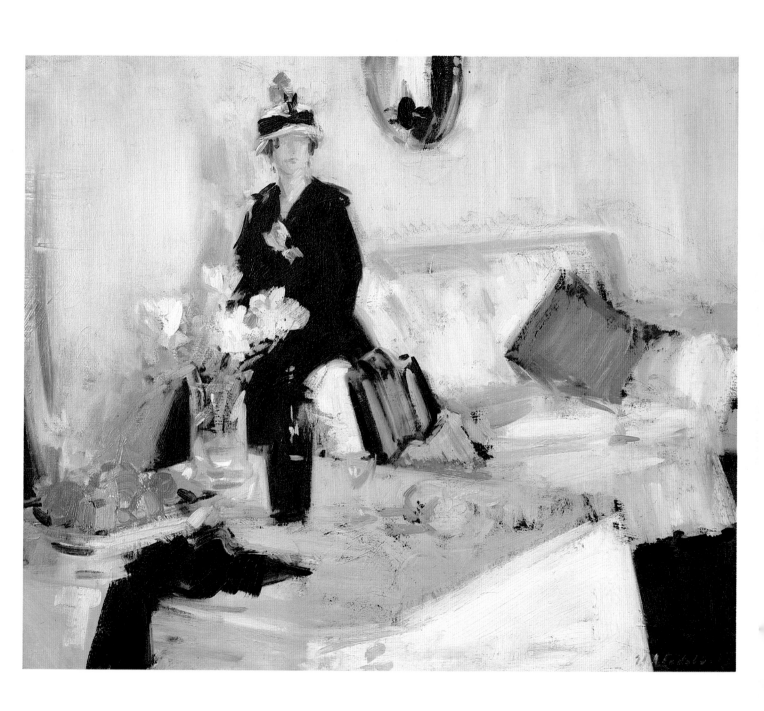

56. F C B Cadell *The White Room* 1915 Canvas 63.5 × 76

57. F C Cadell *Man in a Sailor Cap: Staffa* 1914 Watercolour 31 × 26

58. F C B Cadell *Still Life* c.1915 Oil on canvas 63.5 × 76

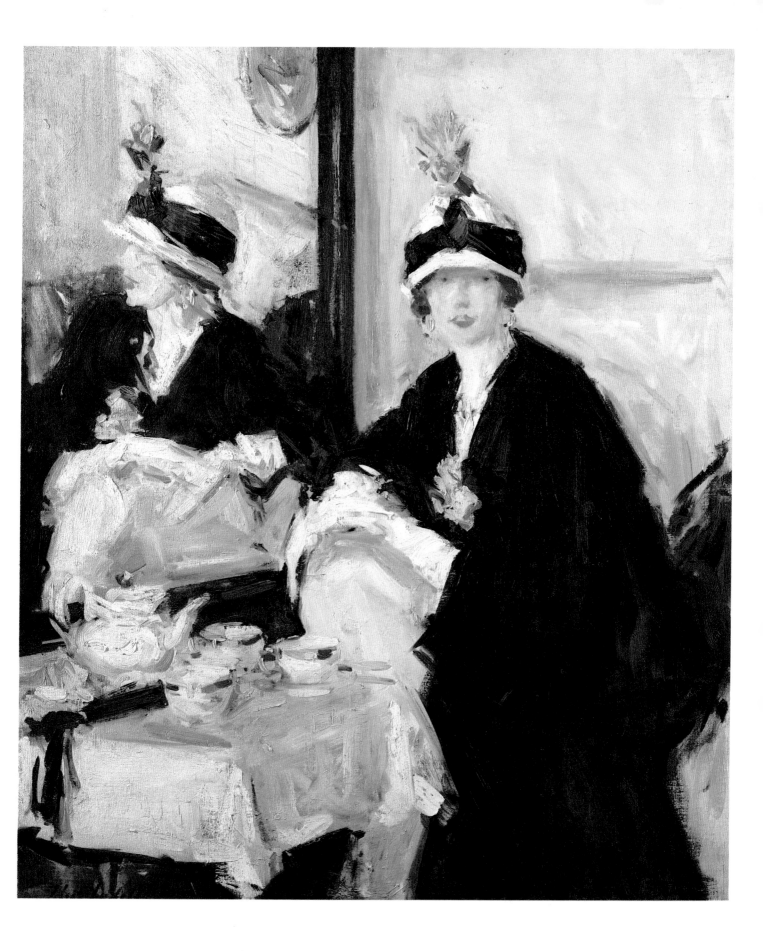

59. F C B Cadell *Reflections* c.1915 Oil on canvas 117 × 101.5

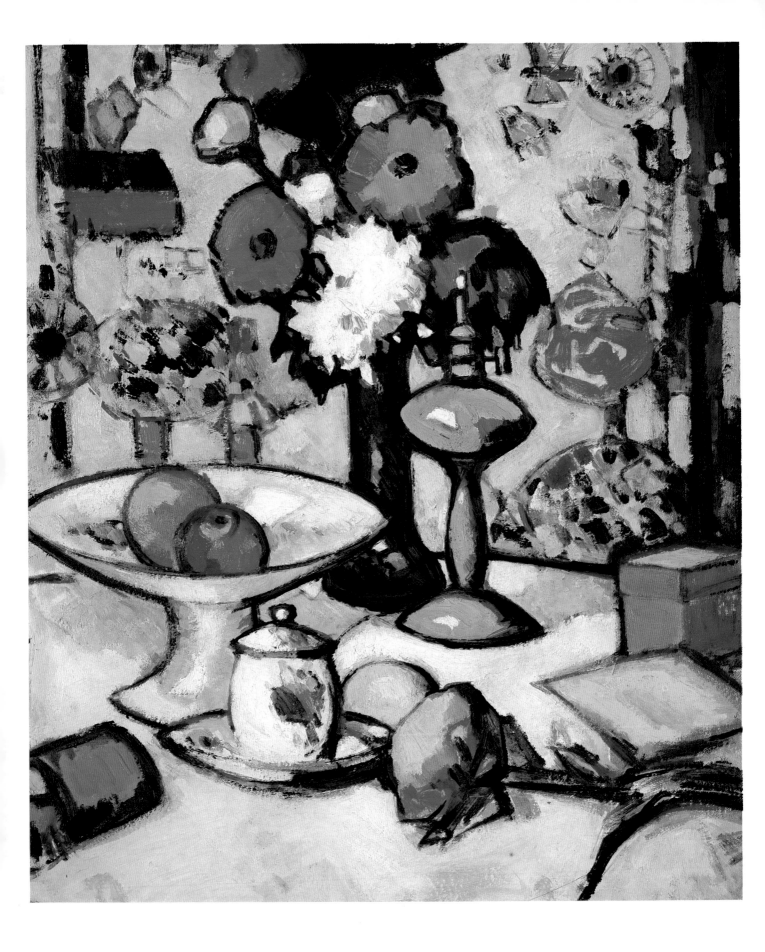

60. J D Fergusson *The Blue Lamp* 1912 Panel 66 × 57

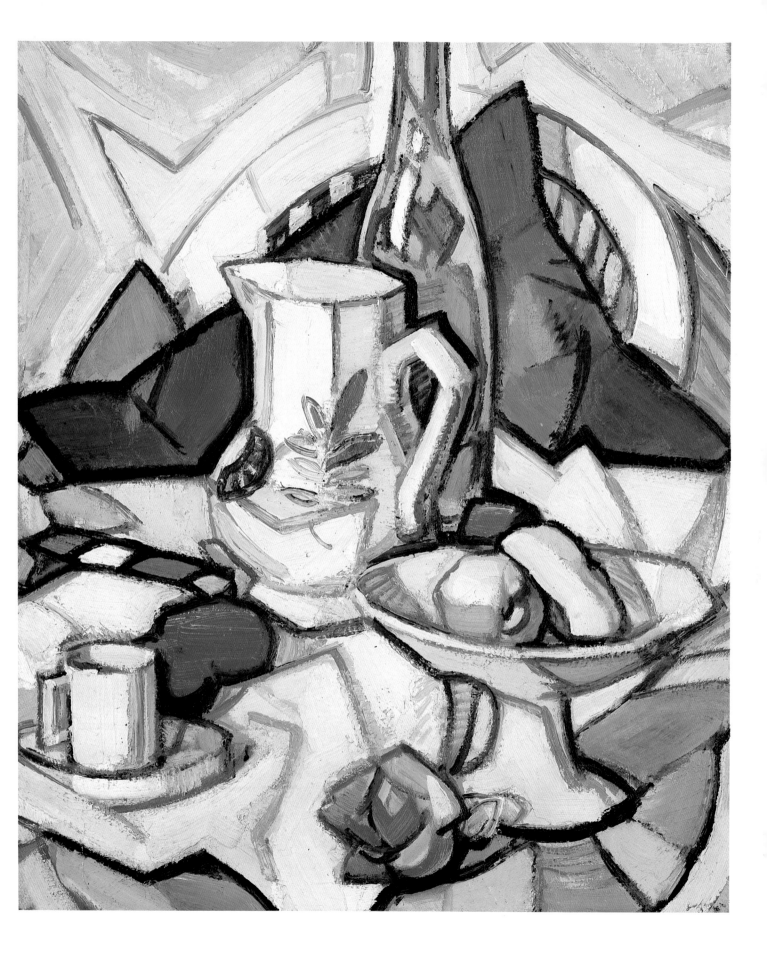

61. S J Peploe *Still Life* c.1913 Oil on canvas 54.5 × 46.5

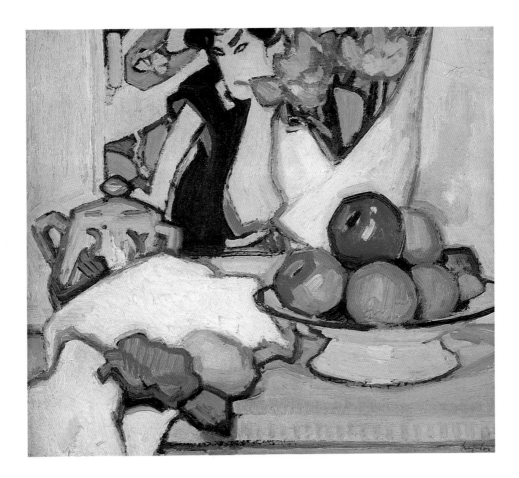

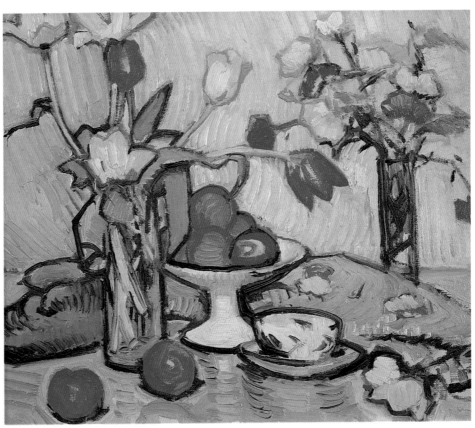

62. S J Peploe *Flowers and Fruit, Japanese Background* c.1915 Oil on canvas 40.5 × 45.5
63. S J Peploe *Tulips in Two Vases* 1912 Oil on canvas 47 × 56

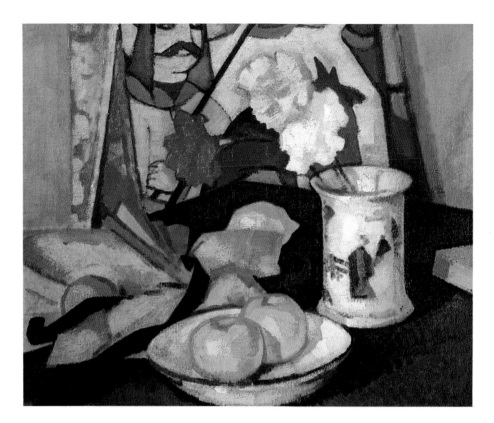

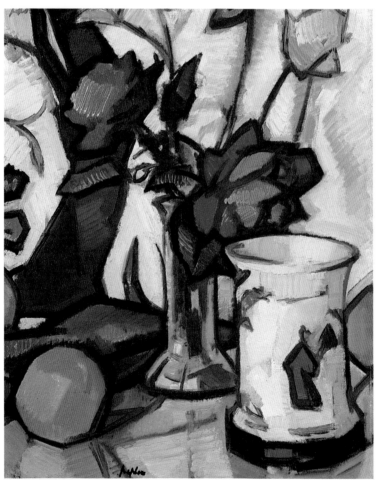

64. S J Peploe *Still Life with three Carnations* c.1916 Oil on canvas 46 × 56

65. S J Peploe *Deep Red Roses* c.1916 Oil on panel 40.6 × 33

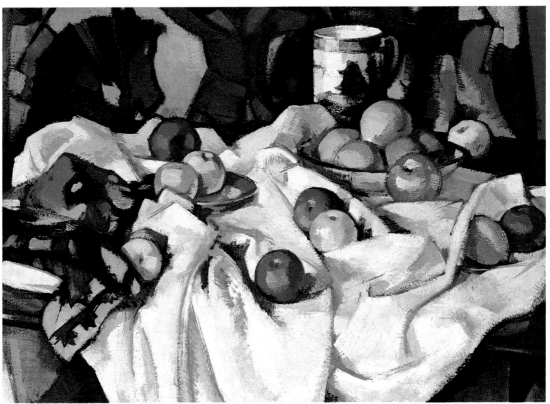

66. S J Peploe *Kirkcudbright* c.1916 Oil on canvas 53 × 63
67. S J Peploe *Still Life with Fruit* c.1918 Canvas 70 × 84.5

68. J D Fergusson *A Lowland Church* 1916 Oil on canvas 51 × 56
69. J D Fergusson *Damaged Destroyer* 1918 Oil on canvas 73.5 × 76

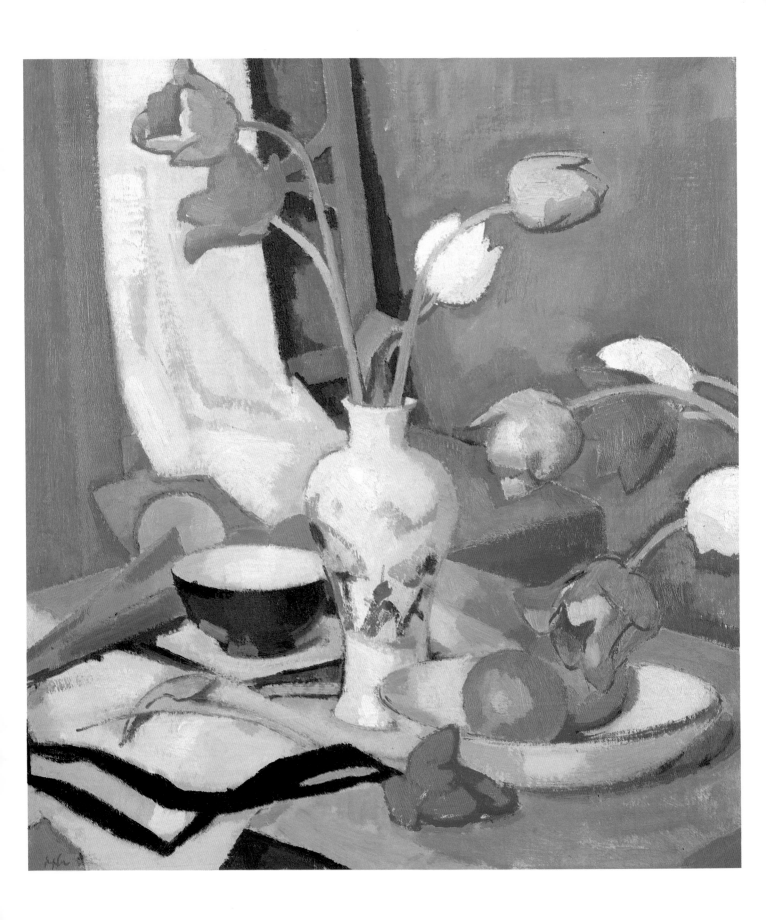

70. S J Peploe *Still Life with Tulips* c.1919 Oil on Canvas 56 × 51

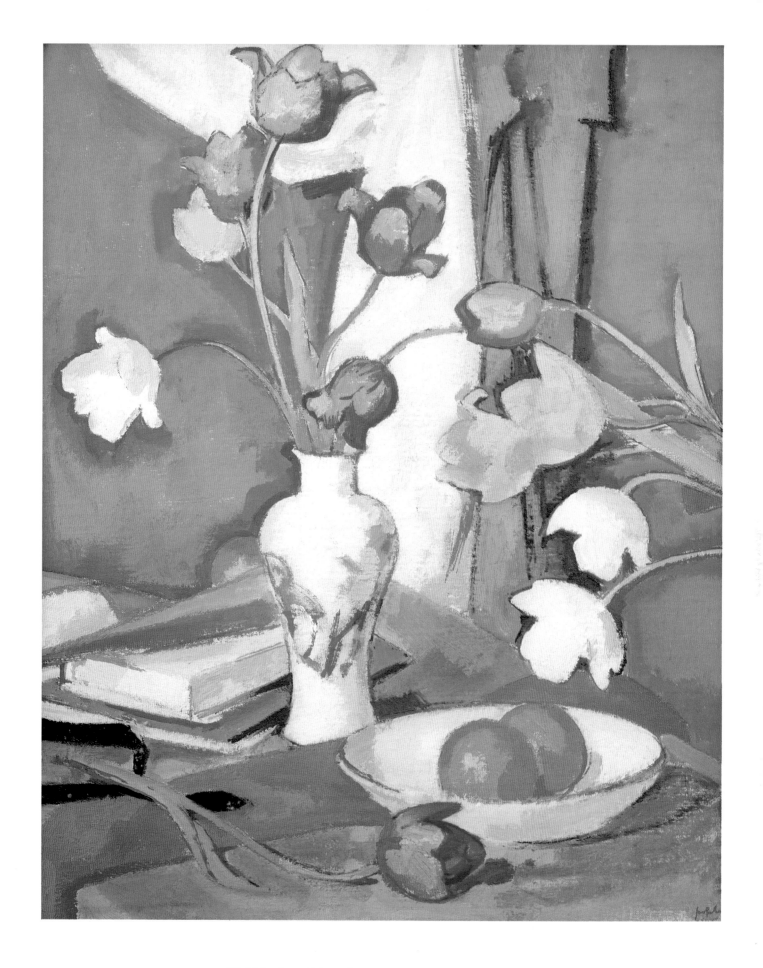

71. S J Peploe *Tulips and Fruit* c.1919 Oil on canvas 58 × 48

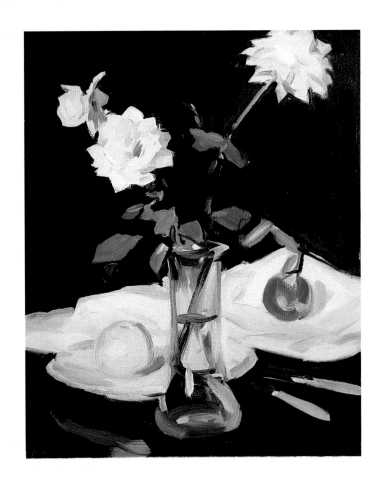

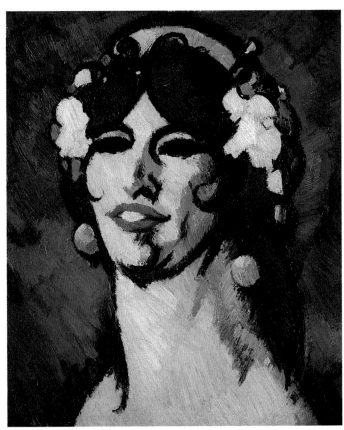

72. S J Peploe *Pink Roses* 1920 Oil on canvas 51 × 40.5

73. J D Fergusson *Margaret Morris dans le Chant Hindu de Rimsky-Korsakov* 1918 Oil on canvas 44.5 × 47.5

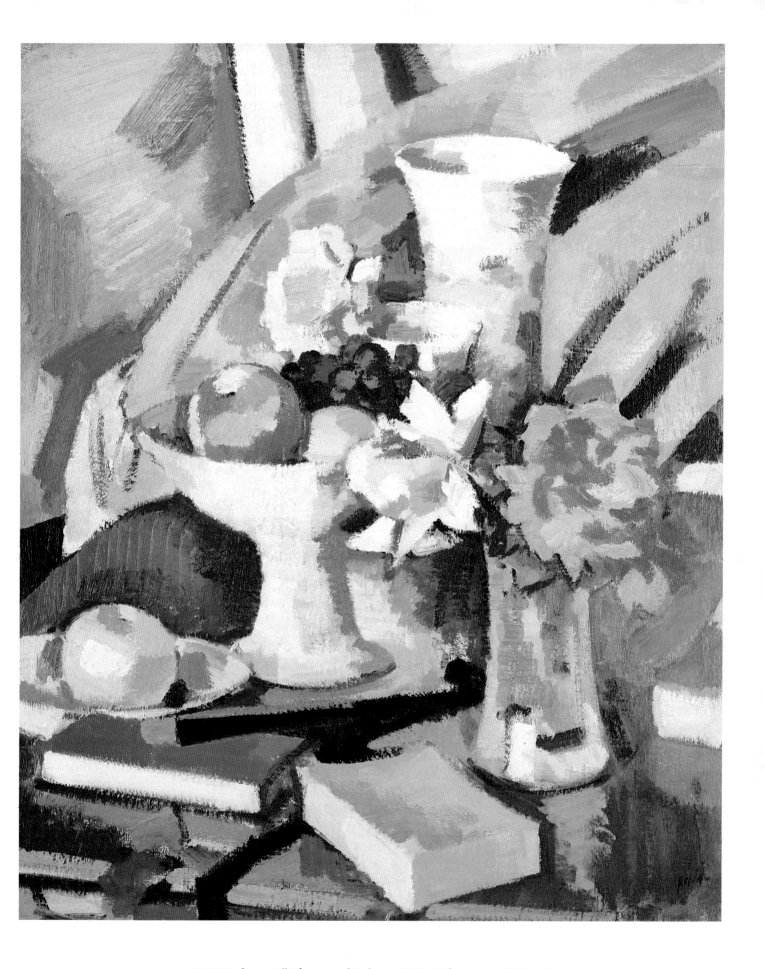

74. S J Peploe *Still Life, Roses and Books* c.1920 Oil on canvas 73.7 × 60

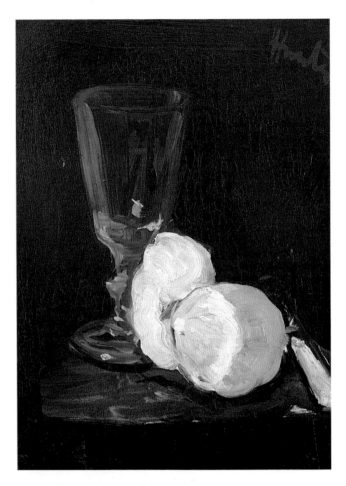

75. G Leslie Hunter *A Peeled Lemon* c.1910 Board 30.5 × 24
76. G Leslie Hunter *Chrysanthemums* c.1908 Oil on canvas 70 × 56

77. G Leslie Hunter *Etaples* 1914 Oil on board 28 × 35.5
78. G Leslie Hunter *Still Life with Blue and White Jar* c.1920 Oil on canvas 55 × 50

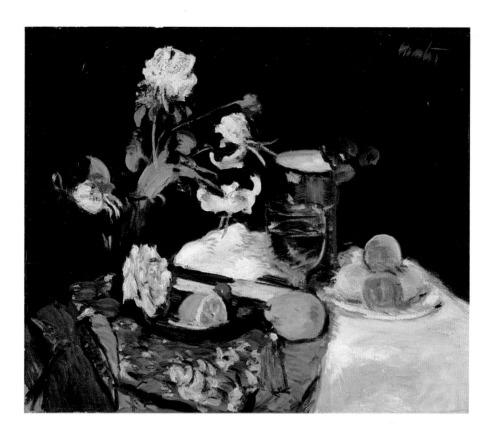

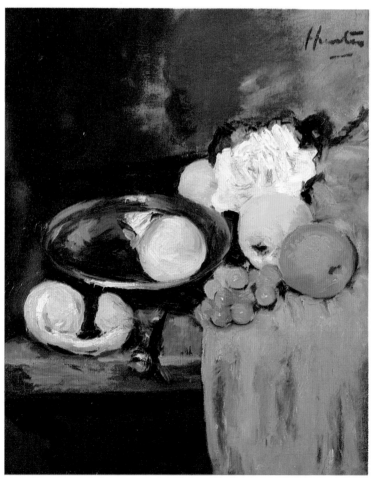

79. G Leslie Hunter *Still Life* c.1918 Oil on canvas 51×61

80. G Leslie Hunter *Still Life: Rose, Lemon and Fruit* c.1917 Oil on canvas 46 × 38

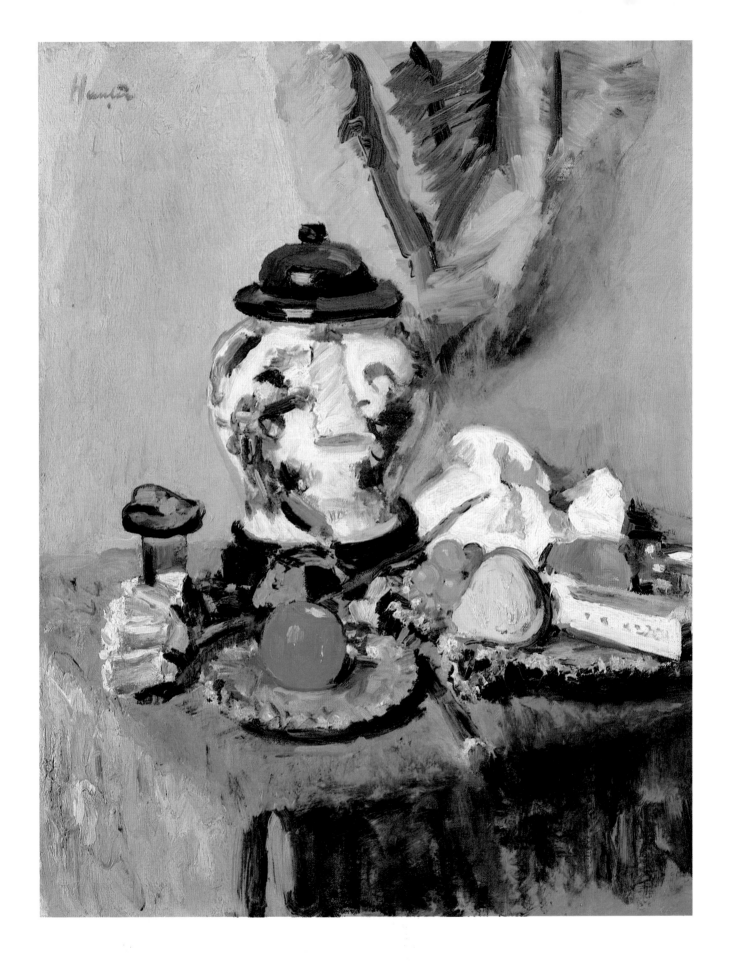

81. G Leslie Hunter *The Green Table-cloth* c.1920 Oil on canvas 76 × 51

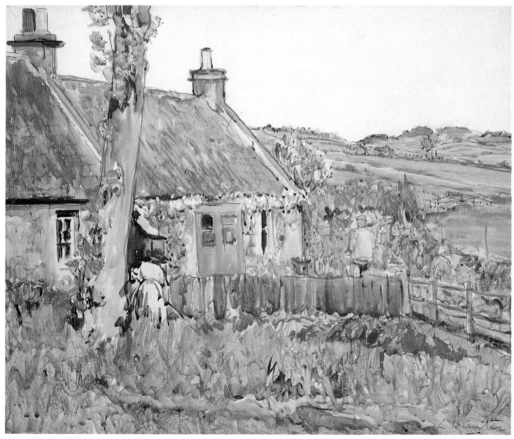

82. G Leslie Hunter *Harbour in Fife* 1919 Watercolour 45.5 × 56
83. G Leslie Hunter *Near Largo* c.1919-20 Watercolour 61 × 51

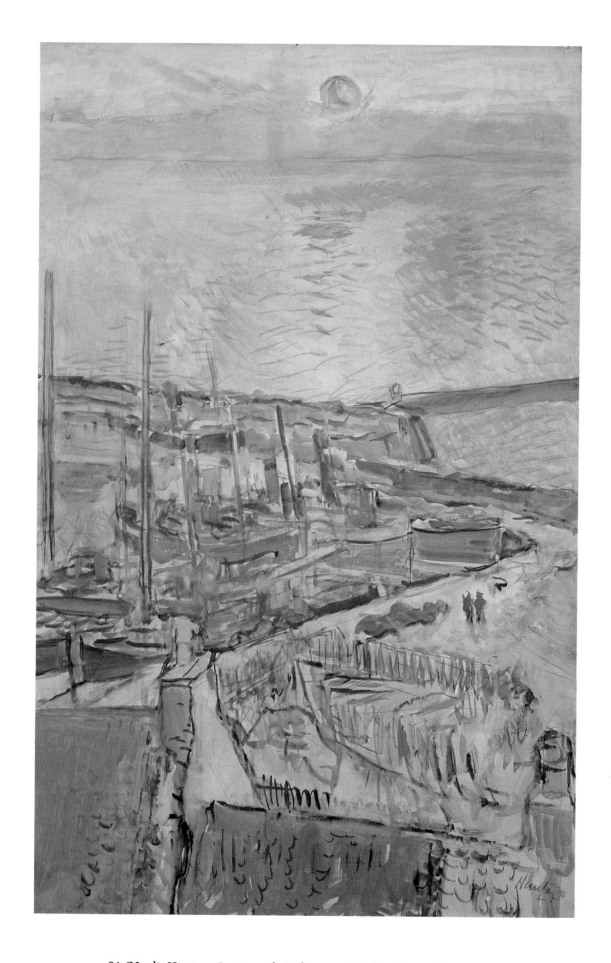

84. G Leslie Hunter *Sunrise over the Harbour* c.1919-20 Watercolour 75 × 50

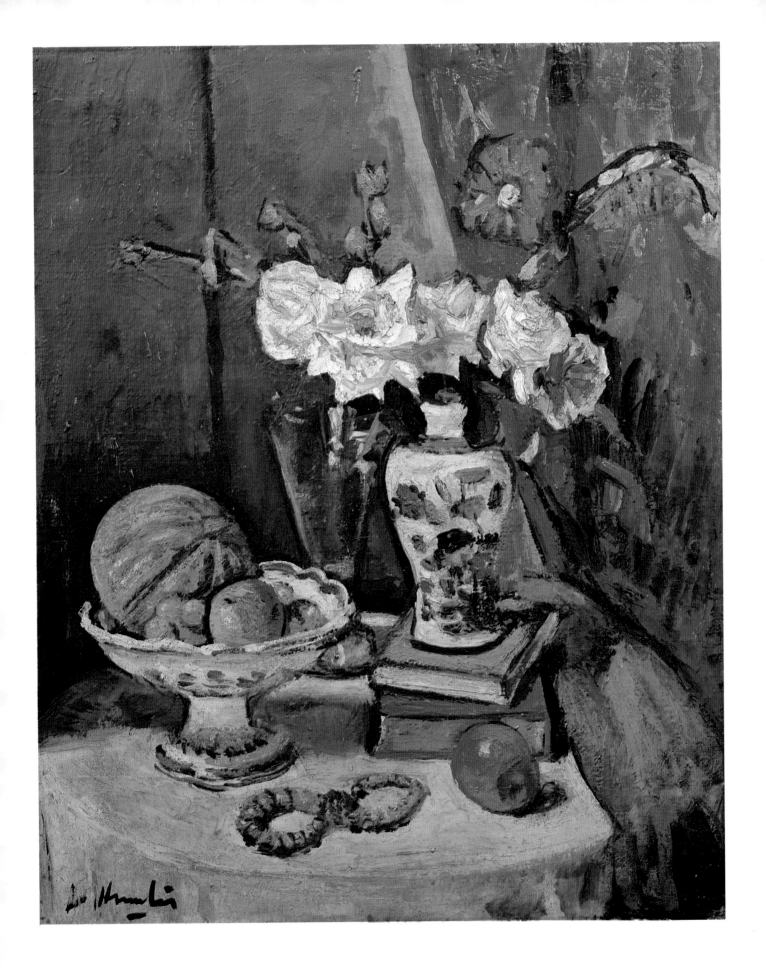

85. G Leslie Hunter *Still Life with Green Beads* c.1922-3 Oil on canvas 69 × 56

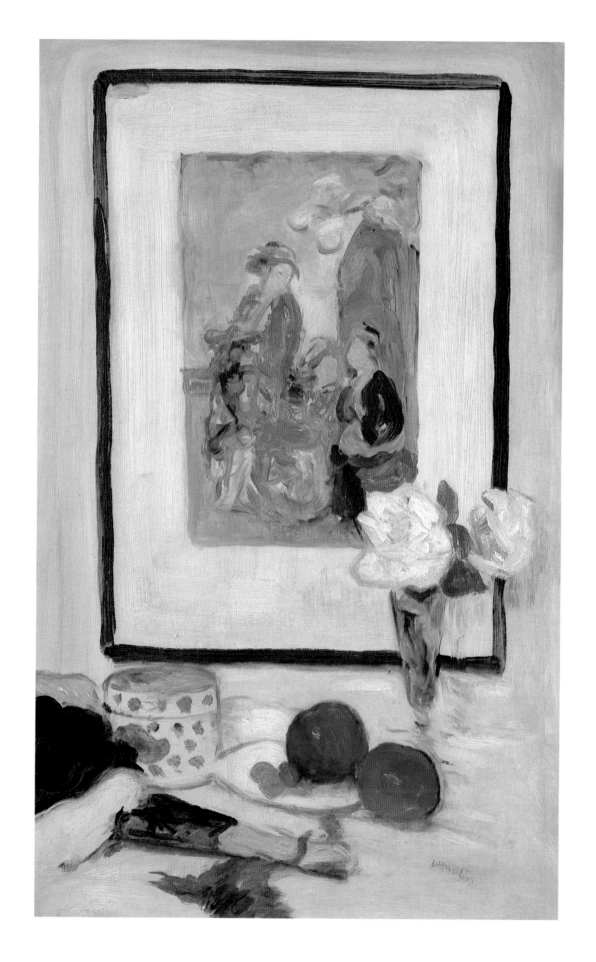

86. G Leslie Hunter *Still Life with Japanese Print* c.1922 Oil on panel 76 × 47

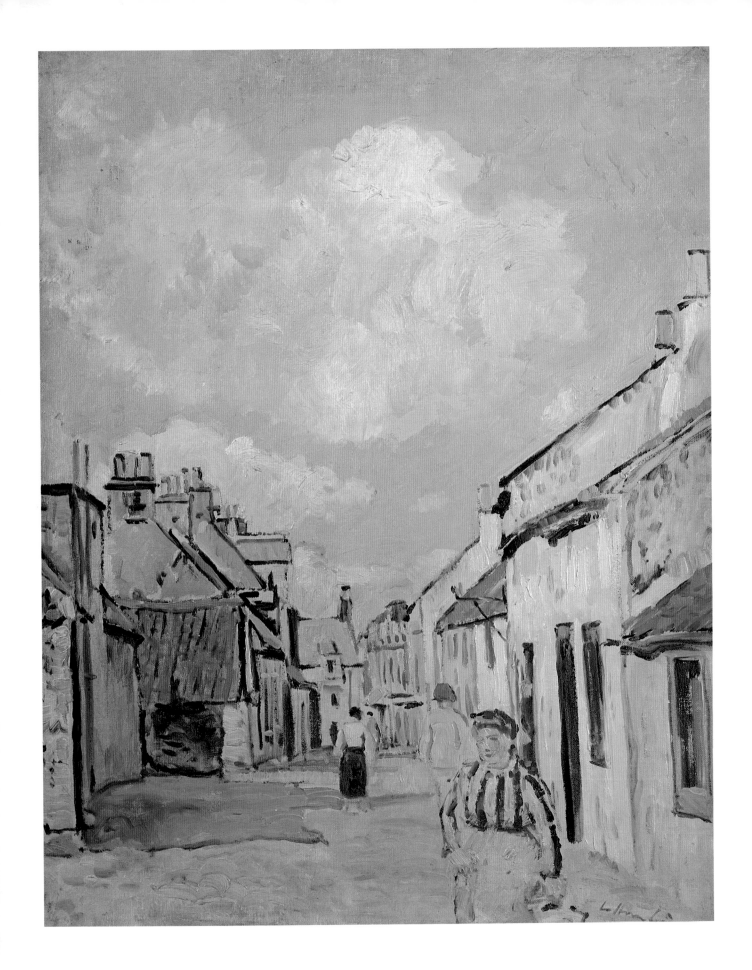

87. G Leslie Hunter *Largo, Fife* c.1920-22 Oil on canvas 63.5 × 21

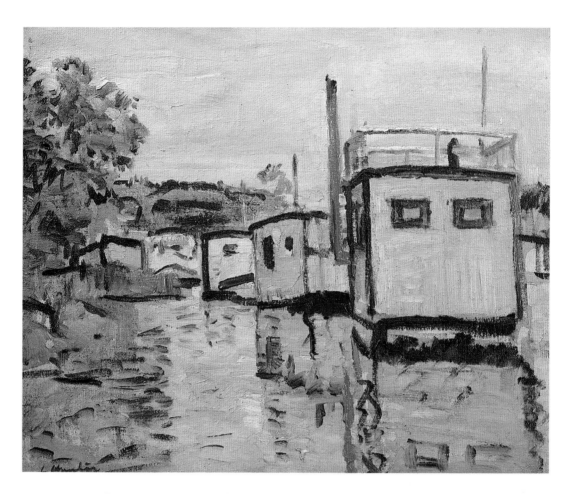

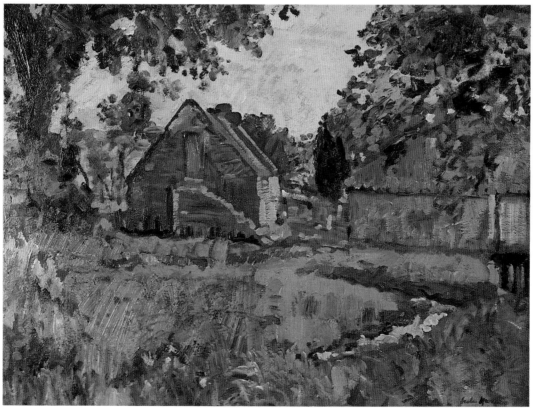

88. G Leslie Hunter *House Boats, Loch Lomond* 1924 Oil on canvas 38 × 46
89. G Leslie Hunter *Farm Buildings, Fife* 1925 Oil on canvas 49.5 × 67

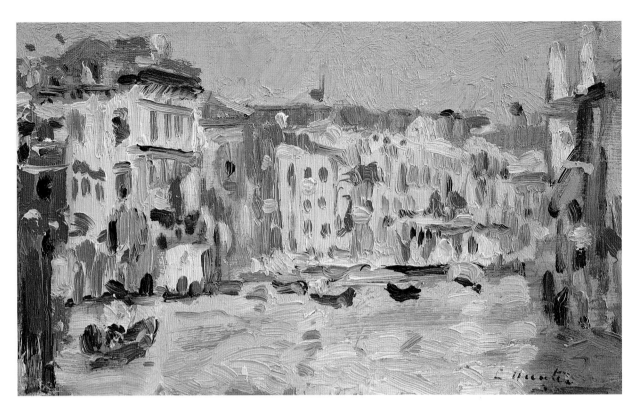

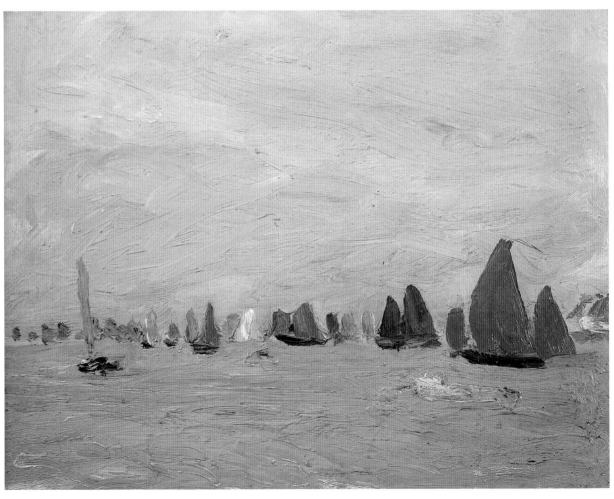

90. G Leslie Hunter *Grand Canal, Venice* c.1922-3 Oil on panel 13.5 × 21
91. G Leslie Hunter *Fishing Boats off Largo* 1923 Board 20 × 25

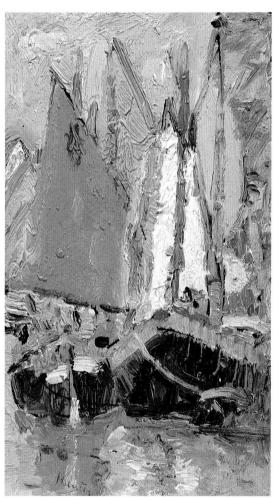

92. G Leslie Hunter *Doge's Palace, Venice* c.1922-4 Panel 12 × 20
93. G Leslie Hunter *Sails, Venice* c.1922-4 Panel 21 × 12

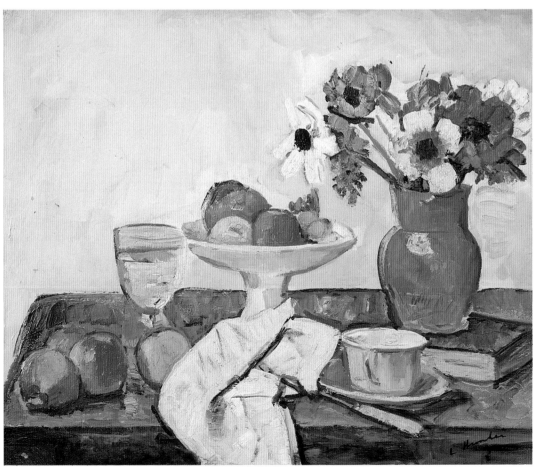

94. G Leslie Hunter *Still Life with Lobster* 1927 Watercolour 33 × 46
95. G Leslie Hunter *Still Life with Tea Cup* c.1926 Oil on canvas 61 × 51

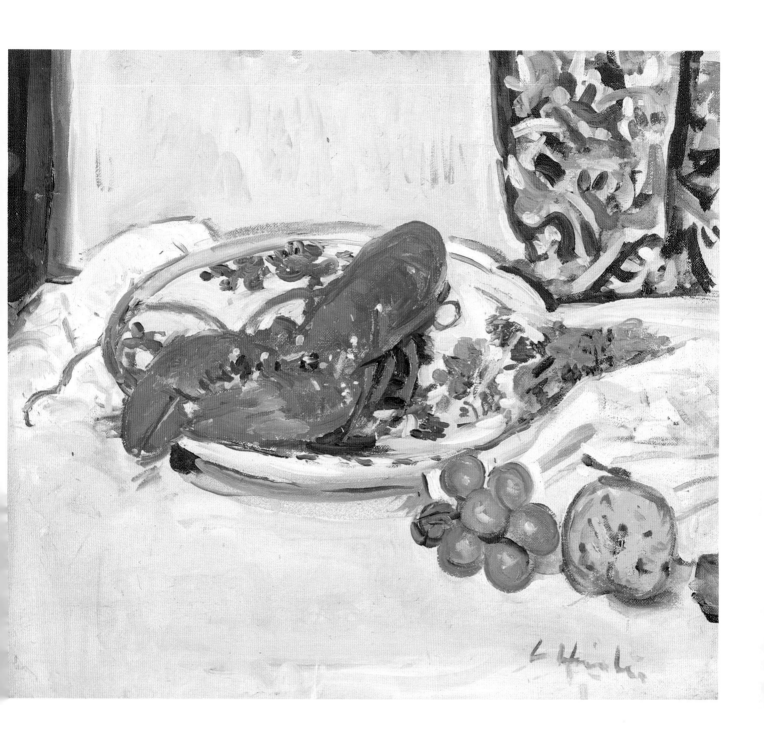

96. G Leslie Hunter *Still Life – Lobster on a Blue and White Plate* 1927 Oil on canvas 35.5 × 40.5

97. G Leslie Hunter *Café, Cassis* 1927 Watercolour 40 × 45
98. G Leslie Hunter *Juan-les-Pins* 1927 Watercolour 35 × 30

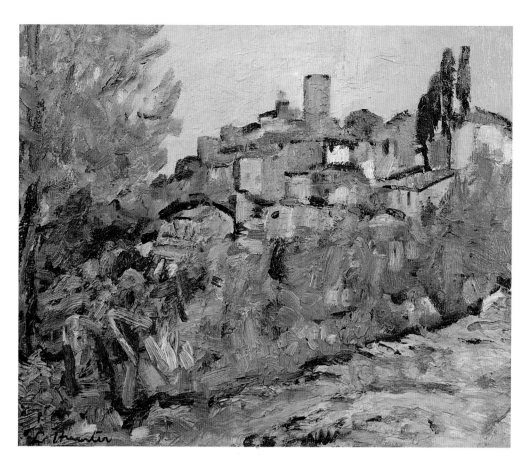

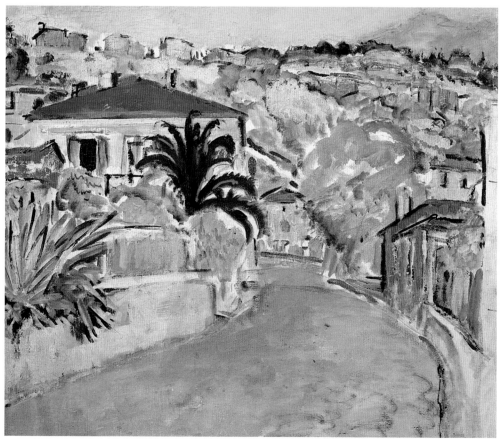

99. G Leslie Hunter *St Paul from the Colomne d'Or* 1927 Oil on canvas 53 × 64
100. G Leslie Hunter *Alpes Maritimes* 1929 Oil on canvas 45 × 54

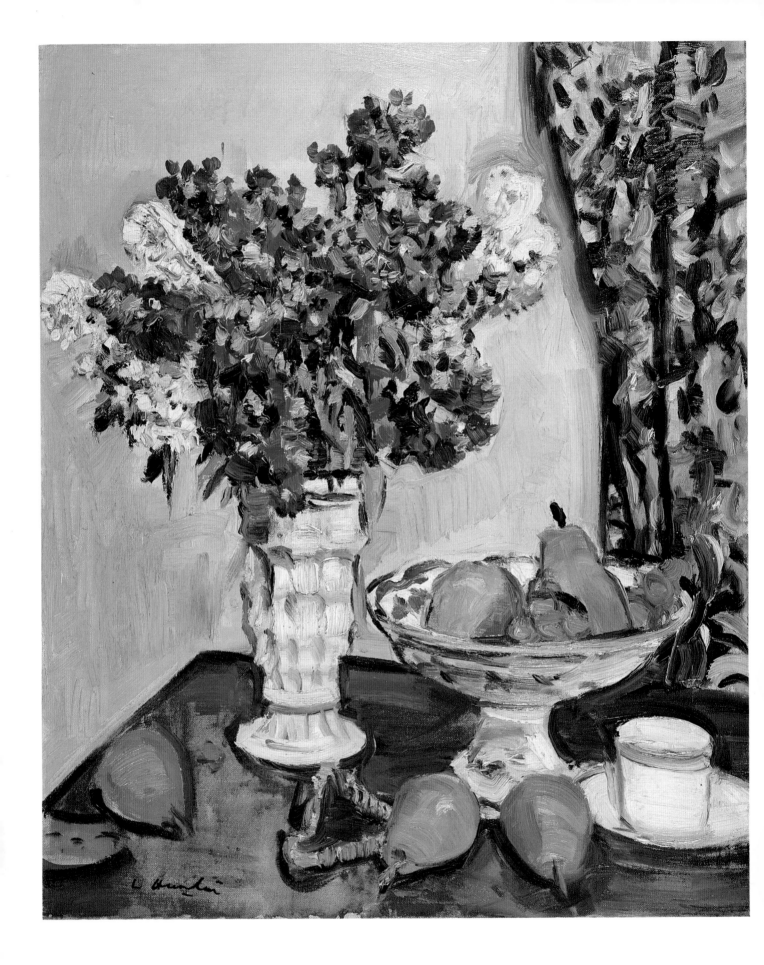

101. G Leslie Hunter *The White Vase* c.1930 Oil on canvas 61 × 51

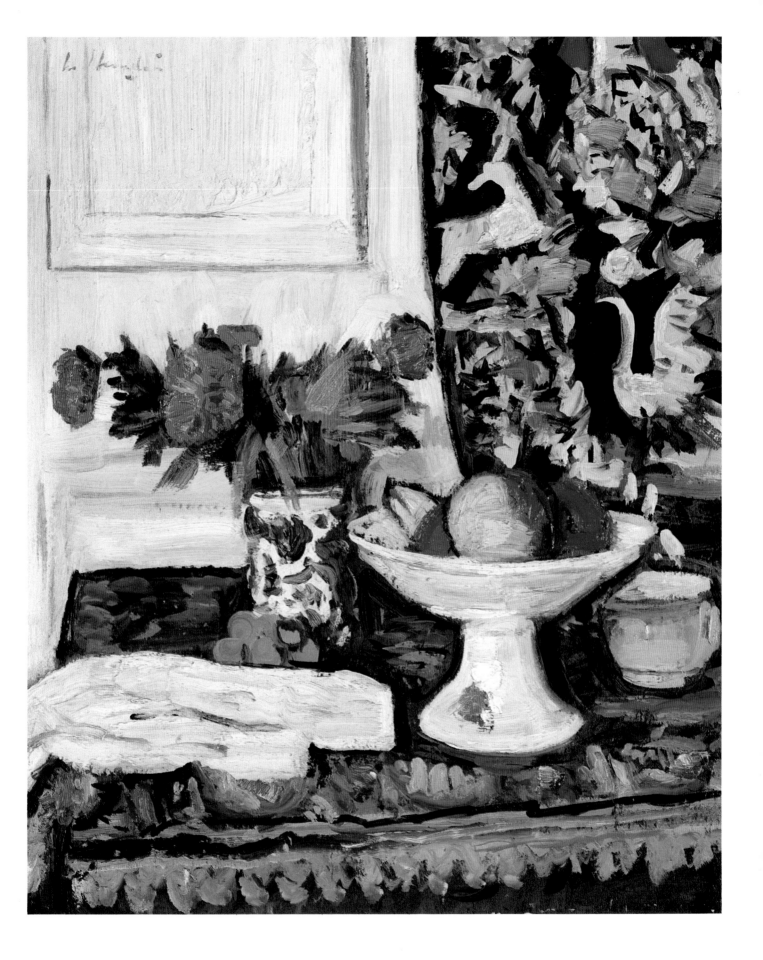

102. G Leslie Hunter *Still Life with Fruit and Marigolds in a Chinese Vase* c.1928 Oil on canvas 59.5 × 49.5

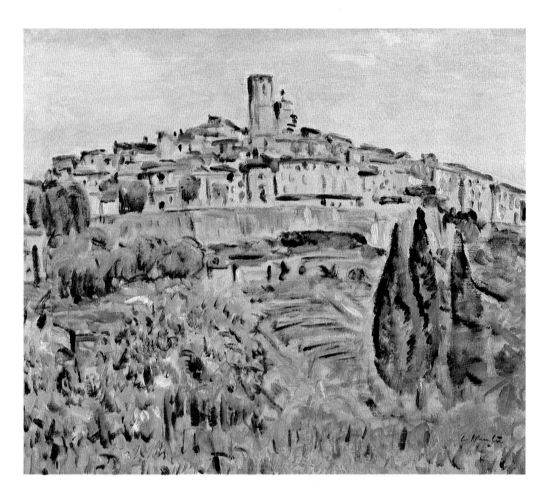

103. G Leslie Hunter *St Paul* 1929 Oil on canvas 56 × 66
104. G Leslie Hunter *Rotten Row, Hyde Park, London* 1931 Watercolour 45 × 58.5

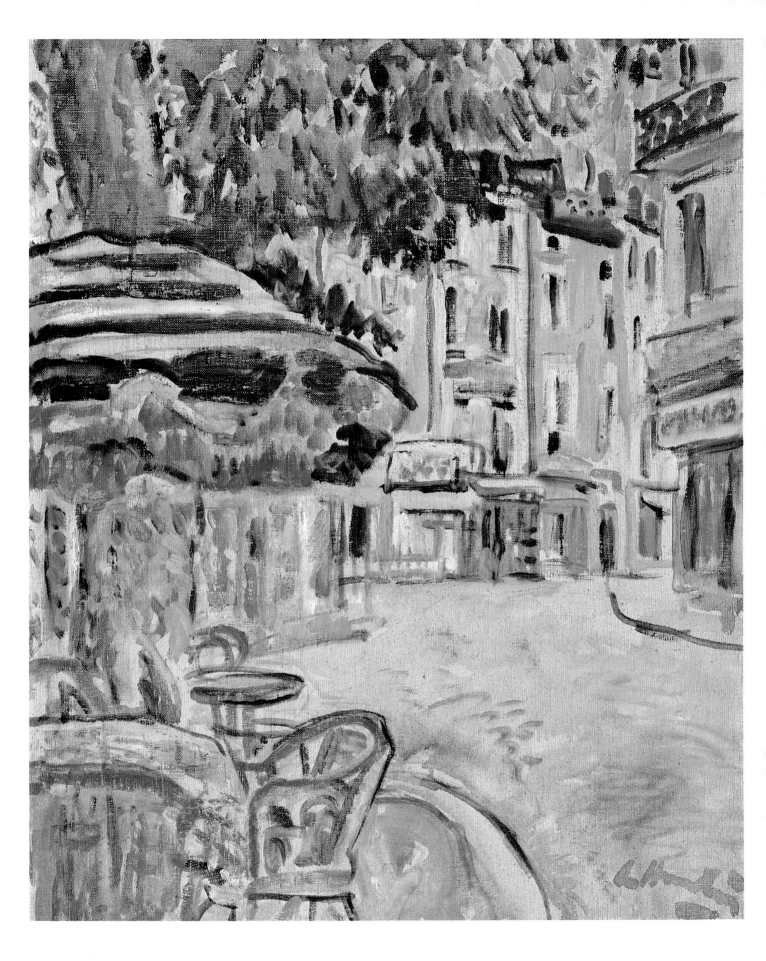

105. G Leslie Hunter *Café Corner, South of France* 1927 Oil on canvas 61 × 51

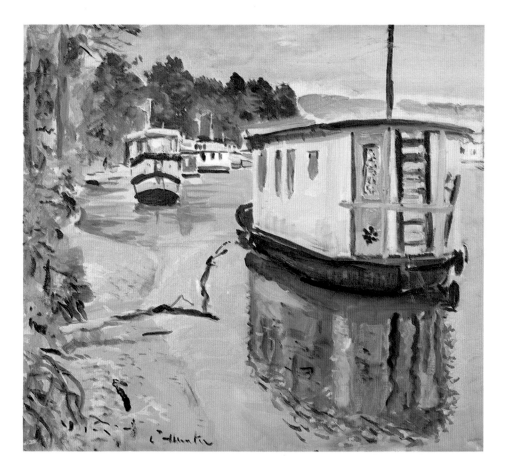

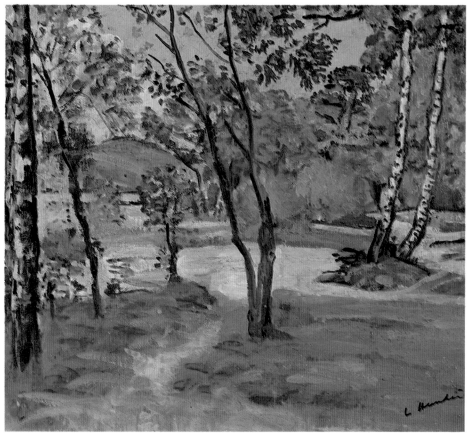

106. G Leslie Hunter *House Boats, Loch Lomond* 1930 Oil on canvas 51 × 61
107. G Leslie Hunter *Loch Lomond* 1930 Oil on canvas 44 × 50.5

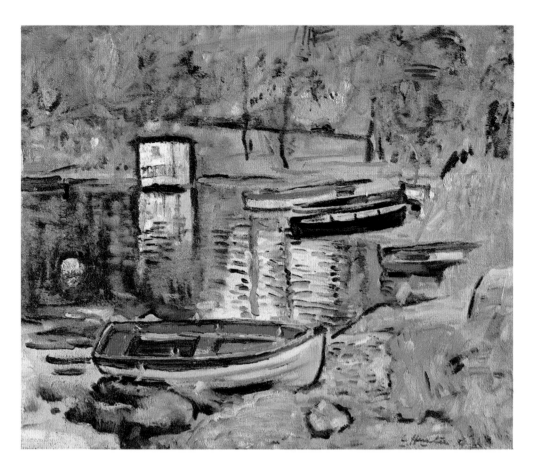

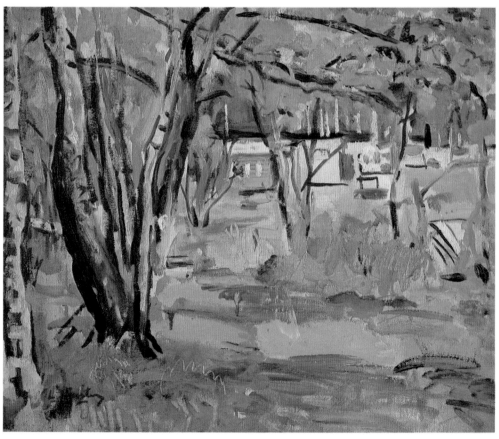

108. G Leslie Hunter *Boat, Loch Lomond* 1930 Oil on canvas 57 × 71
109. G Leslie Hunter *Loch Lomond* 1930 Oil on canvas 51 × 61

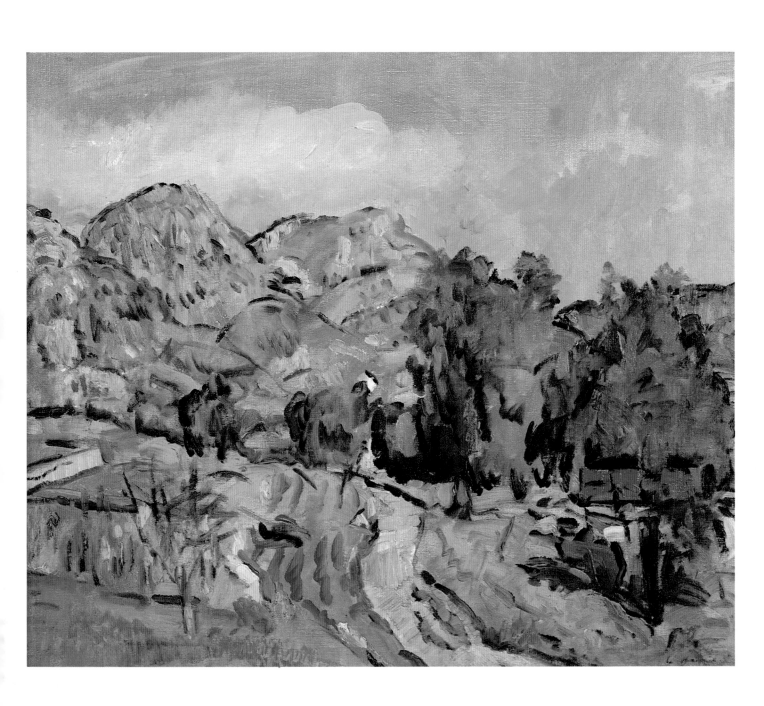

110. G Leslie Hunter *Provençal Landscape* 1929 Oil on canvas 57 × 70

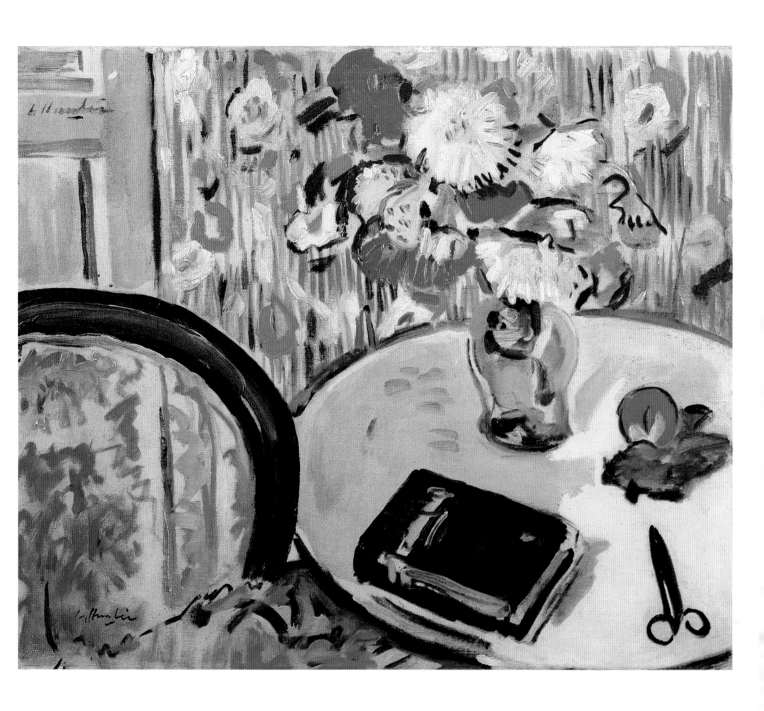

111. G Leslie Hunter *Still Life with Chair and Vase of Flowers* c.1930 Oil on canvas 53 × 63

112. F C B Cadell *Boy in a Pink Jersey* c.1919-20 Oil on canvas 76 × 51

113. F C B Cadell *Harvest on the Croft* 1923 Oil on panel 38 × 46
114. F C B Cadell *Cattle on the Shore, Iona* c.1925-6 Oil on Board 38 × 45.5

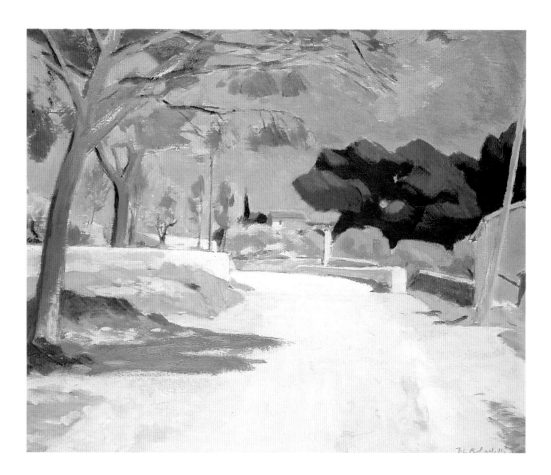

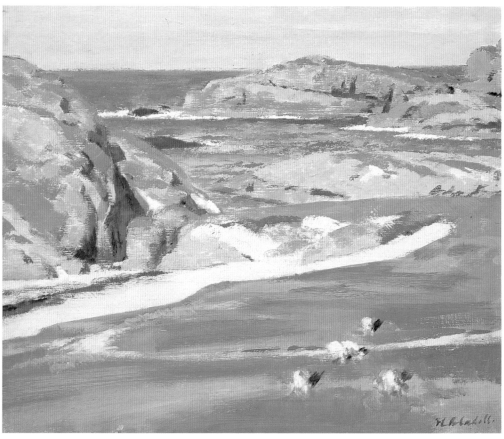

115. F C B Cadell *A Road near Cassis* 1924 Oil on panel 38 × 46
116. F C B Cadell Port Bhan, Iona 1925/6 Board 38 × 45.5

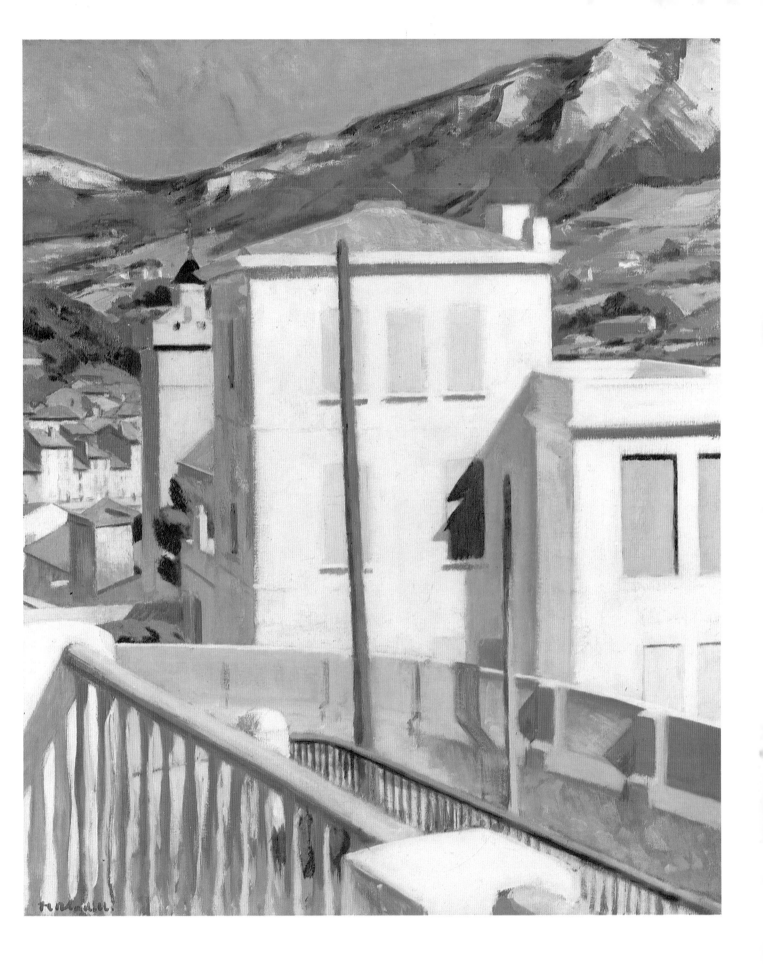

117. F C B Cadell *From the Balcony, Cassis* 1924 Oil on canvas 76 × 63.5

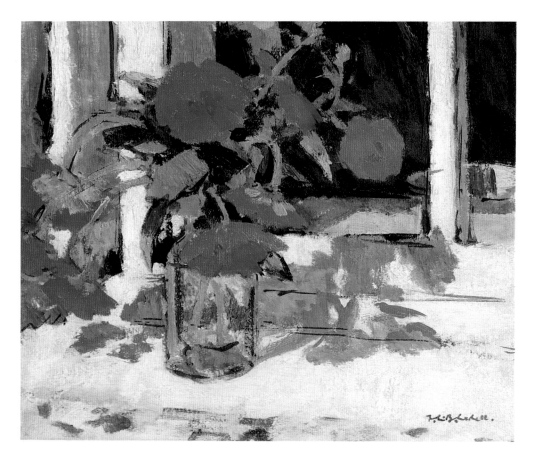

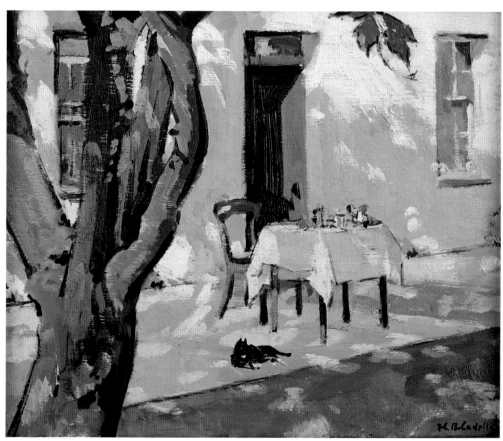

118. F C B Cadell *Marigolds* c.1924 Oil on panel 37.5 × 45
119. F C B Cadell *The Breakfast Table, Auchnacraig, Mull* 1927 Oil on board 38 × 45.5

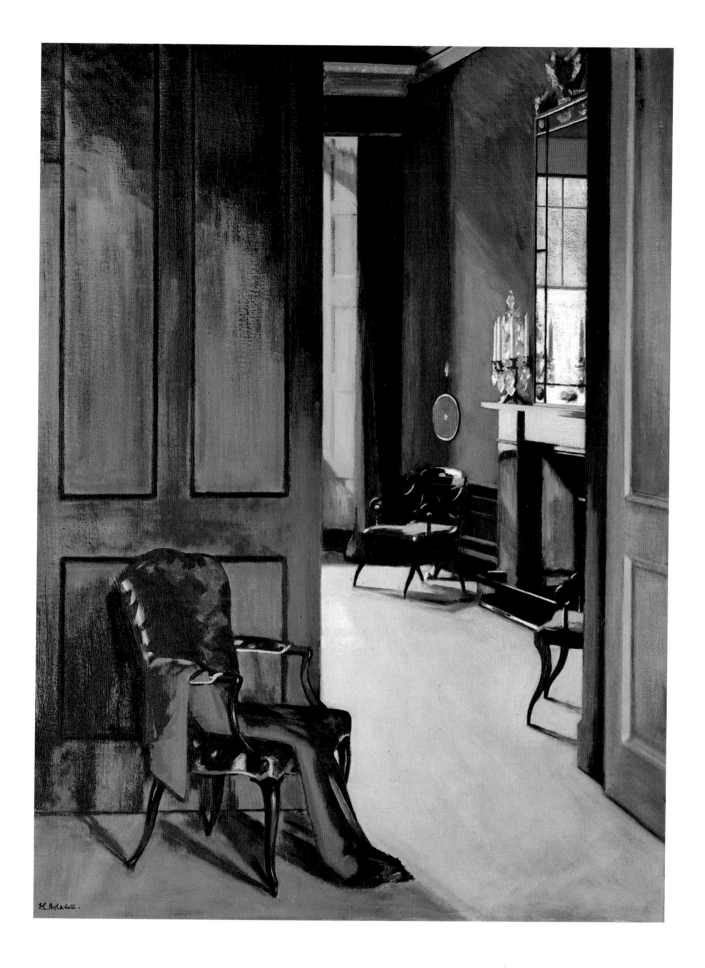

120. F C B Cadell *Interior with Opera Cloak* c.1924 Oil on canvas 101.5 × 76

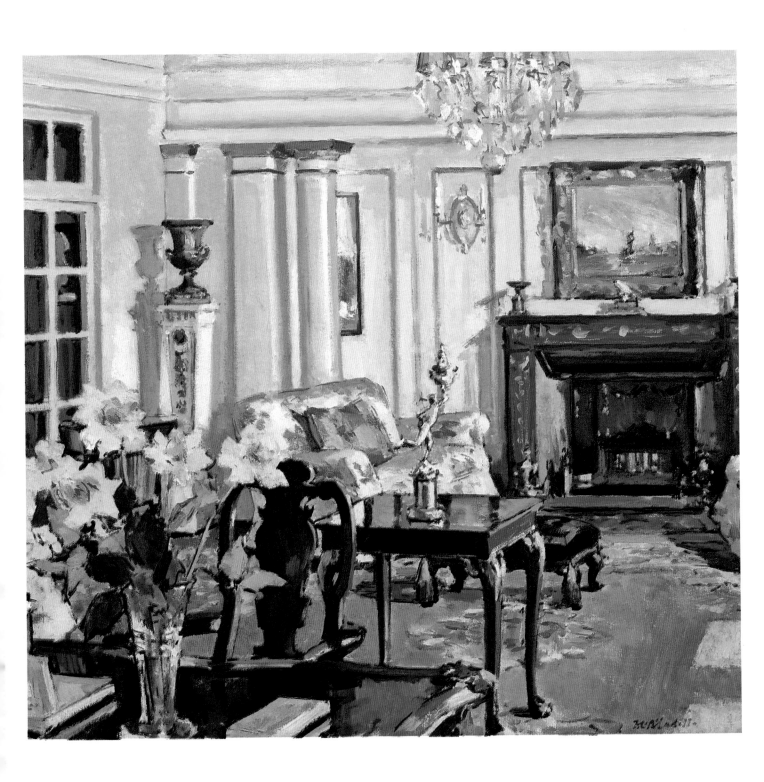

121. F C B Cadell *The Drawing Room, Croft House* 1932 Oil on canvas 63.5 × 76

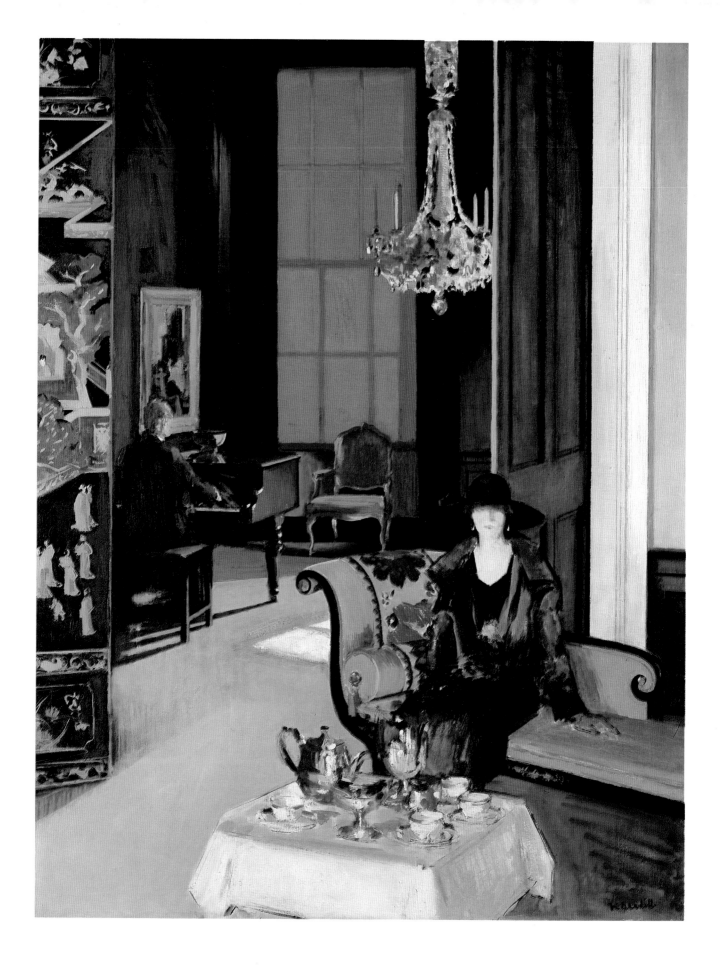

122. F C B Cadell *Interior: the Orange Blind* c.1927 Oil on canvas 112 × 86.5

123. F C B Cadell *Pink Azaleas* 1927 Oil on canvas 61 × 46

124. F C B Cadell *A Lady in Black* c.1925 Oil on canvas 101.5 × 76

125. S J Peploe North End, Iona c.1929 Oil on canvas 46 × 56
126. S J Peploe Ben More, Mull, from Iona c.1925–6 Oil on canvas 63.5 × 76.5

127. J D Fergusson *The Drift Posts* 1922 Oil on canvas 54.5 × 59.5
128. J D Fergusson *A Puff of Smoke near Milngavie* 1922 Oil on canvas 61 × 56

129. S J Peploe *A Vase of Pink Roses* c.1925 Oil on Canvas 60 × 51

130. J D Fergusson *Megalithic* 1931 Oil on canvas 92 × 73

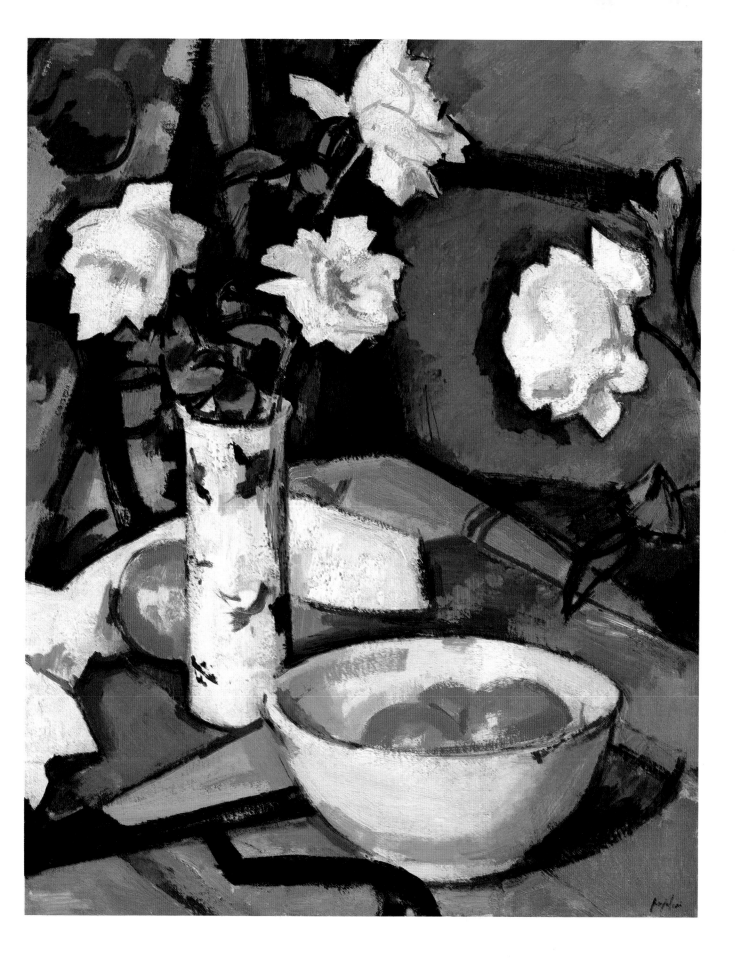

131. S J Peploe *Still Life with Roses* c.1925 Oil on canvas 50.8 × 40.6

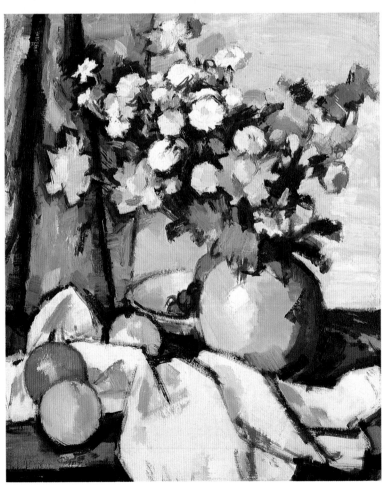

132. S J Peploe *Trees, Antibes* 1928 Oil on canvas 63.5 × 76.2

133. S J Peploe *Michaelmas Daisies and Oranges* c.1927 Oil on canvas 61 × 50.8

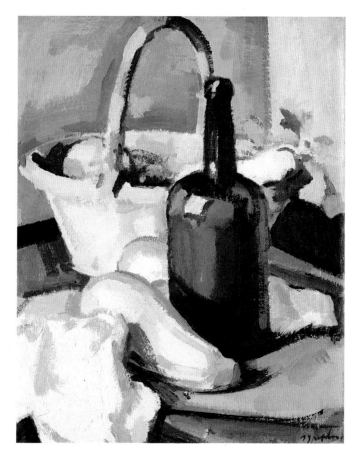

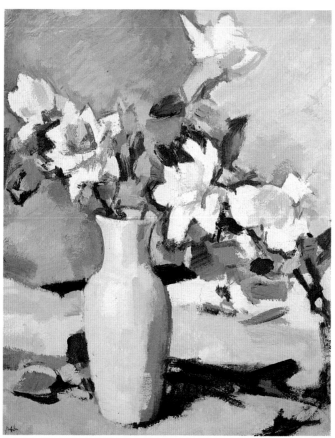

134. S J Peploe *The Black Bottle* c.1930 Oil on canvas 62 × 51
135. S J Peploe *Roses* c.1926 Oil on canvas 51 × 40.5

136. J D Fergusson *Eastra, Hymn to the Sun* 1924 Brass 41 high

The Plates

All measurements are in centimetres, height × width. Unless otherwise stated all watercolours, drawings and pastels are on white paper.

1. J D Fergusson
Jean Maconochie c.1902
Oil on canvas 60.5 × 50.5
Robert Fleming Holdings Ltd

Many of Fergusson's earliest paintings are studies of friends and family in Edinburgh. He was particularly attracted by the fashion for large hats and this is one of the finest of an early series of such studies

2. J D Fergusson
The Ha'Craig Aberdour 1900
Watercolour 38 × 43
Private Collection

Fergusson painted often in Fife before and after discovering the French coast, where he was to work most summers after 1896.

3. S J Peploe
Comrie c.1902
Oil on panel 24 × 32
Private Collection

Peploe's sister lived in Comrie and he and Fergusson visited the small town on a number of occasions in the early years of the century. Some hint of more pure colour first began to appear in these Perthshire landscapes

4. J D Fergusson
In the Garden 1902
Oil on board 14 × 10.5
Private Collection

5. J D Fergusson
Princes Street, Edinburgh 1902
Oil on board 11 × 13.5
Private Collection

6. J D Fergusson
Jenner's, Princes Street, Edinburgh
Oil on board 14 × 11
Private Collection

7. J D Fergusson
Stanley's, Princes Street, Edinburgh 1902
Oil on board 11 × 14
Private Collection

Fergusson made himself a small slotted box in which he could carry a tiny palette and a supply of panels on which to paint. In Edinburgh his favourite painting grounds were the gardens alongside Princes Street. These impressionistic sketches were the kind of exercise that Lavery had set himself twenty years earlier on the advice of Bastien-Lepage

8. J D Fergusson
Girl on a Bicycle c.1902
Oil on board 14 × 10.5
Private Collection

9. J D Fergusson
Carnations and Narcissus 1903
Oil on board 35 × 27
Private Collection

Peploe's success as a painter of still-life was perhaps a spur to Fergusson who, from 1903 to 1907 produced a series of similar compositions where the influence both of his friend and their joint mentor, Manet, can clearly be seen

10. J D Fergusson
Jonquils and Silver c.1904
Oil on canvas 49 × 43
Robert Fleming Holdings Ltd

11. S J Peploe
Evening, North Berwick 1903
Oil on panel 16 × 24
Glasgow Art Gallery and Museum

The coastal town of North Berwick had attracted Peploe to it since about 1897. It offered a quality of light that he had previously only found in the western isles, and which he was to recapture on his visits to France with Fergusson after 1904

12. S J Peploe
Landscape, Barra c.1903
Oil on canvas
Kirkcaldy Museum and Art Gallery

Peploe had first visited the island of Barra in the late 1890s. This later painting shows how free his landscape work had become, in contrast to the tighter, more controlled still-life paintings of a similar date

13. J D Fergusson
Paris-Plage c.1907
Panel 24 × 19
Private Collection

Gradually Fergusson's paintings became brighter, with a greater use of white, perhaps suggested by Peploe who had by this time lightened his own palette in his new studio in York Place, Edinburgh

14. S J Peploe
Paris Plage 1907
Oil on panel 19 × 24
Private Collection

The light of Paris-Plage seems to have freed Peploe from the restraints which Scotland seemed to impose on him. In this little sketch he shows himself to be capable of greater freedom and intuitive handling than his friend Fergusson

15. S J Peploe
Still Life with Coffee Pot c.1904-5
Oil on canvas 51 × 61
Lord and Lady Irvine

Peploe's experiments with a dark background in his still-life paintings came to fruition around 1904-5. These are paintings where the emphasis is on tonal relationships and the fluidity of handling suggests a spontaneity which belies the static subject-matter

16. S J Peploe
Pink Roses and Fruit c.1905
Oil on panel 16.5 × 24
Private Collection

Peploe made a large number of studies of each of his still-life arrangements before embarking on the larger, more considered paintings

17. S J Peploe
Roses in a Blue Vase, Black Background c.1904-5
Oil on canvas 40.6 × 45.7
Private Collection

18. J D Fergusson
Afternoon Coffee c.1904
Oil on board 35.5 × 28
Professor & Mrs Ross Harper

There is a marked loosening of handling and a more ambitious composition in this painting which reflects the advances that Peploe was achieving in still-life at this time. Unlike most of Peploe's compositions, however, the field of view is widened to show the artist's studio, anticipating the series of similar works painted by Cadell after 1911

19. S J Peploe
Interior with Roses in a Vase on a Table c.1906-7
Oil on canvas 15 × 12
Lord and Lady Irvine

Peploe's new studio at 32 York Place was much airier and brighter than his earlier studios and it encouraged him to use brighter colours,

predominantly white, pale grey and pink. Black still had its part to play, however, and many of his paintings from the period 1905-9 have an elegance inspired by the subtle play of black, white and the half-tones in between. Still-life formed the greatest part of his output around 1905-6 but gradually Peploe began to paint more and more figure studies

20. S J Peploe
Still Life with Coffee Pot 1905
Oil on canvas 61 × 82.5
Private Collection

Just before he left his studio in Devon Place Peploe produced a series of two or three larger still-life paintings which re-assessed what he had learned from the earlier studies. The white table-cloth is countered by the dark background and the whole composition continues in a counterpoint of light and dark, tone and colour, line and sphere. This is Peploe's most important and successful painting to date and it established him in Edinburgh as one of the most promising painters of his generation

21. J D Fergusson
Dieppe, 14th July 1905: Night
Oil on canvas 76.5 × 76.5
Scottish National Gallery of Modern Art

Whistler was one of the most important references for Fergusson at this date. He probably saw the large Memorial Exhibition in 1905, either in Paris or London, which included several of Whistler's firework nocturnes. This painting is Fergusson's homage to Whistler and was the most ambitious work he had so far produced. The man in grey, to the right of the group on the left, is S J Peploe who spent the summer of 1905 in France with Fergusson

22. S J Peploe
A Girl in White 1907
Oil on canvas 106.5 × 81
The Fine Art Society

Peploe's studio at York Place had been designed by Henry Raeburn, who had incorporated an elaborate system of shutters over the north-facing windows. By manipulating these the artist could create almost any quality of light within the studio and Peploe soon realised what an asset he had at his fingertips. Using a professional model, Peggy MacRae, he produced a superb series of figure studies, taking full advantage of Raeburn's clever devices. His brushwork became more and more fluid from 1905 and the influence of Whistler and Sargent more pronounced but in this study of Peggy he arrived at a style of his own in his most successful painting to date.

23. J D Fergusson
The Café in the Park c.1906-7
Oil on canvas 101 × 127
Private Collection

Fergusson had a retainer to produce illustrations of Paris life for an American magazine and this painting may well be based on one of the pencil and ink sketches he made around 1906-9. The rather conventional composition suggests an earlier rather than later date, and it could have been painted before Fergusson finally settled in Paris in the autumn of 1907

24. J D Fergusson
La Terrasse, Café d'Harcourt c.1908-9
Oil on canvas 108.6 × 122
Private Collection

The Café d'Harcourt, where Fergusson first met Middleton Murry and Katherine Mansfield, was one of his favourite painting grounds. The girls who worked for the local milliners would visit it at night wearing their latest creations and would often sit for the artists who had their own special tables. An unusually large painting for this date, Fergusson has broken the expanse of the canvas with large areas of colour – the pink of

the girl's dress, the white table-cloth – and has flattened the perspective to create a surface pattern rather than an illusion of recession

25. J D Fergusson
Boulevard Edgar Quinet c.1907-8
Oil on board 35.5 × 28
Professor & Mrs Ross Harper

Most of the paintings Fergusson made after moving to Paris were on a small scale and were often views of the streets and cafés close to his studio in the Boulevard Edgar Quinet

26. J D Fergusson
Pont des Arts, Paris 1907
Oil on board 19 × 24
Private Collection

27. J D Fergusson
Carantec c.1908-9
Oil on board 35 × 27
Private Collection

28 J D Fergusson
Grey Day, Paris Plage 1905
Oil on canvas 35.5 × 45.7
Glasgow Art Gallery and Museum

Painting in the open-air on the beach, Fergusson first began to develop his own particular style in the series of works painted at Paris-Plage in 1905. Although his palette remains primarily low in key there is a loosening of brushstroke and a more fluid handling. Fergusson's field of vision widened from the tighter views seen in the Edinburgh townscapes bringing with it a greater sense of space and movement

29. J D Fergusson
In the Sunlight c.1908
Oil on canvas 44 × 38.5
Aberdeen Art Gallery and Museum

The subject is said to have been a singer at the cafés and music-halls in Montparnasse which Fergusson frequented. Perhaps she was one of the milliners' girls who used to visit the Café d'Harcourt, wearing the large hats that they had borrowed for the evening from their workshops. The green shadows on the girl's face and the dynamic brushwork show how whole-heartedly Fergusson had adopted the Fauvist manner

30. J D Fergusson
The Pink Parasol: Bertha Case 1908
Oil on canvas 75 × 63
Glasgow Art Gallery and Museum

Bertha Case was one of the group of Anglo-American painters and writers whom Fergusson met in Paris. About this date Fergusson began to introduce the dark lines into his paintings, seen here around her face and neck, which he had seen in the work of Auguste Chabaud. Taken to extremes, this cloisonné effect heightened the sense of pattern in his paintings, already hinted at by the almost abstract backcloth behind the sitter

31. J D Fergusson
Closerie des Lilas 1907
Oil on panel 27 × 34
Hunterian Art Gallery, University of Glasgow

The woman in the foreground is Anne Estelle Rice, an American painter whom Fergusson met in Paris in 1907. Both the striking composition and the bold use of colour reflect Fergusson's new interest in Fauvist painting. Matisse had used green in the shadows on faces in several portraits and Fergusson has immediately realised how to put it to similar effect in one of his earliest paintings made after settling in Paris in 1907.

32. J D Fergusson
The Spotted Scarf – Anne Estelle Rice 1908
Canvas 51 × 45
Lord and Lady Irvine

This painting of Anne Estelle Rice is one of the most accomplished paintings that Fergusson ever made. Colour, brushwork and a clear design all combine in one of Fergusson's most sensitive portraits

33. S J Peploe
Park Scene 1910
Oil on panel 19 × 24
Kirkcaldy Art Gallery

The first paintings which Peploe made after he arrived in Paris in 1910 are predominantly cool in tonality, with a lot of white, pale blue, green and grey. They are a natural development from the 'white period' works which he had been painting in his York Placed Studio in Edinburgh. Almost all of them were painted in the streets and gardens of Montparnasse, following the example set by Fergusson in his works of 1907. In his rush to capture a particular effect of the light or incident in the spark, Peploe worked at great speed, with his brushstrokes becoming more and more fluid and impressionistic

34. J D Fergusson
Royan 1910
Oil on canvas 27 × 35
Hunterian Art Gallery, University of Glasgow

The emphasis on pattern and design within his compositions is clearly evident here in this study of the harbour at Royan. The shapes of the house – gable, roof, chimney, window – are simply stated against the linear arrangement of harbour wall, cliffs across the bay and the paths in the foreground. Compare this with Peploe's more impressionist treatment of the same scene (Pl 35)

35. S J Peploe
Royan 1910
Oil on board 29 × 33
Lord and Lady Irvine

Peploe and Fergusson spent the summer of 1910 at Royan, on the Atlantic coast of France. There is much more colour in the paintings of Royan than in the Paris subjects but Peploe has not yet adopted Fergusson's more mature style, with slabs of colour and a flattened perspective

36. S J Peploe
Street Scene, France c.1910
Oil on canvas 34 × 26.5
Private Collection.

Probably a view of a street in Royan

37. S J Peploe
The Luxembourg Gardens 1910
Oil on panel 35.5 × 28
Robert Fleming Holdings Ltd

On his return to Paris the brighter colours he had used at Royan began to appear in Peploe's new works. The brushwork became even more expressive, barely suggesting some of the shapes in the composition

38. J D Fergusson
At My Studio Window 1910
Oil on canvas 158 × 122.5
Fergusson Coll., Perth & Kinross Council

Figures painted *contre-jour* were a common pictorial device, but except for the woman's face there is little shading in this painting. The shapes of trees in the street outside and the curtains around the window blend together to echo elements of the figure painting, where the woman's body has been reduced to a few simple geometric shapes. Like *Rhythm* (Pl 41), this painting forms part of series of nude studies made between 1910 and 1912 where Fergusson experimented with line, colour and pattern to create a pictorial rhythm with a strong emotive impact

39. J D Fergusson
La Bête Violette 1910
Oil on canvas 77 × 77
Lord and Lady Irvine

Fergusson painted few still-lifes in Paris before 1910 but in this painting he brought together many of the themes which were beginning to intrigue him. The most important are pattern, pictorial rhythm and the emotive power of colour. Fergusson has created a circular motion in the composition, highlighted by the prancing beast on the shawl and echoed through the background arrangement of curtains, lamps and bowls. One of his most successful still-life paintings, it looks forward to the more abstract arrangements in *Rhythm* (Pl 41) and *At My Studio Window* (Pl 38)

40. J D Fergusson
Les Eus 1911–12
Oil on canvas 213 × 274
Fergusson Coll., Perth & Kinross Council

The Ballet Russe, which was performing regularly in Paris at this time, had a great effect on many painters and musicians in Paris. Matisse responded with his famous painting, *La Danse* (1910, Hermitage, Leningrad), and the pictorial challenge of dance and movement was answered by several other painters. Fergusson's response was *Les Eus*, the largest work he ever painted. The title, according to Fergusson, means 'The Healthy Ones' and even this first appearance of naked men alongside the women does little to detract from the asexual nature of the subject. It is a celebration of nature which we are witnessing, not some erotic ritual dance

41. J D Fergusson
Rhythm 1911
Oil on canvas 163 × 115.5
University of Stirling

The most static of all the paintings of female nudes which Fergusson painted between 1910 and 1912, *Rhythm* is also the most carefully composed. Fergusson had made a large number of sketches in trying to arrive at a design for the cover of Middleton Murry's magazine of the same title and through these he was able to explore many different possibilities before committing himself to canvas. The symbolism which had become apparent earlier in the series is here fully developed; the figure is stylised, both in form and pose and is surrounded by symbols of the endless rhythm of the seasons of nature.

42. S J Peploe
Ile de Bréhat 1911
Oil on panel
Private Collection

Peploe and Fergusson spent the summer of 1911 on the Ile de Bréhat, an artists' colony off the coast of Brittany. The first signs of a change in Peploe's work can be seen in the paintings of that summer, primarily a greater emphasis on pattern and a simplification of the perspective. The most obvious change, however, is in the brushwork, with Peploe adopting a nervous, repetitive stroke of pure colour which replaces the more fluid paint of the previous year's paintings at Royan and of the Luxembourg gardens paintings of the earlier part of 1911.

43. S J Peploe
Landscape at Cassis 1913
Oil on board 33 × 40.5
Private Collection

44. J D Fergusson
Cassis from the West 1913
Oil on board 26.5 × 35
Fergusson Coll., Perth & Kinross Council

Fergusson decided to leave Paris in 1913, to search for a new light and new subject-matter in the south of France. He eventually persuaded Peploe to accompany him and together the two painters explored the landscape around Cassis, revelling in an intensity of light that they had never before encountered

45. F C B Cadell
Jean Cadell at Dalserf House 1912
Oil on panel 38 × 46
Private Collection

A study of the artist's sister, Jean, who was later to become a well known actress

46. F C B Cadell
Sails, Venice 1910
Oil on panel 46 × 38
Private Collection

47. F C B Cadell
Gardens, Venice 1910
Oil on panel 46 × 38
Private Collection

The light and colour of Venice's squares and canals was a revelation to Cadell. Almost overnight, his palette and brushwork became much more lively and he produced a large number of hastily executed paintings, some of which, like this one, perfectly capture a momentary impression of life in the city

48. F C B Cadell
Reflections 1915
Oil on canvas 63.5 × 76
Private Collection

The model has adopted a very informal pose. The diagonals of her arms give Cadell the opportunity of creating a stylish composition, complicated by the reflections in the mirror of her head and the ellipse of the brim of her large hat

49. F C B Cadell
Carnations 1913
Oil on canvas 76 × 63.5
Robert Fleming Holdings

Cadell was fond of painting 'pictures within pictures'; Peploe and Hunter were also to play with the pun in several of their still-life paintings. Here Cadell has combined the two passions of his life, Iona and flowers in one of his most understated, and most successful, paintings of the period

50. F C B Cadell
The Black Hat 1914
Oil on canvas 107 × 84
City of Edinburgh Art Centre

The sitter is probably the unknown woman seen seated on the right of *Afternoon* (Pl 51). This is a much more formal painting than many of this date, without quite being a commissioned portrait. The sitter looks out of the canvas with an assured and confident air, elegantly dressed in the latest fashions in a harmony of fawn, black and white

51. F C B Cadell
Afternoon 1913
Oil on canvas 101.5 × 127
Private Collection

The largest and most elaborate of the series of pre-1915 interiors. It is a composite of a group of smaller studies – a still-life in the foreground, the seated woman posed in front of the fireplace, and the the two women on the right of the composition – each of which could have existed in its own right as a completed painting

52. F C B Cadell
Crème de Menthe 1915
Oil on canvas 107 × 84
McLean Art Gallery, Greenock

The sitter is almost certainly Peggy MacRae, who also appeared in several of Peploe's figure studies (see Pl 22). This is Cadell at his best, creating a stylish painting from an elegant subject. The rich black velvet jacket with its gold braid forms a foil to the brilliant red of the dress and flower in the girl's hair. Cadell's fascination with reflections is allowed full rein, with mirrored images of the sitter and flashes of light on the carafe and glasses. One of the most successful paintings of the period, elegant, accomplished and full of vitality.

53. F C B Cadell
Reflection: The Silver Coffee Pot
1913
Oil on canvas 51 × 61
Private Collection

54. F C B Cadell
Still Life with White Teapot 1913
Oil on canvas 48 × 61
Private Collection

Cadell's most personal works of this period were his still-life paintings. In two of them, *Still-Life with White Teapot* and *Reflections: the Silver Coffee Pot* he approached the peak of achievement that Peploe had so far reached in his paintings of around 1905 (see Pl 15, 20).

55. F C B Cadell
The White Interior 1914
Oil on canvas 63.5 × 76
Private Collection

This painting and *The White Room* use the human figure merely as a prop in the celebration of the elegance of the setting. More domestic in scale than *Afternoon* (Pl 51) there is a tightening of composition and an effective use of dabs of pure colour to counter the more tonal greys and whites

56. F C B Cadell
The White Room 1915
Canvas 63.5 × 76
Private Collection

57. F C Cadell
Man in a Sailor Cap: Staffa 1914
Watercolour 31 × 26
Private Collection

Possibly a study of George Service, the Glasgow ship owner who became Cadell's chief patron until about 1928. It was painted on a yacht near the island of Staffa in the summer of 1914

58. F C B Cadell
Still Life c.1915
Oil on canvas 63.5 × 76
Dundee Art Gallery and Museum

59. F C B Cadell
Reflections c.1915
Oil on canvas 117 × 101.5
Glasgow Art Gallery and Museum

60. J D Fergusson
The Blue Lamp 1912
Panel 66 × 57
Edinburgh City Art Centre

Fergusson used the same studio props in a series of still-lifes around 1910-13 – the blue oil lamp, the pink

box, the china jam-pot with a knobbed lid. They were usually painted without any real shadows, thus flattening the composition where the illusion of perspective had already been destroyed by the use of a patterned backcloth which echoed the shapes and colours of the objects in the foreground.

61. S J Peploe
Still Life c.1913
Oil on canvas 54.5 × 46.5
Scottish National Gallery of Modern Art

When this painting was exhibited in Edinburgh in 1913 it was described by a critic as 'cubistic'. Although undoubtedly aware of Cubist painting in Paris, Peploe never became an adherent of that movement. In this painting he has simplified the sense of space and perspective by suppressing shadows and isolating each object inside an outline of blue paint. Even the backcloth has been carefully chosen for its bold design to transfer the pattern made by the objects on the table into the background.

62. S J Peploe
Flowers and Fruit, Japanese Background c.1915
Oil on canvas 40.5 × 45.5
Kirkcaldy Art Gallery

Japanese prints, with their strong sense of design and slabs of bright colour, had been popular since the mid-19th century and many artists included images of them in their paintings. Peploe has used this print as a picture within a picture which reinforces our confusion about the reality of the subject, the perspective and the spatial relationships between the different objects within the composition

63. S J Peploe
Tulips in Two Vases 1912
Oil on canvas 47 × 56
Private Collection

One of the first of a series of still-life paintings in which Peploe experimented with a new way of representing pictorial space. The perspective is deliberately flattened, objects are encircled by lines of dark paint, and there is an emphasis on pattern and decorative line, as in the stems of the drooping tulips. The long repetitive brushstrokes recall some of Van Gogh's brushwork and even the colour seems hotter and more emotive, like that in several of Van Gogh's later paintings.

64. S J Peploe
Still Life with three Carnations c.1916
Oil on canvas 46 × 56
Private Collection

65. S J Peploe
Deep Red Roses c.1916
Oil on canvas 40.6 × 33
Private Collection

66. S J Peploe
Kirkcudbright c.1916
Oil on canvas 53 × 63
Private Collection

Kirkcudbright had been an artists' colony for over forty years when Peploe made his first visits about 1916. E A Taylor and Jessie King, whom he had met in Paris, and E A Hornel were the best known of its artist residents. In this painting the strong colour, applied in broad strokes, and flattened perspective recall Peploe's experiments with similar ideas in still-life painting

67. S J Peploe
Still Life with Fruit c.1918
Canvas 70 × 84.5
Private Collection

Cézanne was obviously very much in Peploe's mind when he painted a small group of still-lifes of fruit around 1917-18. They are often larger than the canvases he usually worked on, with dark backgrounds and rich colour in the fruit which is placed against a white cloth

68. J D Fergusson
A Lowland Church 1916
Oil on canvas 51 × 56
Dundee Art Gallery and Museum

Fergusson painted few pictures in Scotland after his return in 1914, although he did make a number of sculptures while staying with his mother in Edinburgh. This landscape looks forward to the series of twenty or so similar paintings inspired by a tour of the Highlands in 1922

69. J D Fergusson
Damaged Destroyer 1918
Oil on canvas 73.5 × 76
Glasgow Art Gallery and Museum

The bold shapes of cranes, chimneys and derricks frame the war-ships in the harbour at Portsmouth, where Fergusson spent a short time in 1918. He was obviously aware of some of the devices used by the Vorticists in their paintings, and while not whole-heartedly espousing their principles he has realised that these mechanistic shapes pass as acceptable metaphors in such unnatural surroundings as a naval dockyard in time of war

70. S J Peploe
Still Life with Tulips c.1919
Oil on Canvas 56 × 51
Private Collection

71. S J Peploe
Tulips and Fruit c.1919
Oil on canvas 58 × 48
Private Collection

72. S J Peploe
Pink Roses 1920
Oil on canvas 51 × 40.5
Glasgow Art Gallery and Museum

An unusual painting, where Peploe seems to have been experimenting to decide whether he should return to an earlier manner of still-life painting of about 1905

73. J D Fergusson
Margaret Morris dans le Chant Hindu de Rimsky-Korsakov 1918
Oil on canvas 44.5 × 47.5
Fergusson Coll., Perth & Kinross Council

74. S J Peploe
Still Life, Roses and Books c.1920
Oil on canvas 73.7 × 60
Private Collection

75. G Leslie Hunter
A Peeled Lemon c.1910
Oil on board 30.5 × 24
Private Collection

76. G Leslie Hunter
Chrysanthemums c.1908
Oil on canvas 70 × 56
Private Collection

One of the earliest surviving oil paintings by Hunter, it shows the influence on him of Dutch and French flower and still-life painting

77. G Leslie Hunter
Etaples 1914
Oil on board 28 × 35.5
Private Collection

Hunter came closest so far to the work of the other Colourists in this small study made on the beach at Etaples. The strength of colour and rapidity of execution recall similar paintings of the beaches at Royan and Paris-Plage by Fergusson and Peploe of 1910 and earlier

78. G Leslie Hunter
Still Life with Blue and White Jar c.1920
Oil on canvas 55 × 50
Private Collection

Hunter's brushwork began to assume a more nervous look in the early 1920s. The colour in his still-lifes is now more consistently strong, reflecting the wider range of hue used in the Fife landscapes of the same period

79. G Leslie Hunter
Still Life c.1918
Oil on canvas 51 × 61
Dundee Art Gallery and Museum

Hunter became confident enough to occasionally break away from the formula he had devised for still-lifes, as in this much more vibrant study of c.1918. A more dynamic composition and lively brushwork point to new developments, although the dark background of many earlier works is still retained.

80. G Leslie Hunter
Still Life: Rose, Lemon and Fruit c.1917
Oil on canvas 46 × 38
Private Collection

81. G Leslie Hunter
The Green Table-cloth c.1920
Oil on canvas 76 × 51
Glasgow Art Gallery and Museum

82. G Leslie Hunter
Harbour in Fife 1919
Watercolour 45.5 × 56
Private Collection

Hunter first visited Fife in 1919, searching for a quality of light that would remind him of California. Most of his best work from this first visit is in watercolour, a medium that he always handled well, probably due to his early career as an illustrator. He uses it in a very un-English manner, not as a transparent medium but more as if it were oil paint. The colour is strong, the brushstrokes gestural, and the pictures have a pronounced emphasis on line and pattern

83. G Leslie Hunter
Near Largo c.1919-20
Watercolour 61 × 51
Private Collection

84. G Leslie Hunter
Sunrise over the Harbour c.1919-20
Watercolour 75 × 50
Private Collection

85. G Leslie Hunter
Still Life with Green Beads c.1922-3
Oil on canvas 69 × 56
Private Collection

A very painterly handling has lifted this still-life out of the usual format. It is one of the more ambitious and successful of the paintings from the first half of the decade, in contrast to the painting on the back of the canvas, which was a view of the Doge's Palace, worked-up from the little sketch (Pl 92), which Hunter had cast aside

86. G Leslie Hunter
Still Life with Japanese Print c.1922
Oil on panel 76 × 47
Private Collection

A rare example of Hunter using a pale background for a still-life, this painting is one of his most successful of the early 1920s. Hunter had a small collection of Japanese prints, one of which forms the background in this composition

87. G Leslie Hunter
Largo, Fife c.1920-22
Oil on canvas 63.5 × 21
Private Collection

Hunter painted a number of views of the streets of Largo and other villages on the east coast of Fife. They are unusual in their inclusion of several figures in the paintings, which rarely appear in any of his Loch Lomond or French landscapes, and the idea was not repeated until his series of drawings of Rotten Row made in 1931

88. G Leslie Hunter
House Boats, Loch Lomond 1924
Oil on canvas
Private Collection

Hunter's search for a more inspirational light in Scotland took him next to Loch Lomond, just outside Glasgow. The paintings produced on his first visit there (he returned in 1930) are often characterised by an agitated handling, with the paint being repeatedly

worked on the canvas, giving the surface a rather wrinkled quality

89. G Leslie Hunter
Farm Buildings, Fife 1925
Oil on canvas 49.5 × 67
Private Collection

90. G Leslie Hunter
Grand Canal, Venice c.1922-3
Oil on panel 13.5 × 21
Private Collection

91. G Leslie Hunter
Fishing Boats off Largo 1923
Board 20 × 25
Private Collection

92. G Leslie Hunter
Doge's Palace, Venice c.1922-4
Oil on panel 12 × 20
Glasgow Art Gallery and Museum

Hunter first visited Venice in 1922 and returned again the following year. He made a number of studies on small panels, mainly of the Doge's Palace, St Mark's Square and of the boats cruising up and down the canals or just moored together at the quayside. All of these were painted very quickly, with very bright colour and a dashing stroke, for use as studies for bigger paintings. Few of the latter were completed, however, and those that were were often rejected by the artist (Pl 85 is painted on the back of a larger version of this study).

93. G Leslie Hunter
Sails, Venice c.1922-4
Panel 21 × 12
Glasgow Art Gallery and Museum

The creamy paint that Hunter used in these little studies can be seen clearly in this little study of moored barges

94. G Leslie Hunter
Still Life with Lobster 1927
Watercolour 33 × 46
Private Collection

95. G Leslie Hunter
Still Life with Tea Cup c.1926

Oil on canvas 61 × 51
Private Collection

96. G Leslie Hunter
Still Life – Lobster on a Blue and White Plate 1927
Oil on canvas 35.5 × 40.5
Private Collection

This and Pl 94 are two very different studies of the same subject which show Hunter's approach to both oil and watercolour on his first visit to St Paul in 1927

97. G Leslie Hunter
Café, Cassis 1927
Watercolour 40 × 45
Private Collection

98. G Leslie Hunter
Juan-les-Pins 1927
Watercolour 35 × 30
Private Collection

Hunter made hundreds of these quick and colourful sketches shortly after he arrived in the south of France. They allowed him to make an immediate reaction to the light and colour of the landscape before committing himself to canvas

99. G Leslie Hunter
St Paul from the Colomne d'Or 1927
Oil on canvas 53 × 64
Private Collection

The thicker impasto of the Fife landscapes would occasionally reappear in the French paintings as Hunter struggled to achieve a particular effect

100. G Leslie Hunter
Alpes Maritimes 1929
Oil on canvas 45 × 54
Private Collection

Hunter produced some of the most successful work of his career on his second visit to St Paul in 1929. It is fresh and vibrant in both colour and handling and assured in composition

101. G Leslie Hunter
The White Vase c.1930

Oil on canvas 61 × 51
Private Collection

After his return from France in 1929 Hunter was encouraged by his friend Tom Honeyman to concentrate on still-life painting. Honeyman was then working for Alex Reid and he knew that he could sell these paintings and thus assure Hunter of a steady income. Over a dozen of these large and ambitious paintings were produced, all containing flowers which Hunter loved to paint.

102. G Leslie Hunter
Still Life with Fruit and Marigolds in a Chinese Vase c.1928
Oil on canvas 59.5 × 49.5
Robert Fleming Holdings Ltd

One of Hunter's most powerful still-life paintings, the controlled brushwork and bright, clean colour combining to give the painting an assured and confident air

103. G Leslie Hunter
St Paul 1929
Oil on canvas 56 × 66
Private Collection

104. G Leslie Hunter
Rotten Row, Hyde Park, London 1931
Watercolour 45 × 58.5
Lord and Lady Irvine

Hunter was fascinated by Hyde Park. He was often there early in the morning to watch the riders on Rotten Row, and he discovered that the misty early morning light presented him with the first real challenge since leaving Glasgow and Loch Lomond. The Hyde park drawings comprise his last coherent series but he had not had time to work them up into oil paintings before his death in December 1931

105. G Leslie Hunter
Café Corner, South of France 1927
Oil on canvas 61 × 51
Private Collection

106. G Leslie Hunter
House Boats, Loch Lomond 1930
Oil on canvas 51 × 61
Private Collection

Hunter returned to Loch Lomond in 1930, making a large series of watercolour sketches and oils. They were broadly painted, high in key, and rarely suffered from the overworking which often affected the first series of Loch Lomond landscapes made in 1924. The lessons learned at St Paul are clearly evident in these paintings, in the more considered and less fussy compositions, the clarity of the light and the assured handling

107. G Leslie Hunter
Loch Lomond 1930
Oil on canvas 44 × 50.5
Robert Fleming Holdings Ltd

108. G Leslie Hunter
Boat, Loch Lomond 1930
Oil on canvas 57 × 71
Private Collection

109. G Leslie Hunter
Loch Lomond 1930
Oil on canvas 51 × 61
Private Collection

110. G Leslie Hunter
Provençal Landscape 1929
Oil on canvas 57 × 70
Private Collection

111. G Leslie Hunter
Still Life with Chair and Vase of Flowers c.1930
Oil on canvas 53 × 63
Trustees of the Late Fulton Mackay

112. F C B Cadell
Boy in a Pink Jersey c.1919-20
Oil on canvas 76 × 51
Private Collection

At the first opportunity after leaving the army in 1919, Cadell returned to Iona, which he had first discovered in 1912. This painting is probably of one of the seven children of George Service, the Glasgow shipowner who became Cadell's main patron in the early 1920s and who was a regular visitor to Iona

113. F C B Cadell
Harvest on the Croft 1923
Oil on panel 38 × 46
Private Collection

While most of Peploe's paintings of Iona are of the bays at the north end of the island and of Ben More, the mountain on the adjacent island of Mull, Cadell found subjects everywhere on the island. He painted the road-menders and the grave-diggers and the everyday life of the small crofting community who lived on the island. The works from the early-1920s are characterised by bright colour, painted into an absorbent white ground which gave the paintings a particular intensity and a rather chalky surface texture

114. F C B Cadell
Cattle on the Shore, Iona c.1925-6
Oil on board 38 × 45.5
Private Collection

115. F C B Cadell
A Road near Cassis 1924
Oil on panel 38 × 46
Private Collection

116. F C B Cadell
Port Bhan, Iona 1925/6
Board 38 × 45.5
Private Collection

Many of Cadell's Iona landscapes have quite static compositions, reflecting the peace and tranquility that he found on the island. This painting, however, is much more lively, with the sweeping curve of the track down to the beach echoed in the diagonals created by the beach and Cadell's view of the rocky outcrops in the bay

117. F C B Cadell
From the Balcony, Cassis 1924
Oil on canvas 76 × 63.5
Private Collection

Cadell visited the south of France in 1923, forsaking Iona for the first summer since the end of the war, and returned with the Peploes in 1924. The brilliance and warmth of the light immediately invoked that same reaction in him which produced the fine series of views of Venice in 1910. In this painting, one of the largest painted in Cassis, he is using the planes of the buildings in the same way that he experimented with the recession of the rooms in his paintings of his Edinburgh studios. The perspective is not emphasised and Cadell has created almost an abstract composition with the rectangles of the different elevations of the houses, the windows and the tower, in counterpoint to the diagonals of the roofs and the balcony railings

118. F C B Cadell
Marigolds c.1924
Oil on panel 37.5 × 45
Richard Green Fine Paintings

119. F C B Cadell
The Breakfast Table, Auchnacraig, Mull 1927
Oil on board 38 × 45.5
Private Collection

This could almost be a painting of Cassis, the brilliant light and unusual composition being more reminiscent of Cadell's French paintings of 1923-4 than of his Iona paintings

120. F C B Cadell
Interior with Opera Cloak c.1924
Oil on canvas 101.5 × 76
Private Collection

The interiors of Cadell's house in Ainslie Place, Edinburgh, became the setting for many of his paintings after 1920. They often explore the view through from one room to another, composed in a counterpoint of flat rectangles of doors and panelling and the diagonals of rays of light and half open doors

121. F C B Cadell
The Drawing Room, Croft House
1932
Oil on canvas 63.5 × 76
Private Collection

During the 1930s Cadell was a frequent visitor to Croft House, Ion Harrison's home in Helensburgh. He painted at least two 'portraits' of its principal rooms, very different from those of his own house in Ainslie Place, Edinburgh

122. F C B Cadell
Interior: the Orange Blind c.1927
Oil on canvas 112 × 86.5
Glasgow Art Gallery and Museum

The masterpiece of Cadell's post-war career, this painting brings together in a matchless way many of the individual elements of his work – still-life, figure painting, and his delight at painting the spatial complexities of his elegant New Town house

123. F C B Cadell
Pink Azaleas 1927
Oil on canvas 61 × 46
Private Collection

This was the first painting by Cadell to be bought by Ion Harrison, who became Cadell's most important patron during the 1930s. Harrison later recalled Cadell's first visit to his house in Helensburgh when Cadell saw the painting hanging on his wall and said, with an infectious laugh, 'I have often wondered where that picture went. I congratulate you on having acquired it and, although I say it myself, you have a damned good Cadell.'

124. F C B Cadell
A Lady in Black c.1925
Oil on canvas 101.5 × 76
Glasgow Art Gallery and Museum

In the latter half of the 1920s Cadell's paintings lost some of the softness of line and colour which characterises much of his earlier work. His palette took on a more metallic or acidic hue, with pale purples, cool pinks, greys and browns coming to dominate his paintings of interiors. He also began to narrow his field of vision; here our attention is concentrated on the sitter and her immediate surroundings. The console table and mirror frame are cut off and we are given no hint of the size of room in which the sitter is posing, unlike the earlier portraits where the setting is almost as important as the figure and is often the true focus of the painting

125. S J Peploe
North End, Iona c.1929
Oil on canvas 46 × 56
Private Collection

126. S J Peploe
Ben More, Mull, from Iona c.1925-6
Oil on canvas 63.5 × 76.5
Hunterian Art Gallery, University of Glasgow

On his many visits to Iona Peploe was drawn towards the rather sombre vista of Ben More rising out of the moors on the adjacent island of Mull. It was not a view that Cadell enjoyed painting but Peploe treated it much as he did his still-lifes, as a continuing challenge and source of inspiration

127. J D Fergusson
The Drift Posts 1922
Oil on canvas 54.5 × 59.5
Robert Fleming Holdings Ltd

128. J D Fergusson
A Puff of Smoke near Milngavie 1922
Oil on canvas 61 × 56
Private Collection

Fergusson spent the summer of 1922 on a motoring tour of the Scottish Highlands, accompanied by his friend and supporter John Ressich. Along the way Fergusson made a series of small pencil sketches and watercolours which he turned into a series of twenty or so finished canvases over the next six months. They left Glasgow via Milngavie en route for the Campsie hills seen in the background of the painting. Many of the works in the series are as close to topographical painting as Fergusson was ever to come but in this first of the series he created the most unusual and interesting of the group. Looking out over the town to the hills beyond Fergusson makes the composition draw us headlong into his journey, down the hill, past the houses with their smoking chimneys (in midsummer, too) across to the first of the Highland ranges on his way north. The device of the overhanging tree, with only the tips of the branches showing, was by no means original, but Fergusson uses it with aplomb and avoids the cliché that it was to become in future landscapes painted in the south of France in the 1930s.

129. S J Peploe
A Vase of Pink Roses c.1925
Oil on Canvas 60 × 51
Robert Fleming Holdings

130. J D Fergusson
Megalithic 1931
Oil on canvas 92 × 73
Private Collection

Margaret Morris is shown adopting one of her dramatic poses against a standing stone monument – hence Fergusson's punning title

131. S J Peploe
Still Life with Roses c.1925
Oil on canvas 50.8 × 40.6
Aberdeen Art Gallery and Museums

Peploe's quest to paint the perfect still-life was probably achieved in a group of paintings made in the mid-1920s. His colour is strong and vital, the handling assured and deft, and the compositions tight and controlled. never satisfied, however, Peploe went on to take the theme of still-life in ever-changing directions

132. S J Peploe
Trees, Antibes 1928
Oil on canvas 63.5 × 76.2
Private Collection

In Peploe's later visit to the south of

170

France, where he stayed at Antibes, there is a growing compulsion to explore the cooler tones created by the shadows cast in the strong sunlight. Peploe recorded these as increasingly blue, grey and green and the same tones and colours were used in his landscape and still-life paintings on his return to Scotland

133. S J Peploe
Michaelmas Daisies and Oranges
c.1927
Oil on canvas 61 × 50.8

Private Collection

One of the most accomplished of the later still-lifes, the paler tonality of this series here being disturbed by the bright colour of the flowers and the orange in the foreground

134. S J Peploe
The Black Bottle c.1930
Oil on canvas 62 × 51
By gracious permission of Her Majesty Queen Elizabeth The Queen Mother

135. S J Peploe
Roses c.1926
Oil on canvas 51 × 40.5
Professor and Mrs Ross Harper

136. J D Fergusson
Eastra, Hymn to the Sun 1924
Brass 41 high
Robert Fleming Holdings Ltd

Eastra was a Saxon goddess of the sun, and Fergusson used brass for the sculpture to ensure that the head not only reflected the light of the sun but also glowed like the sun itself

Source Notes for the Introduction

1. J D Fergusson, 'Memories of Peploe', *Scottish Art Review*, vol. 8, no. 3, 1962, pp.8-12, 31-2.

2. J D Fergusson, 'Chapter from an Autobiography', *Saltire Review*, vol. VI, no. 21, pp.27-32.

3. Letter from E A Taylor to Dr T J Honeyman, 13 Dec. 1939, first quoted by William Hardie in his introduction to *Three Scottish Colourists*, Scottish Arts Council, 1971, p.10.

4. See Elizabeth Cumming, 'Colour, Rhythm and Dance: the Paintings and Drawings of J D Fergusson and his Circle', in *Colour, Rhythm and Dance*, Scottish Arts Council, 1985, p.7.

5. Stanley Cursiter, *Peploe: an intimate memoir of the artist and his work*, Thomas Nelson & Sons, Edinburgh, 1947, p.17.

6. Letter from Cadell to Ion Harrison, post 1929, quoted by T J Honeyman, *Three Scottish Colourists*, Faber, London 1950, p.83

7. *Overland Monthly*, San Francisco, September 1902, five illustrations for Bret Harte's 'The Outcasts of Poker Flat'.

8. T J Honeyman, *Introducing Leslie Hunter*, Faber, London,1937, pp. 59-60.

9. Ibid, p. 62.

10. Ibid, p. 73.

11. J D Fergusson, 'Memories of Peploe', *Scottish Art Review*, vol. 8, no. 3, 1962, pp.8-12, 31-2.

12. John Middleton Murry, *Between Two Worlds: an autobiography*, 1935, p.135

13. J D Fergusson, 'Chapter from an Autobiography', *Saltire Review*, vol. VI, no. 21, pp.27-32.

14. For a more complete account of Rhythm and Fergusson's relationship with Murry, Sadler and Mansfield see the essay by Sheila McGregor in *Colour, Rhythm and Dance*, Scottish Arts Council, 1985, pp.13-17.

15. Guy Peploe in the Introduction to catalogue of the S J Peploe exhibition, Scottish National Gallery of Modern Art, Edinburgh, 1985, p.10.

16. Ibid, pp.11-12.

17. J D Fergusson, 'Memories of Peploe', *Scottish Art Review*, vol. 8, no. 3, 1962, pp.8-12, 31-2.

18. T J Honeyman, *Introducing Leslie Hunter*, pp. 69-70.

19. Ibid, p.76.

20. Ibid, p.85.

21. Ibid, pp.187-8.

22. Stanley Cursiter, *Peploe*, p.73

23. Ibid, pp. 68-9

24. 7 July 1932, Cadell to Peploe, first quoted by T. Hewlett, *Cadell: A Scottish Colourist*, Portland Gallery, 1988, p.81.

25. Ibid, p.91.

26. 16 Dec. 1923, quoted by Margaret Morris Fergusson in *The Art of J D Fergusson*, Blackie, Glasgow, 1974, pp.150-2.

Bibliography

The catalogue of the Scottish Arts Council exhibition, *Three Scottish Colourists*, 1970 contained an appendix compiled by Ailsa Tanner which gave a full bibliography, list of exhibitions, press and magazine references and list of works in public collections for Peploe, Cadell and Hunter. The catalogue of The Fine Art Society's *J D Fergusson Centenary Exhibition*, 1974, gave a full bibliography and list of exhibitions for Fergusson. The Bibliography below does not duplicate the details given in the above catalogues

General Works

Billcliffe, Roger, *The Glasgow Boys*, John Murray, London,1985
Caw, Sir James L, *Scottish Painting – Past and Present*, London, 1908
Finlay, Ian, *Art in Scotland*, London, 1948
Gage, Edward, *The Eye in the Wind: Contemporary Scottish painting since 1945*, Collins, London 1977
Guildford House Gallery, *Three Scottish Colourists*. Catalogue introduction by Richard Calvocoressi, Guildford,1980
Hardie, William, *Scottish Painting, 1837-1939*, Studio Vista, London, 1976
Honeyman, T J, *Three Scottish Colourists*, Faber, London, 1950
Scottish Arts Council, *Three Scottish Colourists*. Exhibition catalogue by T J Honeyman and William Hardie; bibliography and appendices by Ailsa Tanner, Edinburgh,1970.

F C B Cadell

Peploe, Guy, *F C B Cadell, A Critical Memoir*, unpublished dissertation, Aberdeen University, 1982.
The Fine Art Society, *F C B Cadell: A Centenary Exhibition*. Catalogue introduction by Roger Billcliffe, Glasgow, Edinburgh and London, 1983.
Hewlett, Tom, *Cadell, A Scottish Colourist*, Portland Gallery, London, 1988.

J D Fergusson

The Fine Art Society, *J D Fergusson, 1874-1961, a Centenary Exhibition*. Catalogue introduction by Roger Billcliffe, London and Edinburgh, 1974.
Morris, Margaret, *The Art of J D Fergusson: a Biased Biography*, Blackie, Glasgow, 1974
Sheila McGregor, *J D Fergusson: The Early Years*, unpublished M.Litt thesis, Courtauld Institute of Art, University of London, 1981
Crawford Centre for the Arts, *J D Fergusson 1905-15*. Catalogue introduction by Diana Sykes, St Andrews, 1982
Scottish Arts Council, *Colour, Rhythm & Dance: Paintings & Drawings by J D Fergusson and his circle in Paris*.

Contains essays by Elizabeth Cumming, Sheila McGregor and John Drummond; also a further bibliography relating to Fergusson's years in Paris, 1907-14; Edinburgh, 1985.

G Leslie Hunter

Honeyman, T J, *Introducing Leslie Hunter*, Faber, London, 1937
The Royal Glasgow Institute of the Fine Arts, Glasgow 1977. Forty-six paintings by Hunter were included in the annual exhibition of the Glasgow Institute as a centenary tribute.

S J Peploe

Cursiter, Stanley, *Peploe: an intimate memoir of an artist and his work*, Nelson, London, 1947.
Scottish National Gallery of Modern Art, *S J Peploe 1871-1935*. Catalogue introduction by Guy Peploe; contains a full bibliography and list of exhibitions, Edinburgh, 1985.

Index

Only those paintings mentioned in the Introduction are in the Index. Where galleries do not have a separate entry, they will be found under the city where they were located.